THE COLLECTION HIGHLIGHTS FROM THE PORTLAND MUSEUM OF ART

THE COLLECTION

HIGHLIGHTS FROM **THE PORTLAND MUSEUM OF ART**

EDITED BY

Karen A. Sherry

ESSAY BY

Earle G. Shettleworth, Jr.

CATALOGUE ENTRIES BY

Mollie R. Armstrong

Hannah W. Blunt

Ariel Hagan Elwell

Andrew J. Eschelbacher

Diana Jocelyn Greenwold

Jessica May

Karen A. Sherry

CONTENTS

FOREWORD AND ACKNOWLEDGMENTS

Mark H. C. Bessire

Director, Portland Museum of Art

Located in the heart of Maine's largest city, the Portland Museum of Art (PMA) has long held a vital place in the cultural life of New England and beyond, with roots dating back to its predecessor, the Portland Society of Art. Founded in 1882 by artists and civic leaders, the organization was from its inception devoted to the mission of enriching the lives of its community through art. Although the museum has a long track record of publishing exhibition catalogues, this volume, *The Collection: Highlights from the Portland Museum of Art*, is the museum's first collection guidebook. The book also contains the first published institutional history of the PMA, contributed by Earle G. Shettleworth, Jr., Maine State Historian.

The museum's long history of collecting began with its first art acquisition in 1888, Benjamin Paul Akers' *The Dead Pearl Diver* (CAT. 18). Over the following decades, the PMA has amassed a permanent collection of more than eighteen thousand objects encompassing a wide range of styles, artistic practices, and media (paintings, sculpture, works on paper, and decorative arts). This collection consists predominantly of American art dating from the eighteenth century to the present day, with smaller, though significant, holdings of European art from the mid-nineteenth through the mid-twentieth century. In addition, the gallery experience that visitors enjoy at the PMA is greatly enhanced by important loan collections of European art from Isabelle and Scott Black, and Leslie B. Otten.

Like many museums founded in the nineteenth century, the PMA and its collection have evolved through a combination of serendipity and deliberation. What is distinctive and distinctly important about the PMA's collection is how it represents the region's cultural patrimony and demonstrates how regional artistic practices contribute to broader national, and even international, art histories. An impressive seventy-five percent of the permanent collection came to the museum as gifts from more than ten thousand different donors. Indeed, for well over a century, the PMA has enjoyed a broad base of community support, as well as trust in and shared commitment to its

mission. Some patrons have had an outsized impact on the institution through gifts of art. These gifts include the bequest of Elizabeth B. Noyce, who donated her collection of nineteenth- and early twentieth-century American paintings; the bequest of Charles Shipman Payson, which gave the museum its core collection of artwork by American master Winslow Homer; the Joan Whitney Payson Collection, which forms the heart of the PMA's European painting collection; gifts of German Expressionist prints from the collection of David and Eva Bradford; gifts of American art from Owen W. and Anna H. Wells; and gifts from the Alex Katz Foundation, which have built the museum's holdings of contemporary painting. Longtime museum trustee Dr. Walter B. Goldfarb and his late wife Marcia have given the museum a transformative group of nineteenth-century American trompe l'œil paintings.

Yet in addition to these extraordinary gifts, the PMA's collection represents the cultural wealth and collecting tastes of thousands of Mainers, not merely those of a few families. The public-spiritedness and generosity of our community are exemplified in our inaugural acquisition, as Akers' *The Dead Pearl Diver* was acquired through a subscription to raise funds for its purchase. Continuing in this tradition, a wide network of museum members and other supporters donate regularly to the Friends of the Collection, an annual fund used specifically for acquisitions and care of works of art. Since 1983, this fund has provided one of the PMA's most vital avenues for building our collection.

Akers' stunning masterpiece of Neoclassical sculpture also reflects the second distinctive strength of the PMA's collection: art produced by artists working in northern New England (Akers was a Maine native). Historically, Maine has been a magnet for hundreds of artists who came to New England seeking inspiration in its natural beauty and respite from urban centers. Will Barnet, George Bellows, Katherine Bradford, Frederic Edwin Church, Lois Dodd, Marsden Hartley, Winslow Homer, Robert Indiana, Eastman Johnson, Gertrude Käsebier, Alex Katz, Fitz Henry Lane, Paul Strand, and several generations of Wyeths are just some of the nationally (even internationally)

significant artists with strong ties to the state who are represented in the PMA's collection. Since the late nineteenth century, Maine has been home to dozens of artists' communities and collectives in places such as Monhegan and Ogunquit. Today, three of the nation's premier residency programs—the Skowhegan School of Painting and Sculpture, Haystack Mountain School of Crafts, and Maine Media Workshops— are located here. This deep and continuing history suggests the profound importance of Maine as a place where creativity has thrived at an unusual scale and has affected the broader story of art in America.

In the pages that follow, you will find splendid, full-color plates of one hundred of the PMA's most significant and beloved works of art, accompanied by short essays by our curatorial team. Our goal is to introduce our audiences, local and faraway, to the unique contours of the PMA's collection and its institutional history. This publication belongs to a series of projects in the multiyear initiative called *Your Museum, Reimagined*, which includes a searchable database of the entire collection on the PMA's website; the debut of the Peggy L. Osher Art Study and Collection Committee Conference Room; and the reinstallation of the museum's galleries across its campus. While growth and change are the bywords of our current fast-paced museum culture, we at the Portland Museum of Art feel exceptionally proud to usher our institution into the future by honoring our core responsibility as the caretakers of a rich artistic and cultural legacy.

Our ability to act as the stewards of our collection is greatly aided by the support of individuals, foundations, and institutions, and by the spirit of excellence and collaboration that guides our daily work at the museum. The authors of this catalogue and I wish to thank many people and organizations who have contributed their time, talents, and knowledge to this project. First and foremost, for their unwavering professionalism and dedication to managing the documentation and care of our collection, we thank the PMA's Registration staff, including Lauren Silverson, Erin Damon, Allyson Humphrey, Greg Welch, and Kris Kenow. The staff at various area libraries facilitated our research. Moira Steven, Heather Dawn Driscoll, Linda Smallwood, and Amy Shinn of the Joanne Waxman Library, Maine College of Art, were especially helpful in securing resources, as was the staff of the Portland Public Library. Arlene Palmer Schwind

and Laura Fecych Sprague generously shared their art-historical expertise with us. Jennifer DePrizio, Peggy L. Osher Director of Learning and Interpretation at the PMA, deserves special acknowledgment for her invaluable feedback on the catalogue texts.

For the production of this catalogue, we are grateful to Sandra Klimt, who provided expert management of the project from beginning to end. Mollie Armstrong and our former colleague Ariel Hagan Elwell, in addition to authoring catalogue entries, dispatched myriad administrative tasks with efficiency and professionalism. This catalogue has benefited immensely from the editing talents of Jane E. Boyd and Juliet Clark. Pat Appleton of Malcolm Grear Designers produced an inspired design befitting our collection. Elizabeth Jones, Sally Struever, and Graeme Kennedy in the PMA's Audience Engagement and Communication Division helped craft the vision for this publication. Luc Demers produced stunning new photography of many of the works of art featured in these pages. A team of conservators, including Ronald Harvey, Nina Roth-Wells, Lesley Paisley, Rebecca Johnston, and Nina Vinogradskaya, worked with us to ensure that the artwork looks its very best.

This publication would not have been possible without the generous support of grants from the National Endowment for the Arts and the Wyeth Foundation for American Art. We also thank the individuals who expressed their passion for the museum and this project by sponsoring pages in our catalogue. The names of these sponsors appear at the bottom of the page for each catalogue entry. The PMA's Development Department, particularly Elizabeth Cartland and Christi Razzi, helped secure this funding.

The PMA is very fortunate to have a dedicated and engaged institutional leadership. We thank the members of our Board of Trustees and Collection Committee for their unwavering support of the collection and this catalogue. We recognize that the history, knowledge, and collection embodied in *The Collection: Highlights from the Portland Museum of Art* build upon the past efforts of thousands of individuals—staff, trustees, friends, and supporters—who shaped this museum and its artistic treasures over the course of its 130-year history. With this publication, we honor these past contributions and extend the institution's remarkable legacy forward to current and future generations of art lovers.

A SHORT HISTORY OF THE PORTLAND MUSEUM OF ART

Earle G. Shettleworth, Jr.

Maine State Historian

Today, the Portland Museum of Art is a locally treasured, nationally renowned midsized museum located in Maine's largest city. The museum's permanent collection contains more than eighteen thousand objects, primarily American and European art from the eighteenth century to the present day in all media. Its buildings consist of several architecturally significant structures, including the studio of the great American master Winslow Homer. Like many art museums in the twenty-first century, the PMA fulfills many roles: keeper of cultural artifacts, generator of art-historical scholarship, educator about human creativity, and community resource for diverse visitors from near and far. This present-day museum is built upon a long and storied legacy with roots reaching back to the nineteenth century. Over its 130-year history and through trials and triumphs, the museum has evolved from a small local artists' organization to one of New England's leading cultural institutions.

In 1828, Portland art critic John Neal wrote, "a love of painting is beginning to betray itself among our people."[1] Charles Codman, the community's first resident landscape painter, had come from Boston six years earlier to pursue a career in commercial and fine arts. Ranging from the realistic to the Romantic, Codman's pictures figured prominently in the city's first major art exhibition, which Neal arranged in 1838 as part of the Maine Charitable Mechanic Association Fair. Also represented in this show was the work of Charles O. Cole, a prolific local portrait painter. Taking his cue from Neal, Cole assembled two large art exhibits in the 1840s from Portland private collections, presenting more than 200 paintings in 1845 and over 130 in 1849. These three pioneering displays provided artists with exhibition opportunities beyond the typical venues of their studios and the windows of frame shops.

Fueled by maritime commerce, railroads, and manufacturing, Portland's mid-nineteenth-century prosperity produced several important art patrons. Chief among them was the city's wealthiest resident, John Bundy Brown, whose villa, Bramhall, featured a wing added in 1864 to show his distinguished collection of works by Maine artists,

Hudson River School landscape painters, and sculptors such as Benjamin Paul Akers and Randolph Rogers. In the English country house tradition, Brown opened his second-floor gallery to the public.

Several young artists emerged in Portland during the affluent 1850s, including Harrison Bird Brown, John Bradley Hudson, Jr., Charles Frederick Kimball, and George Frederick Morse. While Brown enjoyed commercial success as a landscape painter into the 1890s, Hudson, Kimball, and Morse became avocational artists who founded the Brush'uns painting group in 1860. Regardless of the season, each Sunday for decades the Brush'uns made excursions to scenic spots throughout the region to create plein air canvases.

The shared camaraderie and love of art of the Brush'uns led this group to help found the Portland Society of Art, the forerunner of the Portland Museum of Art. In 1881, discussions between Harrison Brown and his friend James P. Baxter, a prominent businessman and scholar, resulted in the meeting of twenty-five community leaders on January 4, 1882, to consider forming an art society. Among those attending were artists Brown, Kimball, and Morse, architect Francis H. Fassett, newspaper editor Edward H. Elwell, and businessman John E. DeWitt. During subsequent meetings in January and February 1882, Baxter's committee of artists, professionals, and businessmen wrote the bylaws for the Portland Society of Art, incorporated on March 3, 1882. The bylaws stated that the society's purpose was "to encourage a knowledge and love of art through the exhibition of art works and lectures upon art subjects; the acquisition of an art library and works of art, such as paintings, statuary and engravings, and the establishment of an art school and museum."[2] Membership was open to men and women alike.

The new organization acted immediately to implement its goals. Harrison Bird Brown arranged an inaugural exhibit of 295 pictures in June 1882, using his connections with prominent American artists and dealers to borrow works by such leading national figures as Albert Bierstadt, Alfred Thompson Bricher, Jasper Cropsey, and

John Henry Twachtman. The next year, member John Calvin Stevens of the Fassett and Stevens architectural firm designed a small clubhouse. Opened on February 14, 1884, this graceful Shingle Style building contained a 32-by-20-foot exhibition gallery, a gentlemen's smoking room, and a reading room (FIG. 1). There, between 1884 and 1896, the society held an annual exhibition of American and European art, as well as spring and fall exhibits of local art and occasional showings of drawings, etchings, and engravings. Members of the Brush'uns group were well represented in these early exhibitions, as was Winslow Homer, who had been living in Prouts Neck, about twelve miles south of Portland, since 1884. Beginning in 1886, the society conducted art classes, hiring prominent Boston figure painter Frank W. Benson as the first instructor and thus elevating art education to a new level of professionalism. In 1888, a public subscription secured the organization's first acquisition, Benjamin Paul Akers' Neoclassical marble *The Dead Pearl Diver* (CAT. 18).

Despite the initial flurry of activities and enthusiasm that attended its founding, the fledgling society encountered several early challenges. In 1896, the organization lost its clubhouse (which was situated on land owned by the Portland Public Library) and had to relocate its activities to smaller quarters in Harrison Bird Brown's former studio. By 1903, membership had plummeted from 150 to 50, causing the board to vote to give up its rented space, suspend future exhibits, and place its furnishings in storage.

That year, John Calvin Stevens began corresponding about the future of the Portland Society of Art with Margaret Jane Mussey Sweat, a noted writer, book reviewer, and supporter of the historic preservation of George Washington's Mount Vernon estate, who divided her time between her native Portland and Washington, D.C. Sharing

Stevens' concern for the current plight of the society, which she had joined in 1888, Sweat made a five-hundred-dollar donation in 1903 that enabled the group to hold a major exhibition. Expressing her belief that "a small push will give motion to a large body,"[3] Sweat joined forces with Stevens to revive the community's commitment to the arts. Through her vision and support, she had a transformative impact on the society, helping to effect a turnaround from a near-moribund artists' organization to a lasting presence in Portland's cultural scene.

When Margaret Jane Mussey Sweat died in 1908, she bequeathed her historic home, the McLellan House (built 1800–1801) at High and Spring Streets, to the Portland Society of Art along with funds to build an art museum on the adjacent property in memory of her husband, Lorenzo de Medici Sweat, a former U.S. congressman who was named after the great Italian Renaissance ruler and art patron. That year, John Calvin Stevens designed the handsome brick Lorenzo de Medici Sweat Memorial, featuring a Colonial Revival exterior and a Beaux Arts classical interior consisting of a rotunda and five galleries (FIG. 2). When the new complex opened on April 22, 1911, its High Street entrance pavilion linked a historic house museum with a state-of-the-art exhibition space (FIGS. 3 and 4). Among the words of praise for the Sweat Memorial was the comment in the prestigious *American Architect* magazine that "the new building is one of quiet refinement, excellently adapted for its purposes."[4] The combined spaces of

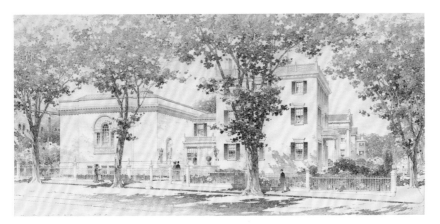

FIG. 2
David A. Gregg (died 1916),
The L. D. M. Sweat Memorial, 1909,
graphite and watercolor on paper,
20 1/4 x 39 3/8 inches. John Calvin
Stevens (United States, 1855–1940)
and John Howard Stevens (United
States, 1879–1958), architects.
Portland Museum of Art, Maine. Gift
of John Calvin Stevens II, 1974.346

FIG. 3
The Rotunda of the Sweat Memorial Gallery, 1911, photograph.
Collection of Paul S. Stevens

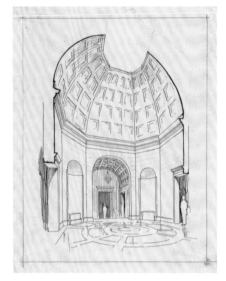

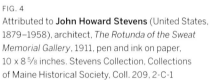

FIG. 4
Attributed to **John Howard Stevens** (United States,
1879–1958), architect, *The Rotunda of the Sweat
Memorial Gallery*, 1911, pen and ink on paper,
10 x 8 ⅝ inches. Stevens Collection, Collections
of Maine Historical Society, Coll. 209, 2-C-1

the Sweat galleries and the McLellan House gave the society its first permanent home
and Portland its first public art museum.

With its new museum in place, the Portland Society of Art turned its attention to
restoring its dormant art education program. In 1911, the society produced a curriculum
for a revitalized art school. In 1914, the board purchased the Charles Q. Clapp House,
adjacent to the McLellan House on Spring Street, and had John Calvin Stevens convert
this 1832 Greek Revival landmark into classrooms and studios.

The fifty years following the opening of the museum in 1911 were characterized by
steady and quiet growth as the Portland Society of Art continued to build its collection,
mount special exhibitions, and operate the art school. In 1922, John Calvin Stevens
assumed the leadership of the society from longtime president George Frederick
Morse. After Stevens' death in 1940, his influence continued through the presidencies
of his son John Howard Stevens and his son-in-law Neal W. Allen, Sr. In 1931, John
Calvin Stevens proposed a major addition to connect the museum to the school, but
the financial constraints of the Great Depression prevented its construction. That year,
artist Alexander Bower was hired as the institution's first paid director.

During the first half of the twentieth century, John Calvin Stevens and his colleagues viewed themselves as guardians of established American landscape painting traditions. The museum's galleries became showcases for work in this vein, especially Impressionist and realist paintings. The collection benefited from this conservative approach, which welcomed nineteenth-century works at a time when many institutions were deaccessioning them in favor of more progressive styles. By 1960, the museum had assembled core holdings of works by dozens of American artists who were drawn to Maine for its renowned natural beauty.

The Portland Society of Art officially changed its name to the Portland Museum of Art in 1953. Three years later, it elected Sally C. Fowler as its first woman president. Her election ushered in a new era of active participation by women volunteers, who remain a vital force in the organization to this day (along with their male counterparts). In 1957, the museum rescheduled its annual exhibition from March to the summer months to attract more visitors during the height of the tourist season and changed the format to a juried show of contemporary art. For the next five summers, exhibits were judged by panels of well-known American artists such as Hans Moller and Louise Nevelson, attracting reviews from the *New York Times* and other important journals.

Encouraged by this success, the museum hired its first professionally trained director in 1960. Donelson F. Hoopes focused on strengthening the nineteenth-century American painting collection. His successor, John E. Pancoast, who served from 1962 to 1969, staged exhibits that hung every work owned by the museum in order to expose the breadth of the collection to the public. These were followed by a series of notable contemporary shows, as well as such major acquisitions as a full-length portrait painting by James Abbott McNeill Whistler (see CAT. 28) and a monumental sculpture by Gaston Lachaise. Cosmopolitan in outlook, Pancoast challenged visitors visually and intellectually, setting high standards for the museum and the cultural scene in Maine.

John Holverson joined the museum as its curator in 1970 and became director in 1975, a post that he held until 1987. Of his many accomplishments, Holverson's approach to businessman Charles Shipman Payson, a great-grandson of John Bundy Brown (who maintained an art gallery in his Portland home in the 1860s), was to prove decisive to

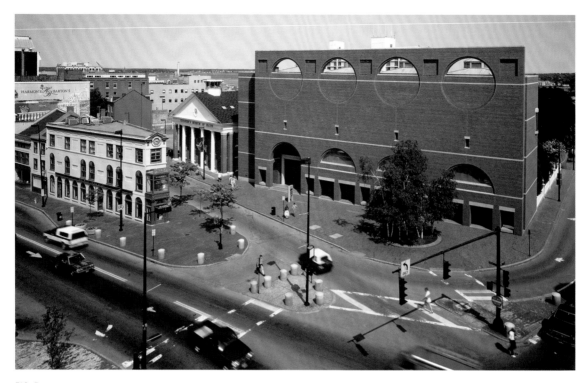

FIG. 5
Payson Building, Portland Museum of Art, Congress Square, 1996,
photograph, exterior view. Portland Museum of Art, Maine

the museum's future. A Portland native, Payson owned seventeen watercolors and oils by Winslow Homer—a valuable collection that was being sought by other museums. Despite the fact that Homer had painted in nearby Prouts Neck for the last twenty-seven years of his life, the museum did not own a single work by him. This absence formed the basis for Holverson's appeal to Payson. In a series of meetings in 1976 and 1977, Holverson and museum trustees D. Brock Hornby and Owen W. Wells negotiated the gift of the Homers (see CATS. 21–23), which paved the way for discussions about the museum's future growth. Payson challenged the museum to consider possibilities for expansion that resulted in the acquisition of adjacent sites on Congress Square and High Street. He then pledged five million dollars toward the construction of a new building and another five million for a twenty-year charitable trust to provide operating income.

In 1978, after a selective competition, the Portland Museum of Art hired the architect Henry Nichols Cobb of I. M. Pei and Partners to plan the expansion.[5] Cobb's firm had designed the East Building addition to the National Gallery of Art in Washington, D.C., and he had been appointed chairman of the Department of Architecture at the Harvard

Graduate School of Design. Cobb devised a bold solution to the challenge of creating a new primary wing that would not overshadow the Sweat Memorial and the McLellan House. He designed a building that faces Congress Square with a monumental post-modern brick façade, forming the initial mass of a structure that gracefully steps down High Street to join with its historic predecessors (FIG. 5). By applying what he defined as the four basic qualities of architecture—coherence, rigor, openness, and audacity—the architect created a museum of enduring quality, tailored for Portland but with an eye to the world.

By October 1980, the Portland Museum of Art had secured the 11.6 million dollars to construct the Payson Building through a major capital campaign that elicited wide-spread support from the region and beyond. The site was cleared and construction proceeded over a two-and-a-half-year period with a grand opening of the Charles Shipman Payson Building on May 14, 1983. Visitors entered the great hall, an atrium illuminated in natural light, surrounded by three floors of galleries. These intercon-nected galleries of varying sizes created a sense of discovery when experiencing works of art. The Payson Building provided twenty thousand square feet of new gallery space—five times the area of the Sweat galleries and McLellan House combined—as well as art storage rooms, a two-hundred-seat auditorium, and spaces for other museum functions.

The 1983 opening of the Payson Building marked the beginning of a new era for the century-old Portland Museum of Art. The museum and the school had recently split into separate entities so that each institution could better serve its core mission. (The newly independent school became the Maine College of Art.) For the museum, this mission included building the collection, modernizing operations in keeping with new industry standards, and expanding its role as a leader in the arts community. The next three decades would witness a series of stunning achievements accomplished by deeply committed trustees and supporters working in close cooperation with four dynamic directors: John Holverson (1975–1987), Barbara S. Nosanow (1988–1993), Daniel E. O'Leary (1993–2008), and Mark H. C. Bessire (2009–present).

The acquisition of Charles Shipman Payson's Homers and the construction of the Payson Building fostered the expectation that other great collections would follow.

In direct response to the Payson gift, the 1979 donation of the Hamilton Easter Field Collection added more than fifty paintings, sculptures, and works on paper by American modernists. In 1991, eight European works of art collected by Joan Whitney Payson, Charles Shipman Payson's wife, were given to the museum in an innovative shared exhibition agreement with the Colby College Museum of Art.[6] That same year, longtime museum patrons Peggy and Harold Osher donated their extensive collection of Winslow Homer prints to complement the Payson Homers (see, for example, CAT. 20). In 1996, philanthropist and art collector Elizabeth B. Noyce bequeathed sixty-six works of American art, many depicting Maine subjects, by major painters of the nineteenth and twentieth centuries.[7] Since 2002, David and Eva Bradford have given more than 140 works from their collection of German Expressionist prints to the collection, affording the museum particular depth in this area (see CAT. 57).

The museum galleries were also enriched by two major loan collections. Since the 1980s, Maine native Scott Black and his wife Isabelle have generously shared their important collection of European modernist works. In 1993, Leslie Otten loaned his collection, which covers significant developments in European art from the late nineteenth century to the mid-twentieth century. Together, the Black and Otten Collections, along with the museum's own holdings, make the Portland Museum one of the few places in northern New England where visitors can experience European art.

Daniel O'Leary's fifteen-year tenure as director saw the museum strengthen its financial base, increase its membership and visitation, and expand its real estate—all while continuing to grow the permanent collection. In addition, a biennial exhibition devoted to contemporary art was established in 1998 with an endowment from artist William Thon and his wife Helen. The museum has held nine biennials to date and has an active program of collecting contemporary art. In October 2000, the museum initiated a 13.9 million-dollar project to reunite the Payson Wing with the Sweat Memorial and the McLellan House, both of which had been closed since 1980. In recognition of the significance of the McLellan House as one of Portland's grandest early nineteenth-century domestic spaces, the architectural ornamentation of the house was restored to its original glory and the rooms decorated with period-appropriate reproduction

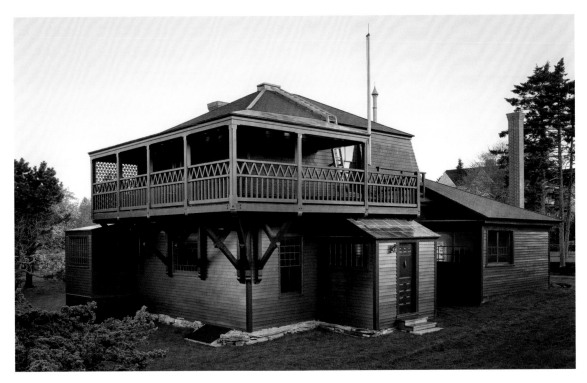

FIG. 6
Winslow Homer Studio at Prouts Neck, 2012, photograph, exterior view
from the southeast. Portland Museum of Art, Maine

wallpapers and floor coverings. On October 5, 2002, First Lady Laura Bush cut the ribbon to reopen the museum's original buildings as part of a celebration of their restoration.

In 2006, the Portland Museum of Art purchased from family descendants Winslow Homer's studio, which is perched on the Maine coast at Prouts Neck and is one of the most significant sites in the history of American art (FIG. 6). Built as a carriage house for Homer's father, this small frame building was converted by the artist into his studio and residence in 1883 with the help of John Calvin Stevens, founding member of the Portland Society of Art. For twenty-seven years until Homer's death in 1910, this rustic oceanfront dwelling was the setting for the creation of his late seascapes, widely considered among America's greatest paintings of the late nineteenth and early twentieth centuries. Deeply committed to Homer's artistic legacy through its Payson and Osher Collections, the museum embarked on this challenging acquisition and a six-year, multimillion-dollar restoration of this National Historic Landmark. After major preservation work that returned the structure to its late nineteenth-century appearance, the PMA opened the Winslow Homer Studio to the public in the fall of 2012. A recent

initiative by the museum and the local community has succeeded in purchasing the land surrounding the Studio, ensuring the preservation in perpetuity of the ocean views that inspired the artist. Through the museum's stewardship, generations of visitors will be able to walk in Homer's footsteps and appreciate the influence of this place on his art and the national imagination.

With an eye to the future, the museum acquired two properties adjacent to its downtown Portland location, the YWCA at Spring and Oak Streets in 2007 and the historic Charles Q. Clapp House on Spring Street in 2008. A recent building, the YWCA was demolished and its site converted into an attractively landscaped parking area until the land can be dedicated to a new purpose. The historic Clapp House, which had been retained by the Maine College of Art when the museum and school split in 1982, was transferred back to the museum in 2008, reinstating it to the campus and assuring its continued historic relationship to the McLellan House.

The institution's 130-year history has witnessed its transformation from a small, local artists' organization to a nationally renowned museum. Building on its storied legacy, the Portland Museum of Art today continues to fulfill its original mission of encouraging appreciation for art. With its permanent collection of more than eighteen thousand works of art, its campus of architecturally significant buildings, and its dynamic slate of exhibitions and educational programs, the museum serves a vital role in the cultural life of the region and beyond. Under the leadership of current director Mark Bessire, the museum has recently completed construction of the Peggy L. Osher Art Study and Collection Committee Conference Room and published its collection database online. Both projects are in keeping with the institution's guiding commitment to making art accessible to all. The collection continues to grow, and visitation numbers, membership levels, and corporate and foundation support have reached unprecedented highs. While committed to honoring its past and preserving its collection and historic buildings, the museum is simultaneously looking ahead and planning strategically for the future. As times change and museums (and the needs of museumgoers) evolve, the Portland Museum of Art will continue to foster the enjoyment and encouragement of art for generations to come.

Notes to the Reader

All catalogue works are in the collection of the Portland Museum of Art.

Entry authors are identified by their initials.

The works of art featured in this catalogue are generally arranged in chronological order. A full list of catalogue artists is provided in the index.

Dimensions are given in inches, with height preceding width and (for three-dimensional objects) depth or diameter.

The names appearing along the bottom left edge of the pages represent the sponsors for each catalogue entry.

Catalogue Entry Authors

Mollie R. Armstrong (MRA)
Exhibitions Coordinator

Hannah W. Blunt (HWB)
Assistant Curator, Mount Holyoke College Art Museum

Ariel Hagan Elwell (AHE)
Formerly, *Curatorial Coordinator*

Andrew J. Eschelbacher (AJE)
Susan Donnell and Harry W. Konkel Assistant Curator of European Art

Diana Jocelyn Greenwold (DJG)
Curatorial Fellow

Jessica May (JM)
Chief Curator

Karen A. Sherry (KAS)
Formerly, *Curator of American Art and Director of Collections*

CATALOGUE ENTRIES

PEZÉ PILLEAU

England, born France, 1696–1776

1 **Grace Cup** 1740–45

Silver

12 x 10 1/2 x 6 1/8 inches

Museum purchase with gifts from
Mr. and Mrs. Joseph William Pepperrell
Frost, estate of William P. Palmer III, and
five anonymous donors, 1982.122.3a,b

British Admiral Peter Warren presented this trophy to Sir William Pepperrell, a hero of the Seven Years' War and an eminent resident of Maine, for his help in capturing the French fortress at Louisbourg, Nova Scotia, in 1745. The French-born silversmith Pezé Pilleau decorated the silver grace cup in his London workshop with the Pepperrell family seal, depictions of the weapons and spoils of war, and large affixed leaf patterns offset by a cross-hatched outline. Two cast double-scroll handles emerge on either side of the cup's body as symbolic remnants of the grace cup's traditional function as a drinking vessel passed from hand to hand among celebrants.

The commemorative object is part of a larger set of presentation silver created in England to honor Pepperrell, a shipbuilder, merchant, landholder, and public figure in Maine, then a district of Massachusetts under the reign of George II. In 1744, the king recruited Pepperrell as head of the local militia to command troops that would storm the newly erected and seemingly impregnable French fortress at Louisbourg on Cape Breton Island. With the help of the British navy under Peter Warren, Pepperrell's small contingent successfully besieged the fort and forced the French to surrender.[1] As a reward, the king made Pepperrell the first American-born British citizen to receive the title of baron. The British celebrated Pepperrell's triumph as one catalyst for the steady decline of French influence in the New World. Yet the victory also planted the seeds for future conflict between Britain and its American colonies. The siege empowered New England militias, who recognized their potential strength when united to combat a foreign occupier.

As tensions mounted between the colonies and the king in the following decades, Pepperrell and his offspring remained staunchly loyal to the Crown. Sir William's grandson stayed in the service of the king until 1775, when local dissatisfaction with his loyalist sympathies forced the family off their land in Kittery, Maine, and down to Boston. The family silver, including this cup, traveled south with them under the watch of British soldiers. In 1778, colonists formally dissolved the Pepperrell family's titles and land claims and banished them to England. The grace cup once again journeyed with them, descending through Pepperrell's son-in-law's family. The cup returned to Maine in 1977 when Joseph William Pepperrell Frost, a direct descendant of the Pepperrell family, discovered the cup in England and brought it back to the United States. DJG

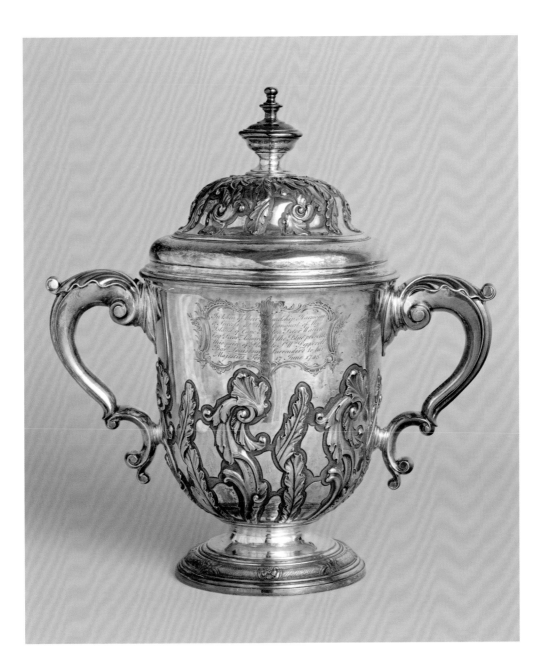

SIR JOSHUA REYNOLDS

England, 1723–1792

2 **Portrait of the Lady Elizabeth Somerset** 1777

Oil on canvas

24 1/8 x 20 1/8 inches

The Joan Whitney Payson Collection at the Portland Museum of Art, Maine. Gift of John Whitney Payson, 1994.49

Between the middle of April 1777 and May 10 of that year, Lady Elizabeth Somerset (1773–1836) sat for ten modeling sessions with Sir Joshua Reynolds. These meetings brought together the most acclaimed portraitist of eighteenth-century British society and the eldest daughter of a noble line—Somerset's father was the 5th Duke of Beaufort and had his own picture painted by Reynolds in 1760. In this painting, the artist offered an engaging representation of a young girl that reveals visual constructs of class and aristocratic refinement.

Many of Reynolds' works include complex landscape settings or allegorical narratives. In this picture, however, he painted an oval frame and an indistinct blue background to focus the viewer's attention on the half-length representation of the child. Reynolds' depiction of Somerset's face offers insight into the girl's personality, as her inquisitive eyes and sophisticated attitude are charmingly at odds with her rosy cheeks that suggest childish naïveté and innocence. His treatment of Somerset's posture and clothing—perhaps painted after the pair had finished their modeling sessions—reflects her social position. The exquisite gloves that bunch elegantly along Somerset's petite forearms and the artist's deft use of bright accent marks against the light gray tone of her dress create a textural richness that suggests the superiority of the fabrics. The chic cut of her scoop-neck dress, too, shows Reynolds' effort to draw attention to the young aristocrat's style, as the material fits snugly across her torso and cascades fashionably in folds past her elbows.

Throughout his career, Reynolds was one of the preeminent artists and theorists in the development of eighteenth- and nineteenth-century British art. He was a founder of the Royal Academy of Arts in 1768 and served as its first president. In a series of annual lectures delivered to students and members of the Academy between 1769 and 1790 (later published as "Discourses on Art"), Reynolds called on artists to return to the grand style of antiquity and the Renaissance and to produce works that were noble, simple, and beautiful. Though he ranked history painting as the most revered and important genre of painting, Reynolds made his career through the robust market for society portraiture, which was in high demand in late eighteenth-century England. Having a portrait painted by Reynolds was a mark of social prestige that often ensured a virtuoso image. AJE

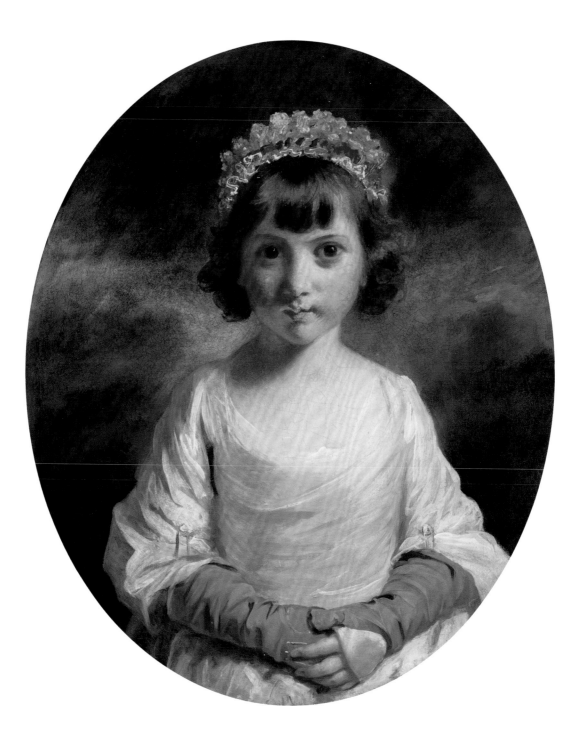

EDWARD GREENE MALBONE

United States, 1777–1807

3 **Portrait of Charles Fox** circa 1805

Watercolor on ivory

3 ¼ x 2 ¾ inches

Gift of the children of
Mr. and Mrs. Eben Fox Corey, 1992.31

Miniature painting—small pictures made with watercolor on thin sheets of ivory—thrived as a form of portraiture during the late eighteenth and early nineteenth centuries. (Its popularity dwindled with the advent of photography in 1839.) Considered one of the era's most powerful tokens of affection, miniatures were frequently exchanged between loved ones and commissioned to commemorate an engagement, marriage, or other milestone event. This miniature portrait of prominent Portland shipping merchant Charles Fox (1782–1845) was likely made around the time of his wedding to Eunice McLellan (1784–1837). Eunice was the daughter of Hugh McLellan, a banker, Revolutionary War soldier, and merchant who, in 1801, built the elegant Federal-style mansion that is now part of the PMA's campus. Charles Fox and Eunice McLellan were married in the McLellan House on May 14, 1805, and went on to have twelve children. In addition to his shipping interests, Fox was a partner of the Bank of Portland (founded in 1815).

For his likeness, Fox sought the talents of America's most celebrated miniaturist of the early national period. Largely self-taught as a painter, Edward Greene Malbone had a short but prolific career traveling between Newport, Rhode Island (his hometown), Providence, Boston, New York City, Philadelphia, and Charleston, South Carolina. He typically spent several months in a city, announcing his arrival with an advertisement in the local newspaper and finding ample patronage for his miniature portraits. There is no documented trip of Malbone's to Portland, but he had a long and productive stay in Boston from September 1804 through January 1806. Fox's business interests would have likely taken him there on a regular basis. In 1807, the artist died of tuberculosis at age twenty-nine.

This miniature portrait of Charles Fox shows Malbone at the height of his powers. Placing the young man in front of a cloud-filled sky, Malbone's typical background, the artist captured his sitter's appearance with meticulous precision, describing his aquiline nose, full lips, and other facial details with tiny stippled brushstrokes. Wearing a fashionable black jacket over a white shirt and cravat, Fox gazes at the viewer with limpid blue-gray eyes. His slightly tousled hair adds an air of whimsy to an otherwise serious-looking gentleman. Malbone fully exploited the inherent properties of his medium. The natural luminosity of the ivory support shines through the transparent strokes of watercolor, endowing the sitter with a lifelike glow. KAS

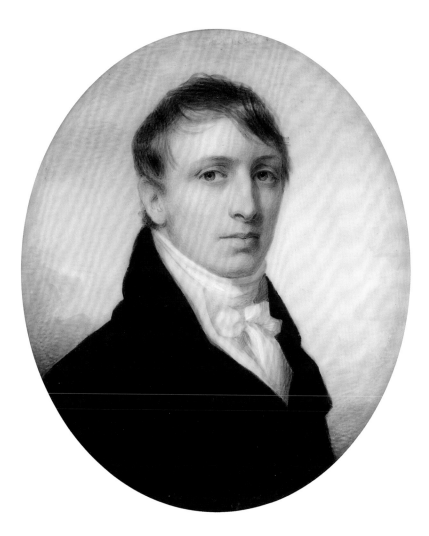

DANIEL RADFORD

United States, 1786–1836

4 Card Table circa 1805

Mahogany and brass

29 15/16 x 38 1/8 x 18 9/16 inches

Museum purchase with support from Mr. and Mrs. Fletcher Brown, Frances W. Peabody, Mrs. John R. Rand, Earle G. Shettleworth, Jr., Mr. and Mrs. Seth Sprague, Eleanor Parker Merrill, Margaret Sowles, Mr. and Mrs. Charles W. H. Dodge, an anonymous donor, and the Margaret H. Jewell Fund, 1988.14

Cabinetmaker Daniel Radford created this elegant card table around 1805 in the Portland workshop he shared with his brothers William and Benjamin. The table, a refined and understated example of Federal-era workmanship, is the only known piece by the Radfords bearing Daniel's signature. The cabinetmaker fashioned the table from mahogany, offset with thin bands of string inlay to highlight the undulating front curtain. Radford adorned the table with two pieces of beautifully burled mahogany veneer and created ovolo, or rounded, corners at the table's edges. Tapered legs lend the table lightness and delicacy.

To create such elegant furnishings, Federal-era craftsmen like the Radfords borrowed from European and British Neoclassical design, which in turn mimicked the order and symmetry of ancient Greek and Roman art and architecture. Greco-Roman forms and patterns remained popular in the early nineteenth century among furniture makers, designers, and architects in Europe and particularly in the United States, where the Neoclassical style helped the young nation to fashion itself as the natural successor to those famed republics.

The Radfords moved to Portland in 1797 to join the growing community of cabinetmakers, such as Benjamin Ilsley and John Seymour, who were working to outfit the city's most sophisticated clientele. By the beginning of the nineteenth century, Portland was a bustling port that boasted more than forty cabinetmakers catering to a growing contingent of wealthy merchants. The Radfords received commissions from many of the city's most prominent citizens, such as Asa Clapp, James Deering, Commodore Edward Preble, and Stephen Longfellow. The Longfellow family purchased at least eight pieces of Radford furniture, including a four-poster bed with turned and reeded posts very similar to the legs of this card table.[2]

Technological innovation and refined taste migrated outwards from cities to smaller enclaves as new residents and craftsmen settled in cities like Portland. These artisans produced regional variations of styles popular in Boston and the furniture centers of Massachusetts' North Shore, such as Salem, where the Radfords had learned their trade. The ovolo corners, symmetrical veneering, and tapered legs exemplify the brothers' roots in American furniture-making centers and their dedication to bringing luxury materials and refined techniques to Portland. DJG

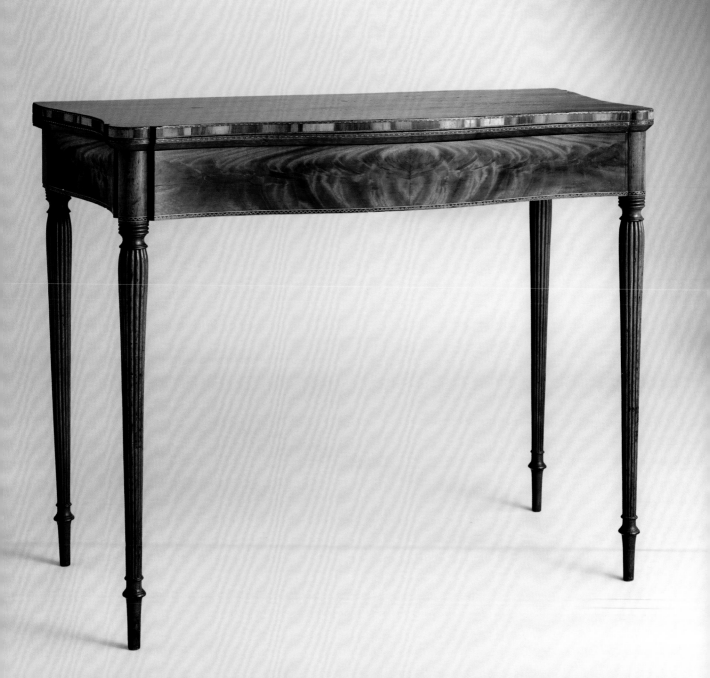

LIVERPOOL TYPE

England, circa 1790–1840

5 **Pitcher: Signals at Portland Observatory** after 1807

Creamware with transfer-printed decoration

9 x 9 1/2 x 4 7/8 inches

Gift of Mrs. James McKinley Rose in memory of her father, William B. Goodwin, 1976.12

This large creamware pitcher depicts the Portland Observatory, one of the city's most prominent landmarks in the nineteenth century. On the front of the rounded form, red, yellow, and blue signal flags surround a red tower, illustrating the signals that the tower's builder, Captain Lemuel Moody, flew from the observatory's twin flagpoles beginning in 1807. On the obverse of the pitcher is a ship in full sail—the type of vessel Moody would have spotted from his perch and reported to awaiting port workers.

Moody built the Portland Observatory in 1807 on one of the city's highest points to record shipping movements in the port's busy waters.[3] To convey his observations from the tower, he developed a system of flag signals indicating the numbers and types of arriving vessels and the fleets to which they belonged so that stevedores could prepare to unload goods in advance of the ships' docking. During the War of 1812, Moody adapted his signal language to warn Portland's citizens of British advances and to broadcast the results of naval battles, such as the American *Enterprise's* victory over the *Boxer*, a British brig, in 1813.

The Portland Museum of Art's pitcher is likely one of seventy-five nearly identical vessels that Moody commissioned for the dedication of his tower. Moody was not only a naval observer, but also a surveyor and draftsman who produced early maps of Casco Bay. In addition, he created drawings that recorded his flag code, such as an illustration of the tower set above a grid of flags (FIG. 7). Moody's drawing is nearly identical to the design that appears on the pitcher, suggesting that he sent the manufacturer his own illustration for the group of commemorative ceramics that circulated in Portland.

Though the tower sat on the coast of Maine, the pottery that produced these commemorative pitchers was located across the Atlantic Ocean in England. Thanks to rich mineral deposits, the city of Liverpool and county of Staffordshire became ceramics manufacturing centers that shipped goods worldwide. Factories in these areas popularized the transfer-print technique for decorating ceramics on a large scale. Artisans fashioned copperplate engravings printed onto tissue paper that they then applied to the bodies of earthenware "blanks" in standard shapes and sizes, such as this pitcher form. Firing affixed the designs onto the surfaces of the objects, which artists then colored by hand. British potteries debuted a vast range of original patterns, but also accepted images from patrons like Moody across Europe and the United States that they printed and returned as finished products. DJG

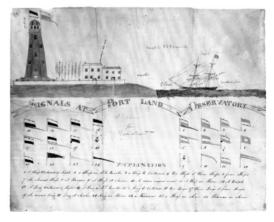

FIG. 7
Lemuel Moody (United States, 1767–1846), *Signals at the Portland Observatory*, circa 1807, watercolor on paper, 16 x 21 1/2 inches. Collections of Maine Historical Society, GA-57

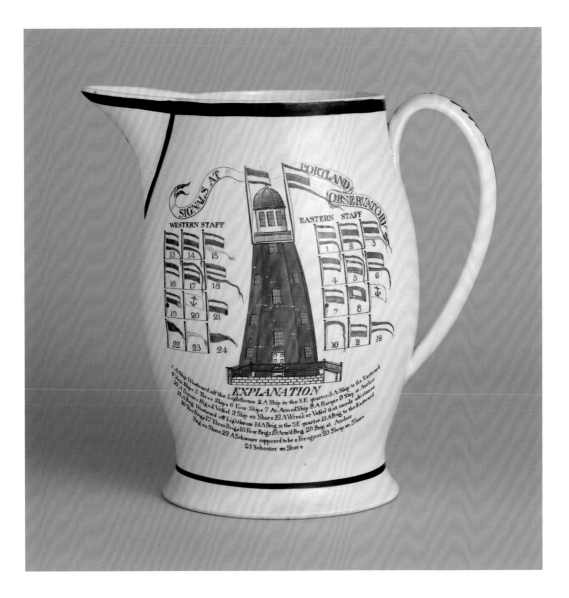

NARCISSA STONE

United States, 1801–1877

6 **Sampler** 1810
Silk on linen
18 7/8 x 16 3/8 inches
Museum purchase, 1973.9

Narcissa Stone sewed this sampler at the age of nine. The diligently stitched letters, decorative borders, and blocky landscape record a young New Englander's early education and presage her career as one of the most successful businesswomen in Brunswick, Maine (FIG. 8). Middle- and upper-class young women such as Stone often stitched these textiles at finishing schools to help improve their reading and writing while learning necessary skills for domestic work. On this marking sampler, the first embroidery a young girl would complete, Stone rendered a series of alphabets in both print and cursive using cross- and backstitches. Following conventions for nineteenth-century samplers, she also included her name and age above a symmetrical landscape including a house, trees, and a pair of outsized fruit baskets. Narcissa Stone's efforts closely resemble samplers made by her younger sisters Lydia, Rebecca, Hannah, and Mary (also in the Portland Museum of Art's collection).

Narcissa Stone produced this work under the guidance of Penelope and Elizabeth Martin at their school in Portland, Maine, founded in 1803. For nearly thirty years, the Martins, emigrants from Great Britain, taught reading, French, music, drawing, painting on wood, lacemaking, penmanship, and geography to almost six hundred well-to-do young women, including Stone and her sister Mary. In addition to sewing and embroidery, pupils learned the genteel arts of painting pictures on silk and decorating small furnishings.

Stone's early grounding in writing and arithmetic at the Misses Martin's school served her well. Her father, Captain Daniel Stone, was a sailor and prominent businessman in Brunswick who left his various

enterprises to his eldest daughter upon his death in 1828. Stone never married, but raised her younger siblings while supervising her family's store and growing real estate empire. She cofounded a manufacturing plant in Brunswick that produced cotton, wool, iron, and steel and also invested in a local steam mill that processed lumber and grain. Stone gave liberally to local churches and collected natural history specimens. By the time of her death in 1877, Narcissa Stone was so well known in Brunswick that local residents referred to the mound on which her home stood as "Narcissa's Hill." According to her obituary in the *Brunswick Telegraph*, "a more intelligent and clear-headed woman never lived."[4] DJG

FIG. 8
A. Kellogg, *Narcissa Stone*, undated, albumen print, 4 x 2 1/2 inches. Portland Museum of Art, Maine. Gift of Charlotte McLellan, 1974.758

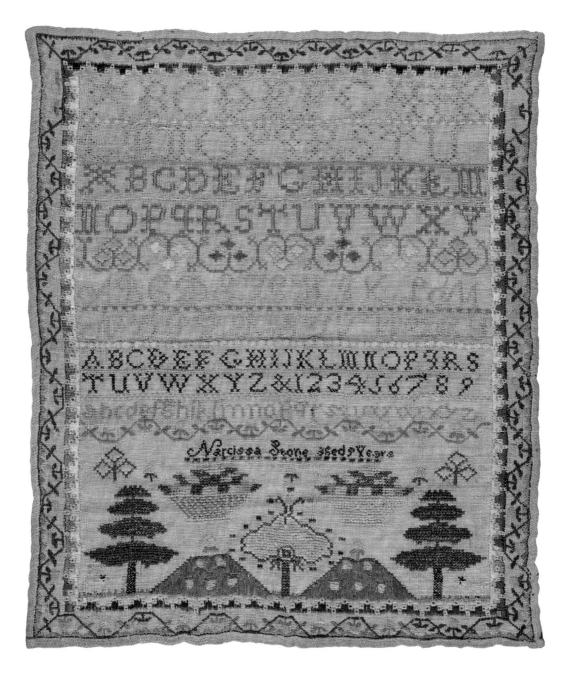

SUSAN MERRILL

United States, 1791–1868

7 Memorial to Mrs. Lydia Emery 1811

Watercolor and silk

15 1/8 x 18 9/16 inches

Gift of Helen Harrington Boyd in memory of Susan Merrill Adams Boyd, 1968.4

Susan Merrill created this mourning picture in 1811, using watercolor and embroidery on silk to honor her grandmother, Lydia Emery (1717–1800). Merrill's composition depicts a monument set in a landscape, a common subject in memorial imagery produced by educated middle- and upper-class women during the early nineteenth century. Often designated as the "sentimental sex," American women performed the majority of the rituals around bereavement, producing these stitched and painted mementos to immortalize the dead. Historian Anita Schorsch has explained that the seemingly formulaic symbols that appear in many mourning pictures of the period constituted a sophisticated and well-understood language, drawn from religious and pagan sources, that highlighted the piety of the maker and her family. As Schorsch explains, "mourning art was hieroglyphic."[5]

Merrill's composition features a central grave marker bearing the deceased's name and relationship to the embroiderer. Beneath, Merrill included a short poem explaining her grandmother's passing and exalting the pleasures awaiting her after death: "With sublunary cares and sorrows tir'd, / And wearied with the ills of four score years; / Glad of release, she smil'd as she expir'd, / And fled to endless rest above the spheres."

Merrill filled the pastoral landscape surrounding the memorial with familiar icons. Above the architectural marker, she painted and stitched an urn with a bright flame to represent her grandmother's undying memory. Beside the grave, Merrill added a pair of mourning figures, draped in flowing robes, which harken back to antique personifications of sorrow. In the foreground, she included a weeping willow beside a meandering river, a popular addition to such scenes that represents the continuous passage of life and the tears of mourners. Stands of trees grouped in threes also dot the composition, alluding to the Holy Trinity.

Such carefully constructed pictures provided visual language to help a young woman confront loss and turn her pain towards productive ends. The resulting image, which often hung in a family's parlor, also made the act of mourning public. The image showed visitors and potential suitors that its maker was a skilled needlewoman, watercolorist, and dedicated family member. Susan Merrill recorded her own name in gold on the frame of this composition at nearly twice the size of her grandmother's, suggesting that the picture, created more than ten years after Lydia Emery's death, displayed the virtue of its maker as much as it celebrated the life of the deceased. DJG

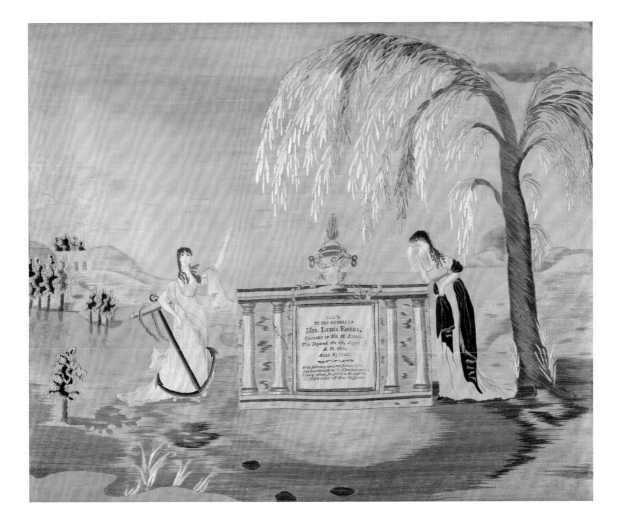

GILBERT STUART

United States, 1755–1828

8 **Major General Henry Dearborn**
circa 1813
Oil on panel
28 1/8 x 22 9/16 inches
Gift of Mary Gray Ray in memory of
Mrs. Winthrop G. Ray, 1917.23

Born in New Hampshire, Henry Dearborn (1751–1829) began his career during the American Revolution as an officer in the Continental Army. After the war, he held various positions in the leadership of the new nation, including as a U.S. congressman from Massachusetts and secretary of war under Thomas Jefferson. At the time of this portrait, Dearborn was the newly appointed senior major general of the U.S. Army in charge of the Northeast, expected to be the chief theater of combat in the War of 1812. (Due to ineffective management, he was relieved of this command in 1813.) Dearborn was one of the many prominent figures who sat for Gilbert Stuart, the most talented and sought-after portraitist in early national America. The artist painted more than one thousand likenesses of presidents, statesmen, merchants, distinguished women, and other leading citizens of the young republic. His canonical image of George Washington, based on live sittings with the first president in 1795, is reproduced on the dollar bill.

A Rhode Island native, Stuart spent most of the first two decades of his professional career in the British Isles. Like many aspiring American artists who traveled abroad for training during the eighteenth century, he worked in the London studio of his compatriot Benjamin West before establishing his own thriving practice. Stuart, who adopted the fashionable portrait manner of Thomas Gainsborough and Sir Joshua Reynolds (see CAT. 2), was dubbed "the Vandyke of the Present Day," a reference to the renowned seventeenth-century portraitist Sir Anthony van Dyck.[6] Returning to the United States in 1793 with an international reputation and prominent contacts, Stuart found his talents in high demand in the nation's centers of political and economic power. He painted in New York City, Philadelphia, and Washington, D.C., before settling in the Boston area in 1805 for the remainder of his life. In addition to the clients who flocked to his Boston studio, artists regularly visited to seek advice from the celebrated master.

This handsome portrait of Henry Dearborn exemplifies Stuart's ability to endow an individualized likeness with a strong sense of personality. Wearing an elaborately embroidered uniform, including the eagle insignia of the Society of the Cincinnati (a prestigious organization of Revolutionary War officers), the major general exhibits an air of robust authority. His penetrating gaze and creased brow suggest mental acuity. Stuart described the sitter's appearance with fluid strokes of paint that create the translucent quality of living flesh.[7] Although Dearborn has an imposing, sculptural presence, the artist seems to have minimized his considerable girth. The Portland Museum's painting is one of two replicas Stuart made after his original portrait of Dearborn (1812–13, Art Institute of Chicago). In 1812, before the major general was called to the front, both artist and sitter were living in Roxbury, Massachusetts. They had a mutual friend in Sarah Bowdoin, who subsequently became Dearborn's wife.[8] KAS

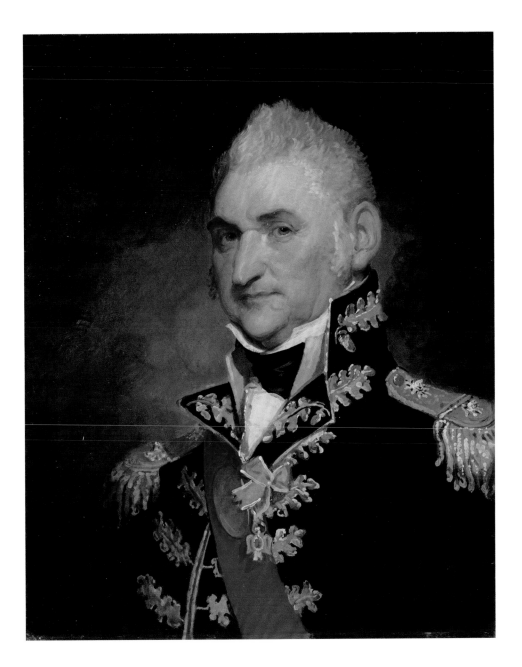

ANTHONY RASCH

United States, born Bavaria, circa 1780–1858

9 **Teapot** 1812–1817

Silver

6 7/8 x 10 9/16 x 4 1/2 inches

Museum purchase with support from
the Friends of the Collection, 1985.5

Bavarian-born silversmith Anthony Rasch created this silver teapot in Philadelphia during the early nineteenth century. The intricately adorned Neoclassical form features several baroque flourishes. Forged from precious metal, the object would have been among a family's most valuable possessions, far more prized, for instance, than painted portraits. Works such as Rasch's teapot would have graced the mantles and tabletops of upper-class homes in metropolitan centers to display wealth, sophistication, and patriotism to visitors and subsequent generations of the family.

Skilled immigrant craftsmen such as Rasch fashioned these wares in Philadelphia, then the second-largest city in the United States and a major scientific, cultural, and financial center. Initially partnering with French silversmith Simon Chaudron, Rasch opened his own studio by 1812. He specialized in the ornate presentation and commemorative silver in high demand among the city's emerging patrician class. Rasch brought knowledge, expertise, and the latest European fashions to the United States.

The silversmith developed a sophisticated Neoclassical vocabulary, visible in this teapot's banded vegetal ornament and its rounded yet boxy shape. The pot rests atop a rectangular platform supported by beautifully detailed cast feet. Rasch had honed his design sense in Europe at a moment of great discovery, when archeologists at Pompeii and Herculaneum in Italy unearthed scores of household goods and architectural fragments from ancient Rome. European and American designers and consumers embraced the geometric contours, abstracted plant and animal motifs, and symmetrical and repetitive decoration that such excavations brought to light. In the United States, Neoclassical motifs proved especially popular for domestic and civic architecture and interiors. The Neoclassical façades of Benjamin Henry Latrobe's Bank of Pennsylvania in Philadelphia or the U.S. Capitol and the White House in Washington, D.C., applied Greco-Roman stylistic principles to the very heart of American financial and political power.

Rasch applied Neoclassical design principles to domestic objects on a more modest scale, but with no less gusto. The silversmith also included baroque flourishes such as the organically inspired rose finial on the pot's lid and bearded grotesques on either side of the pot that connect the handle and spout to its body. In addition, he affixed a pronounced square handle and prominent spout capped with an eagle head. When the owner poured tea from this vessel, liquid would emerge from the eagle's open beak. This feature added a humorous touch and a particularly American flourish to Rasch's work. DJG

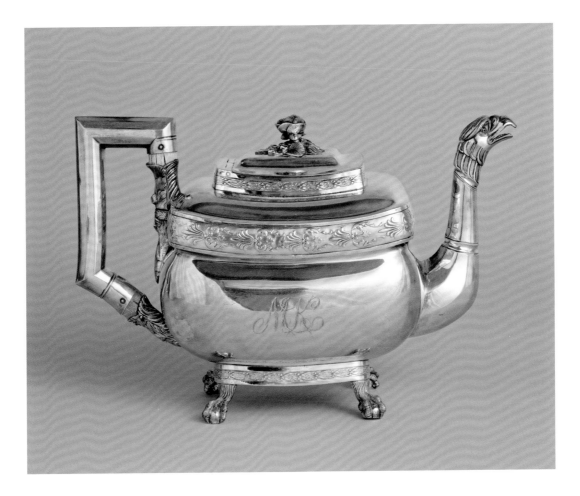

JEAN-AUGUSTE-DOMINIQUE INGRES

France, 1780–1867

10 **Portrait of the Honourable Frederick Sylvester North Douglas, Son of Lord and Lady Glenbervie** 1815

Graphite on paper

8 1/4 x 6 1/4 inches

The Joan Whitney Payson Collection at the Portland Museum of Art, Maine. Gift of John Whitney Payson, 1997.61

After the collapse of the Napoleonic Empire in 1814, British travelers had access to the major cities of the European continent for the first time in nearly two decades. Many descended on Rome, newly free from the French occupation that had begun in 1798. A number of these wealthy tourists sat for portraits by the leading French painter of the period, Jean-Auguste-Dominique Ingres, who had settled in the city in 1806.

With the fall of the French regime, Ingres found his patronage networks increasingly tenuous, but he nevertheless remained in Italy until 1820.[9] In need of money, he executed graphite portraits for British tourists, such as this image of the Honourable Frederick Sylvester North Douglas (1791–1819). Despite the clear success of this drawing (and others like it), the artist bemoaned the drop in status that this new venture created. In the prime of his career, he loathed being seen as a simple portraitist rather than as a history painter of great renown.[10]

Ingres' portrayal of Douglas is a masterly example of his superior draftsmanship. He carefully composed the figure's outline and rich areas of shadow through a series of varied lines. For instance, he rendered the contours of Douglas' nose and cheekbones with a crosshatched pattern of short, straight, and tightly woven marks. In other places, he modified the tone, shape, and length of his pencil strokes to suggest the textural qualities of his sitter's clothing.

When Ingres executed this work, Douglas was already a member of the British House of Commons and a published author who had written on the links between ancient and modern Greece.[11] Ingres was also interested in these connections. Like his peers at the École des Beaux-Arts in Paris, he developed his style with an eye to classicizing influences, such as a linear approach to depicting form and texture and a concern for ennobled subjects and grand compositions. Even when the narrative or sensuality of Ingres' paintings broke from the constraints of classicism, the works retained the precise draftsmanship and highly finished elegance that marked the so-called academic style. A J E

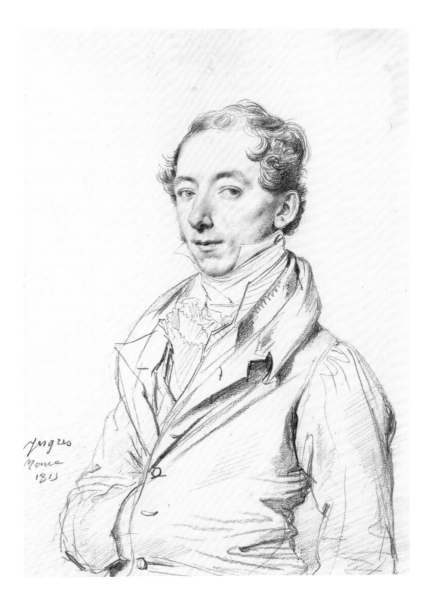

SARAH MIRIAM PEALE

United States, 1800–1885

11 **Portrait of John Neal** circa 1823

Oil on canvas

28 1/2 x 23 1/8 inches

Gift of Henry F. Picking and
descendants of John Neal, 2013.13

This modest, though engaging, portrait embodies the friendship of two important trailblazers in American cultural life during the early nineteenth century. The sitter, John Neal (1793–1876), was the nation's first professional art critic and the painter, Sarah Miriam Peale, was one of its first professional female artists. Born in Portland, Maine, Neal was a multitalented man of many roles, including lawyer, editor, publisher, businessman, and internationally famous author. He wrote prolifically throughout his career, publishing more than a dozen novels, as well as poetry, plays, and hundreds of articles on America's literary and visual arts.

In Baltimore, where he had settled in the mid-1810s, Neal met members of the prominent Peale family, who operated a museum in the city. His review of the museum's first annual exhibition in 1822 launched his lifelong vocation as an art critic. After a four-year stint in Europe, Neal returned to Portland in 1828 and continued his staunch advocacy of American art in general and the local cultural scene in particular. Health reform, school integration, and the rights of women were among the other causes he championed.[12]

Sarah Miriam Peale had a long and distinguished career as a portrait and still-life painter at a time when limited training opportunities and social conventions made it difficult for women to paint professionally.

But art was her family's business. Her father, James Peale, was an artist, as was her uncle Charles Willson Peale and many of his children, including Rembrandt, who established the Peale Museum in Baltimore. Born in Philadelphia, Sarah learned to paint in her father's studio. By the late 1810s, she was established as a portraitist and was regularly exhibiting her work. She and her sister, Anna Claypoole Peale, became the first female academicians of the Pennsylvania Academy of the Fine Arts in Philadelphia. Sarah worked in Baltimore (where Neal also lived) from the 1820s through the 1840s, then moved to St. Louis, Missouri. Throughout her career, her talents earned her ample commissions from prominent patrons. She never married, instead supporting herself with her art.

In Peale's portrait of her good friend John Neal, the writer gazes out at the viewer with warm blue eyes and a genial manner. Although simple in costume and setting, the painting expresses the force of Neal's personality—an effect achieved, in part, through Peale's strong tonal contrasts and her skillful layering of glazes to endow his flesh with a lifelike quality. This portrait was likely made in Baltimore before Neal's departure for England in 1823. KAS

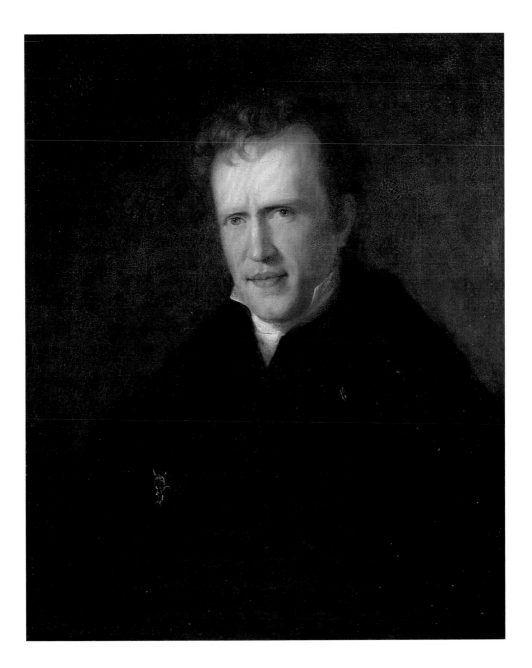

CHARLES CODMAN

United States, 1800–1842

12 **View of Diamond Cove from Great Diamond Island** circa 1829

Oil on panel

31 $^7/_{16}$ x 48 $^5/_{16}$ inches

Museum purchase with support from Iris Almy, Mrs. Alexander Fowler, Margaret Payson, Mrs. Millard S. Peabody, Mr. and Mrs. John Rand, Mr. and Mrs. Raymond B. Small, Mr. and Mrs. J. Weston Walch, Roger and Katherine Woodman, and an anonymous donor, 1973.116

Considered the father of Maine landscape painting, Charles Codman was also one of the first professional painters to take up residence in Portland.[13] In this bustling seaport and commercial center, he established a thriving practice during the early 1820s that offered both ornamental painting (for signboards, military banners, and other decorative work) and fine art landscapes. For the next two decades, Codman was a prominent figure in the city's burgeoning cultural scene, regularly exhibiting his paintings in Portland and farther afield. In 1828, he began opening his studio to the public every day except Sunday, a gesture intended to foster both appreciation and patronage for his landscapes. John Neal, the internationally famous author and art critic who lived in Portland (see CAT. 11), championed the artist, writing that of all the American landscape painters, "there is none with superior natural genius to that of Mr. Codman."[14]

Codman's career paralleled the emergence of landscape painting as a major genre in American art. In the early decades of the nineteenth century, artists and their audiences found aesthetic inspiration, spiritual meaning, and patriotic pride in images of the nation's distinctive scenery. *View of Diamond Cove from Great Diamond Island* depicts a site in Portland's Casco Bay that was a popular destination for day-trippers who, beginning in 1822, could reach the island by steamship service. James Deering, a local shipping tycoon who owned the northern part of Great Diamond Island (including the cove), commissioned this painting as a fireboard, a decorative panel for covering a fireplace in the summertime. Codman captured the picturesque charm of this locale with tiny figures of tourists frolicking along the shore and an expansive vista of

the bay dotted with sailboats and Crow Island. He described the scene with careful brushwork, building up dabs of paint in certain areas to create texture, as in the bark of the large tree at left. Codman's composition, with its framing trees, calibrated spatial perspective, and contrast between a shady foreground and well-lit background, follows established conventions for landscape imagery. As an integral part of the fireboard, Codman painted a decorative gilded border around his picture, consisting of stenciled foliate forms and a trompe l'œil frame that seems to cast a shadow.

View of Diamond Cove, the first of many oil paintings that Codman made of this site, became his best-known landscape image. His composition was also widely disseminated through printed reproductions (for example, FIG. 9), which in turn were copied by other artists. KAS

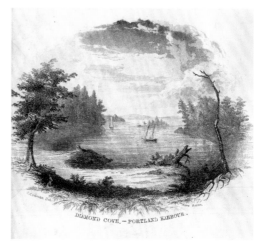

FIG. 9
After **Charles Codman** (United States, 1800–1842), *Diamond Cove—Portland Harbour*, 1836, engraving on paper, 3 $^1/_2$ x 3 $^1/_8$ inches. Collections of Maine Historical Society

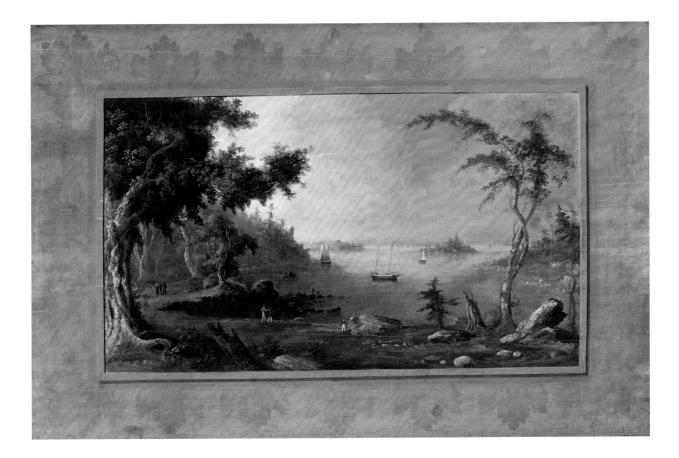

EDWARD L. GRUEBY

United States, 1808–1896

13 **Wall Clock** 1830s

Pine, brass, gilt, and *verre églomisé*

41 1/2 x 11 3/4 x 3 7/8 inches

Museum purchase with support from the
Friends of the Collection, the Margaret H. Jewell
Fund, Mr. and Mrs. Fletcher Brown, Mrs. Alexander
R. Fowler, Mr. and Mrs. George M. Lord, Frances W.
Peabody, Mr. and Mrs. Seth Sprague, and an
anonymous donor, 1989.24

Edward L. Grueby was one of Portland's premier clockmakers during the early nineteenth century. This decorated wall clock represents the full extent of his craftsmanship and his fruitful relationships with regional artists. Grueby designed this gilded timepiece in the popular lyre shape. The clock features a slender neck that expands into a rotund base, carved in low relief with stylized acanthus leaves. Grueby adapted the dramatic form from a clock patented in 1802 by the Willard firm of Roxbury, Massachusetts. The Willard "banjo clock" was the first commercially successful wall clock produced in the United States.

Grueby's wall clock features a glass panel, inset with gold detailing, that runs down the center of the neck and allows viewers to inspect the clock's swaying pendulum. The clockmaker also added an ornate panel of *verre églomisé* (reverse-painted glass), intricately decorated with curls of gold that adorn black and red oval and teardrop shapes set against a pink surface. Grueby (or perhaps one of the clock's later owners) further embellished the timepiece by affixing gilded wood finials to its top and bottom.

Though only the clockmaker marked his name on the dial, the clock showcases the carving and painting of other local craftsmen. Many of Portland's early artists, such as Charles Codman, who may have decorated the glass panel on this clock, began their careers painting glass, household objects, signs, and other everyday items. Codman was a skilled glass painter who decorated fire screens alongside his landscapes on canvas and panel (see CAT. 12).

Edward Grueby was an established member of the Portland community who, unlike many Boston-trained northern New England makers, learned his trade in Maine. He lived near his Court Street storefront, bought and sold land in Cumberland County, and served as a master mason at Portland Lodge No. 1. In 1838, the clockmaker submitted six objects, including at least one clock, to the Maine Charitable Mechanic Association exhibition, an important display venue for regional craftsmen. Like many of his peers, however, Grueby saw his business falter because of increased competition from large-scale New England manufacturers, who produced goods at a pace and price that local manufacturers could not match. By 1864, Grueby faced a dwindling market for his goods in Maine. Perhaps to escape local debts, he moved his firm to Boston, where he remained until his death in 1896. DJG

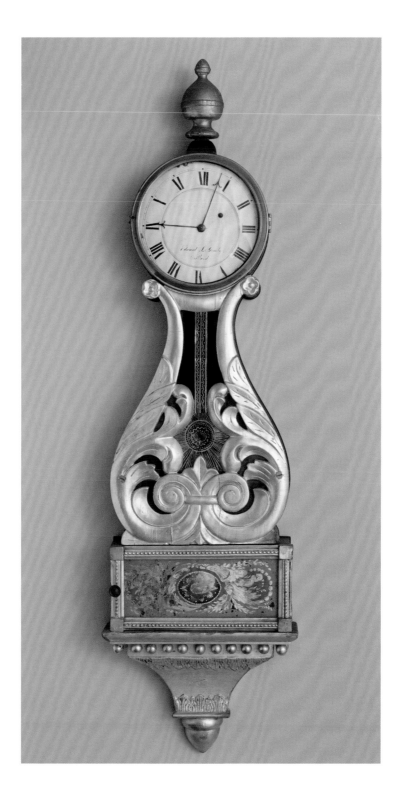

DAVID HILL

Scotland, 1802–1870

ROBERT ADAMSON

Scotland, 1821–1848

14 **Elizabeth Rigby, Lady Eastlake**
circa 1845
Salt print from calotype negative
8 1/8 x 6 inches
Gift of Michael Mattis and Judith Hochberg, 2003.11.3

Elizabeth Rigby (1809–1893), a prominent journalist and art critic, was a close collaborator of David Hill and Robert Adamson. In this photograph, one of many for which Rigby sat, the artists focused on her literate and erudite nature. Her open pose reveals the desk behind her, where two books prop up her left elbow. She rests her head in her hand and gazes downward as if deep in thought.

Hill and Adamson were the leading portrait photographers of Victorian-era Scotland and fundamental innovators in the development of photographic portraiture across Europe. The pair first began collaborating in 1843, just two years after William Henry Fox Talbot patented his salted-paper print technology. Talbot's invention signaled the birth of reproductive print photography, as his process allowed artists to capture a negative (reversed) image on paper. From this negative, artists could produce multiples of the positive image. For Hill and Adamson, the speed and reproducibility of the technique proved crucial. They combined artistic composition, scientific innovations, and entrepreneurial spirit to create nearly three thousand pictures in a few years.

The partnership began when Hill was preparing a massive modern history painting depicting the first General Assembly of the Free Church of Scotland in 1843. To fund his project, he intended to sell engravings of the 450 people to be included on the canvas. These prints would also give Hill the opportunity to sketch his sitters and position them as he intended to paint them. At that moment, Adamson had just moved to Edinburgh, where he established a photography studio with the encouragement of Talbot, who hoped to spread his invention. A colleague of Talbot introduced the two men, and the duo quickly began working together.

Through the collaboration, Hill was able to create preparatory studies for his painting and produce marketable images of the influential men of Scottish society. As the pair photographed their subjects, Hill composed the portraits with his ultimate goal in mind, carefully arranging the sitters' poses, gestures, and attitudes. Adamson took the photographs, a very delicate and demanding task involving mechanical and chemical manipulation, and refined the development technique to create more stable prints. After compiling the pictures needed to satisfy Hill's original intention, the duo expanded their work to depict other sectors of Edinburgh society, including the circle of Elizabeth Rigby. Hill and Adamson's productive partnership was tragically short. Less than five years after the pair met, Adamson became severely ill in late 1847, dying in January of the following year. AJE

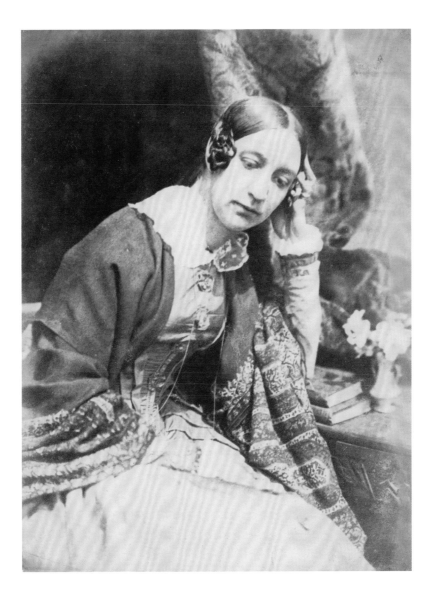

FITZ HENRY LANE

United States, 1804–1865

15 **Castine Harbor** 1852
Oil on canvas
20 1/8 x 30 1/8 inches
Bequest of Elizabeth B. Noyce, 1996.38.29

Born in the seaport of Gloucester, Massachusetts, as the son of a sailmaker, Fitz Henry Lane felt a deep and lifelong connection to the ocean. Active throughout the middle decades of the nineteenth century, he worked as a painter and printmaker specializing in seascapes, harbor views, and ship portraits. Although his œuvre includes subjects from up and down the Eastern Seaboard, Lane is best known for his scenes around Boston, Gloucester, and coastal Maine.

After apprenticing in a lithography shop and establishing a successful printmaking practice in Boston, Lane moved back to Gloucester in 1848. Around this time, he made the first of six trips to Maine with his good friend Joseph Stevens, Jr., a Gloucester merchant who had a home in Castine, Maine. The two men and other friends explored the inlets, coasts, and waterways around Mount Desert Island and Penobscot Bay by sloop. For Lane, these summertime excursions were equally for recreation and work. He filled sketchbooks with drawings that would inform paintings made back in his studio. A traveling companion recalled the lengths to which the artist would go to capture a picturesque view: "on one occasion [Lane] was hoisted up by some contrivance to the mast-head of a vessel lying in the harbor in order that he might get some particular perspective that he wished to have."[15]

Painted in 1852, the same year as one of his Maine trips, *Castine Harbor* exemplifies Lane's mature artistic style and the qualities that make him a leading practitioner of the so-called Luminist mode of American landscape painting, which flourished from around 1850 to 1875. Characteristics of Luminism include a focus on atmospheric effects, large radiant skies, crisply detailed forms, and an overarching stillness. In *Castine Harbor*, the foreground is filled with rocky outcroppings of land, boats of varying types, and several small figures of men moving barrels of cargo. The carefully delineated riggings show Lane's talents as a draftsman and ship portraitist. Yet despite this human activity, the primary actor in *Castine Harbor* is nature, specifically the broad expanse of luminous sky. During the 1850s, Lane increasingly simplified his compositional format, suppressing narrative content in order to focus on the effects of light, air, and color along the coast. Here, the entire scene is enveloped in the warm glow of the setting sun. The pink, yellow, and lavender hues of the sky are reflected on the water's surface, unifying these elements. Lane's smooth brushwork and softly modulated colors further enhance the overall sense of stasis and poetic tranquility. KAS

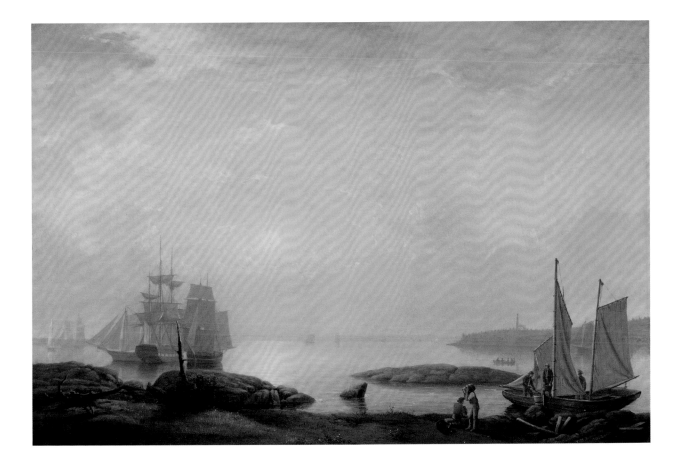

UNITED STATES POTTERY COMPANY

United States, 1849–1858

Christopher Webber Fenton founded the United States Pottery Company in 1850 in Bennington, Vermont. With the help of British potters, Fenton used New England's rich deposits of feldspar and other minerals to introduce a sturdy and affordable porcelain called Parian ware to American middle-class consumers. Although Parian ware originated in England, Fenton pioneered its use in the United States and capitalized on the medium's malleable quality to produce objects in a range of forms. Newspaper editor Horace Greeley admired Fenton's wares, produced by pouring wet clay into molds, at the New York Crystal Palace exhibition of 1853, noting that the items were "light in material, of graceful outline, and of two tints."[16]

The United States Pottery Company's Niagara Falls pitcher was among its most popular styles, designed to celebrate one of the country's best-known and most awe-inspiring natural features. Explorers, tourists, and artists alike had long marveled at the sheer size and power of this mighty cascade, and in the 1850s, Niagara Falls was also a popular destination for American and European tourists. Since the beginning of the nineteenth century, American painters of the Hudson River School such as Frederic Edwin Church had attempted to condense the size and power of Niagara Falls into a single image (FIG. 10).

The Niagara Falls pitcher attempted a similar feat in the medium of porcelain, as Fenton compressed the energy of the waterfall into a compact, handheld object. Produced in three sizes, the pitcher's all-over high-relief design pictured water spilling over rocky outcroppings and plant life, sending up spray as it hit rocks and brush on its way towards the clusters of rocks at the base of the vessel. The pitcher miniaturized and tamed the seemingly unfathomable scene pictured in Church's sublime landscape, turning an American natural wonder into something graspable. By wrapping one's hand around the tree-shaped handle, the user could modulate the fall of water from the vessel into a polite stream or a mighty rush. If Church's vision reduced the viewer's place in relation to nature to near nothingness, the Niagara pitcher proposed that the experience of the falls could be contained, reproduced, and enjoyed on an affordable, domestic scale. DJG

FIG. 10
Frederic Edwin Church (United States, 1826–1900), *Niagara*, 1857, oil on canvas, 40 x 90 ¹⁄₂ inches. National Gallery of Art, Washington, D.C., Corcoran Collection (Museum purchase, Gallery Fund), 2014.79.10

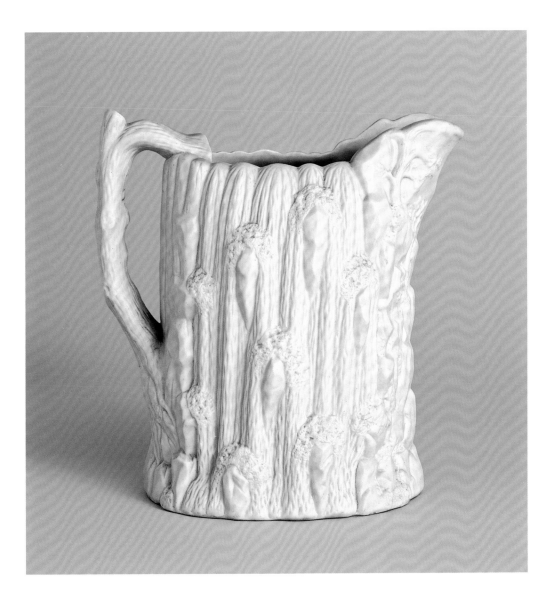

GUSTAVE LE GRAY

France, 1820–1884

17 **The Brig (Brig in Moonlight)** 1856

Albumen print from wet collodion negative

12 ³/₈ x 15 ³/₄ inches

Museum purchase with support from the
Susan Donnell Konkel Memorial Fund
and the Freddie and Regina Homburger
Endowment for Acquisitions, 2013.6

Describing his greatest professional ambition, Gustave Le Gray wrote, "I wish that photography, instead of falling within the domain of industry, of commerce, will be included among the arts. That is its only, true place."[17] *The Brig* is a technological and aesthetic testament to this effort and the potential of the photographic medium. In the work, a solitary ship floats quietly on the vast ocean, as the reflection of water and sky produces an ethereal quality in the clouds that hang hauntingly. The Romantic image exemplifies the period's interest in rendering nature's sublime expanse, which was normally the domain of painters. Rather than using the more conventional medium, however, Le Gray used a photographic process that captured similar artistic sensibilities, but allowed him to create a reproducible and technologically inventive image.

Le Gray began his career as a painter before turning to photography in the late 1840s. He quickly became an innovating force, bringing William Henry Fox Talbot's paper-negative process to France (see CAT. 14). Soon thereafter, he adopted a new photographic technique that used large glass-plate negatives. The glass plates combined with the chemistry of albumen prints to produce an exceptionally clear and detailed image that was also more stable than Talbot's salted-paper prints. Moreover, glass-plate negatives allowed photographers to work on a much larger scale than before, making landscape views like *The Brig* possible. The solidity of the glass plate also proved important, as it allowed artists to make many more reproductions than the paper negative offered.

The Brig became a well-known and celebrated image in the middle of the nineteenth century, and Le Gray produced hundreds of versions of it. Although he captured this scene on a single-plate negative, he later refined his technique for subsequent harbor pictures by using two negatives. In the double-plate system, Le Gray created one view of the sky and one of the water. He then aligned the two negative plates together before exposing them for the positive print. The combination produced an even clearer view of the seascape atmosphere.

Despite achieving major artistic success, the artist faced severe financial difficulties in the late 1850s, eventually fleeing France—and his debts—in 1860. After visits to Italy, Malta, and Lebanon, Le Gray settled in Egypt, where he spent the last two decades of his life. AJE

BENJAMIN PAUL AKERS

United States, 1825–1861

18 **The Dead Pearl Diver** 1858

Marble

27 x 67 x 28 inches

Museum purchase with support from Mrs. Elizabeth Akers Allen, John M. Adams, F. R. Barrett, John M. Brown, Philip H. Brown, Abba H. Burnham, A. W. H. Clapp, Nathan Cleaves, Francis Cushing, William G. Davis, Henry Deering, John E. DeWitt, Mark P. Emery, Francis Fessenden, S. C. Gordon, Charles M. Gore, J. H. Hamlin, George S. Hunt, James H. McMullan, W. F. Milliken, Edward A. Noyes, Lewis Pierce, William L. Putnam, Thomas B. Reed, H. W. Richardson, Henry St. John Smith, A. A. Strout, L. D. M. Sweat, W. W. Thomas, Payson Tucker, and George P. Wescott, 1888.1

In this romanticized portrayal of death, Benjamin Paul Akers idealized the elegant sensuality of a drowned pearl fisherman. The figure lies supine with his arms stretched gracefully over his head, in peaceful repose after succumbing to the power of nature. His nude body arcs and twists subtly over a massive, roughly textured rock dotted with seashells. An exquisitely rendered mesh net, heavy with the weight of gathered oyster shells, covers the hero's lap—for modesty and to demonstrate Akers' bravura handling of the marble.

Akers, a native of Westbrook, Maine, created this work while living in Rome in the 1850s. Like many American sculptors, he traveled to Italy to access its world-famous marble quarries, skilled studio assistants, and examples of the great sculptural treasures of Western art. During these years, his studio was a destination for American visitors touring the Continent. Nathaniel Hawthorne, one of these travelers, saw *The Dead Pearl Diver* in Akers' studio and later discussed it in *The Marble Faun* (1860). Hawthorne's novel describes the work as "a pearl-fisher, who had got entangled in the weeds at the bottom of the sea, and lay dead among the pearl-oysters, the rich shells, and the seaweeds." One of the characters notes, "the form has not settled itself into sufficient repose."[18] While this report could reflect Hawthorne's artistic license, it is more likely that the author had seen an earlier version of the sculpture (location unknown). Indeed, Hawthorne's son Julian reputedly noted that the work in Akers' studio depicted a figure "entangled in the weeds" and in "a painful and uncomfortable attitude"—a far cry from the current composition.[19] The difference is telling, suggesting how Akers likely refined his statue to create a calmer and more poignant image of death.

The Dead Pearl Diver is undoubtedly Akers' master-piece in a career cut short by tuberculosis before his thirty-seventh birthday. Throughout his years abroad, Akers remained closely connected to his native Portland. The sculptor's widow, Elizabeth Akers Allen, remembered that her late husband "was always anxious for [this] statue to find a home in Portland—the city of his love."[20] In 1888, his wish came to fruition when the Portland Society of Art, forerunner of the Portland Museum of Art, acquired *The Dead Pearl Diver* as the first work to enter its permanent collection. AJE

WINSLOW HOMER

United States, 1836–1910

19 **Sharpshooter** 1863

Oil on canvas

12 1/4 x 16 1/2 inches

Gift of Barbro and Bernard Osher, 1992.41

The late nineteenth-century realist painter Winslow Homer occupies an eminent position in both the canon of American art and the history of the Portland Museum of Art. In the 1980s, the gift from Portland philanthropist Charles Shipman Payson of seventeen works by this artist, along with funds to help construct a new building, had a decisive impact on the PMA's growth. Additional acquisitions of art and of Homer's historic studio at Prouts Neck along Maine's rocky coast further secured his primacy in the lifeblood of the institution.[21] The PMA's collection spans the scope of Homer's œuvre in terms of chronology, subject matter, and medium, providing a rich survey of the artistic talents and powerful vision of this American master.

Trained in J. H. Bufford's lithography shop in his hometown of Boston, Homer began his professional career in commercial illustration during a time that coincided with the Civil War. On assignment from the magazine *Harper's Weekly*, the artist made several trips to the Union front in Virginia in 1861 and 1862. His firsthand observations of battles and life in camp informed his early illustrations and paintings. Homer occasionally used the same iconography in both media, as in his canvas *Sharpshooter* (CAT. 19) and a closely related wood engraving, which appeared

in *Harper's* in 1862. This painting is not only one of Homer's first efforts in oil, but also one of his most iconic images of the war. It shows the young artist already in full command of the medium, with a sophisticated approach to design and narrative. For his subject, Homer selected a modern, elite type of soldier that used the latest weapons technology. Wielding a rifle fitted with a telescopic sight, a sharpshooter could deliver death from unprecedented distances with anonymity and precision.[22] Painted with muted earth tones in the broad style of realism embraced by progressive artists of the period, a Union sharpshooter perches in a tree, taking aim at an unseen and unsuspecting target. Homer obscured the figure's face and positioned his rigid left arm parallel to the gun barrel in order to underscore this impersonal, almost mechanical approach to killing. The unusual vantage point of this composition— close-up and from treetop level—not only heightens the tension of the scene, but also implicates the viewer, who has a "sight line" like that of a sharpshooter. With such perceptive and powerful images of the shifting nature of modern warfare, the artist earned the designation "the best chronicler of the war."[23]

WINSLOW HOMER

20 **Our Watering-Places—The Empty Sleeve at Newport** from *Harper's Weekly*, August 26, 1865, p. 532

Wood engraving on paper

9 5/16 x 13 3/4 inches

Gift of Peggy and Harold Osher, 1991.25.66

Homer continued to explore aspects of contemporary life in his art throughout the 1860s and 1870s. Middle-class leisure pursuits, such as croquet, ice skating, hiking in the mountains, and frolicking along the seashore, were favorite subjects. While often playful in theme and witty in tone, such imagery also contained incisive social commentary. The wood engraving *Our Watering-Places—The Empty Sleeve at Newport* (CAT. 20), which appeared in *Harper's Weekly* in 1865, addresses the impact of the Civil War on gender relations in the setting of a seaside resort.[24] Here, a fashionable young woman and her mate, a veteran who lost an arm in battle, are depicted taking a carriage ride along the beach. She literally holds the reins, an act symbolizing a reversal of power in their relationship. The veteran's war wounds—his "empty sleeve"—render him incapable of taking the traditional masculine role as driver. Although the accompanying story in *Harper's* assured readers that "his eye is on the road and his voice guides her; so that, in reality, she is only his left hand, and he, the husband,

drives," Homer's picture makes no such concession to convention.[25] Instead, his female protagonist controls the carriage with a firm hand and focused gaze. Furthermore, the couple's lack of emotional interaction reflects the tensions caused by women's expanded skills and independence in postwar society.

By 1880, Homer was firmly established as one of America's most original artists. His paintings were widely exhibited and regularly elicited commentary from critics, although the reviews were often mixed. He had incorporated watercolor as a vital part of his practice and given up the bread-and-butter work of commercial illustration. This moment also marks the beginning of a transition that would dramatically change Homer's art and lead to his relocation from New York City (where he had lived since 1859) to Prouts Neck, Maine, a small spit of land jutting out into the Atlantic Ocean.

WINSLOW HOMER

21 **Looking Out to Sea, Cullercoats** 1882
Watercolor on paper
13 ¾ x 20 inches
Bequest of Charles Shipman Payson, 1988.55.17

One catalyst for this transition was the artist's eighteen-month sojourn in 1881–82 in the English fishing village of Cullercoats, on the coast of the North Sea. Here, Homer witnessed the daily and sometimes deadly struggles of those who made their livelihoods on the sea. He was particularly captivated by the "exotic" beauty and heroic resilience of the local fisherwomen. The artist made numerous pictures of these women mending nets, helping haul in the daily catch, and keeping vigil at the water's edge for the safe return of their menfolk, as in *Looking Out to Sea, Cullercoats* (CAT. 21). In this watercolor, two robust fisherwomen, standing with hands on hips and holding a basket and nets, face the sea with stoic determination, undaunted by the breeze that flutters their aprons. Their traditional dress and occupations, combined with their monumental solidity, endow them with a sense of timelessness, in stark contrast to the fashionable modern female types who populated Homer's earlier art. He masterfully exploited the watercolor medium, deploying a range of techniques for different effects: broad, transparent washes to capture the limpid sky, flickering strokes of paint to describe grasses, and scraping and using resist (a material that blocks the watercolor from being absorbed into the paper) to create the white areas in the aprons and nets.

WINSLOW HOMER

Soon after returning to the United States, Homer settled in Prouts Neck in 1883 and continued his investigation of marine subjects in this new vein. He re-envisioned the seaside, a site of middle-class leisure in his earlier art, as a metaphorical arena for the contest of life and death. His 1884 painting *Eight Bells* (Addison Gallery of American Art, Phillips Academy, Andover, Mass.) is one of a series of narrative pictures that explore the often perilous relationship between humankind and the sea. This canvas served as the basis for an etching (CAT. 22) that Homer made several years later, during his brief foray into printmaking.[26] Set aboard a ship, the boldly cropped composition depicts two oilskin-clad sailors using octants to determine their location based on the sun's angle. The title refers to bells rung to signal the time of day, in this case, noon. Billowing clouds and swelling waves indicate an approaching storm, but as in many of his late works, Homer did not resolve the narrative, leaving the fate of the sailors uncertain.

22 **Eight Bells** 1887

Etching on parchment

23 1/2 x 29 1/2 inches

Museum purchase with support from the Peggy and Harold Osher Acquisition Fund and partial gift of Mr. and Mrs. Vaughan W. Pratt, 2014.3

WINSLOW HOMER

23 **Weatherbeaten** 1894
Oil on canvas
28 ½ x 48 ⅜ inches
Bequest of Charles Shipman Payson, 1988.55.1

Homer's greatest achievements at Prouts Neck are widely recognized to be his seascapes of the crashing surf along the Maine coast in varying seasons and weather conditions.[27] One such late masterpiece, *Weatherbeaten* of 1894 (CAT. 23), embodies the titanic forces of nature in the materiality of paint. The artist used thick, vigorous brushstrokes to capture the rugged texture of the rocks and the frothy spray of surging waves with powerful immediacy. The view of land, sea, and sky is closely cropped, situating the viewer directly at the water's edge. On one hand, this painting possesses a sense of specificity rooted in Homer's intimate knowledge of this place. Yet, on the other, it evokes the cyclical rhythms and vastness of the ocean as a symbol of the ebb and flow of life.

With their ability to bridge the literal and the metaphorical, the contingent and the timeless, the specific and the universal, Homer's *Weatherbeaten* and other late seascapes received high praise.[28] They were admired not only for their aesthetic sophistication, but also for their sense of originality, independence, and authenticity—qualities long associated with the American character. These paintings helped to forge an iconic image of the New England coast in the national imagination, inspiring generations of artists to follow Homer's footsteps to Maine. KAS

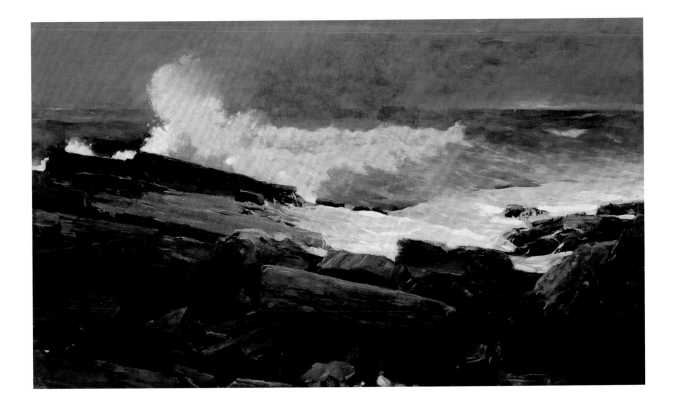

BRUCE J. TALBERT

England, 1838–1881

24 Cabinet circa 1867

Walnut with gilt, incised, and
ebonized marquetry

87 1/4 x 48 1/8 x 24 5/8 inches

Museum purchase, 1985.99 a-i

Bruce J. Talbert's 1860s cabinet is a riot of decoration. Every surface of this monumental object is adorned, from the intricate circular inlay on the cabinet doors to the ebonized and gilded tracery on its pinnacle. Featuring at least six different types of wood and a variety of finishes, the cabinet displays abundant floral motifs offset with angular geometric ornamentation. Reflecting Victorians' eclectic tastes and passion for embellishment, Talbert's Gothic-inflected design proved popular in the upper-class homes of late nineteenth-century Britain.

If this cabinet's deeply incised surfaces appear more like carved stone architectural ornament than traditional home decoration, no wonder. Talbert trained as an architect in Glasgow before moving to London for a career in design, and his penchant for Gothic and Jacobean architecture influenced many of his creations. He worked for celebrated furniture firms such as Holland and Sons, designing furniture, carpeting, metalwork, stained glass, textiles, and wallpaper. His designs won accolades at international expositions and at the Royal Academy of Arts.

Talbert joined architects, artists, and critics, including A. W. Pugin, John Ruskin, and Charles Eastlake, in seeking out a style unique to Britain that was based on the nation's medieval past. Like his fellow tastemakers, Talbert turned to historic precedents as a pointed rejection of the poor quality, mass-produced home goods then flooding the market. In particular, he condemned designs that relied on veneering, polish, staining, or glue, techniques and materials that he deemed "false construction."[29] This cabinet, while effusively decorated, relies on a base of solid wood-frame construction and takes advantage of the natural qualities of each type of wood employed in its making.

In 1867, Talbert published the first edition of *Gothic Forms Applied to Furniture, Metal Work and Decoration for Domestic Purposes,* a treatise outlining his principles for applying medieval accents to contemporary objects. The book illustrated several of his furniture designs, including a drawing of this sideboard (FIG. 11). In his writing, Talbert acknowledged the creative license he took in interpreting medieval precedents, admitting that no twelfth- or thirteenth-century domestic furnishings survived from which to copy. "It is not Medieval Furniture, confined to the antiquarian knowledge of the past, that is wanted," he explained, "but a recognition of the more honest principles that governed them, substantial work, and ornament, not at war, but having some fellowship, with the Gothic Architecture of the present day."[30] DJG

FIG. 11
Bruce J. Talbert (1838–1881), Illustration from *Gothic Forms Applied to Furniture, Metal Work and Decoration for Domestic Purposes* (Boston: James R. Osgood, 1873), plate 4.

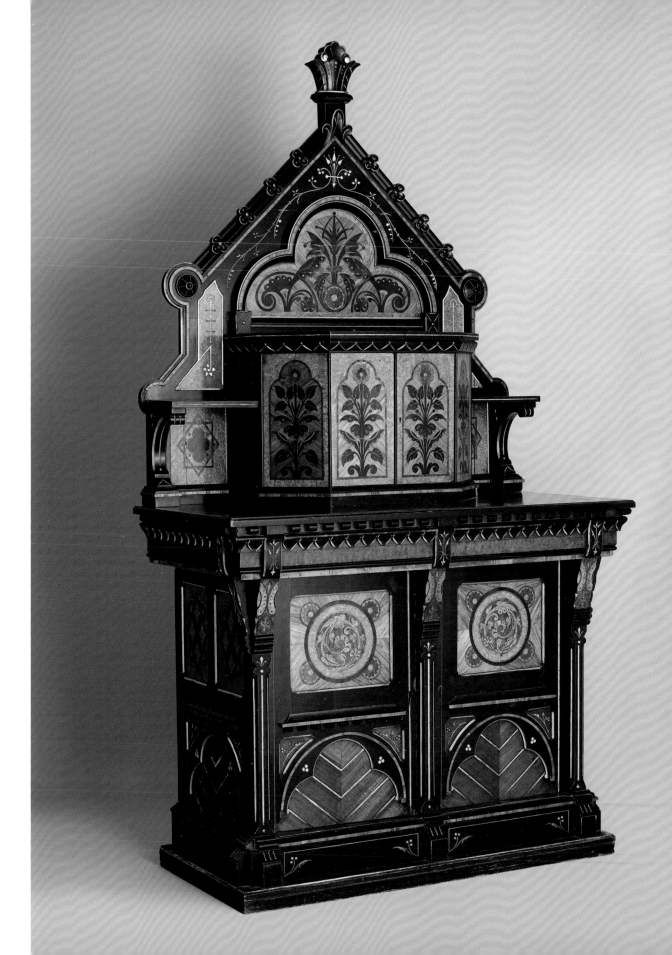

PORTLAND GLASS COMPANY (PORTLAND GLASS WORKS)

United States, 1863–1873

25 **Footed Bowl** 1868–73

Colorless pressed flint glass in Palmer Prism pattern

7 3/4 x 11 inches

Museum purchase with support from the Lowell Innes Fund, 1989.3

The Portland Glass Company opened in 1863. Over its ten-year lifetime, the firm produced popular pressed and blown glass, both functional and decorative, for New England consumers. The company's waterfront factory, designed by Englishman Enoch Egginton and financed by Portland businessmen, employed the latest technologies, such as coal-burning conical furnaces and imported English clay crucibles. Thanks to overwhelming demand, Portland Glass expanded rapidly. Just two months after its founding, the factory was producing five thousand items per day. It manufactured a staggering one million objects per year by 1865.

The company, which changed its name to the Portland Glass Works in 1870, is best known for its decorative pressed glass, such as this elegant footed bowl. During its single decade of operation, Portland Glass manufactured more than fifty unique pressed glass patterns, ranging from the Venetian-inspired Tree of Life pattern to the Greek key motif to whimsical squirrel cups. The firm patented only three designs, one of which was the Palmer Prism pattern featured on this footed bowl. The patent describes the pattern as "composed of prisms and figures formed by indentations or depressions in the glass, having three corners, arranged upon the surface of the glassware."[31] Vessels featuring the Palmer Prism design mimic expensive European hand-cut crystal, with regularly spaced depressions and sharp angles that sparkle when the bowl catches the light.

Designer William O. Davis and the Portland Glass Company borrowed from many historic and contemporary sources in order to provide affordable alternatives to imported handcrafted designs. Taking cues from published manuals, including designer Charles Eastlake's 1869 *Hints on Household Taste*, middle-class Americans in the late nineteenth century began to purchase such newly available decorative objects to adorn and personalize their domestic spaces. Empowered with new sources of expendable income and an expansive range of mass-produced goods at their fingertips, consumers added items such as Portland Glass' designs to their homes to reflect their particular tastes.

The Portland Glass Company's products are often difficult to authenticate, as copies from competing studios circulated widely even during the factory's lifetime. After the company folded in 1873, its artisans and molds dispersed across the United States. Soon after the company closed its doors, Portland designs emerged from furnaces from Pittsburgh to West Virginia. Because the firm patented the Prism design, however, one can more easily attribute examples of this particularly rare pattern to the versatile and successful, yet short-lived, Maine manufacturer. DJG

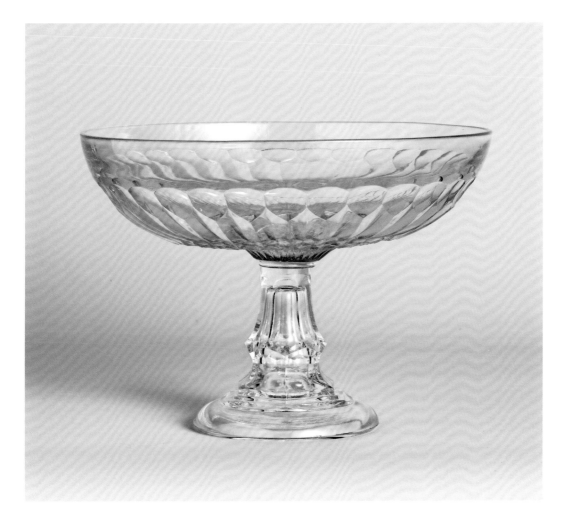

GUSTAVE COURBET

France, 1819–1877

26 **Temps d'orage à Etretat (Stormy Weather at Etretat)**

circa 1869

Oil on canvas

28 7/8 x 36 3/8 inches

The Joan Whitney Payson Collection at the Portland Museum of Art, Maine. Gift of John Whitney Payson, 1998.162

Between the summer of 1869 and the following spring, pioneering French Realist painter Gustave Courbet created nearly a score of pictures depicting waves breaking on the Normandy coast. In *Stormy Weather at Etretat*, Courbet emphasized the flatness and sheer façades of the region's famed cliffs through unblended passages of color and visible, vertical marks on the canvas. This paint handling imbues the rock face with a physical force, asserting its presence as a real object that denies the viewer access to the sea's full expanse. At the left, Courbet deftly modulated his colors to create a sense of atmospheric density and to suggest the storm's weight as it rolls into the coast.

The artist's unsentimental composition and bold paint handling rejected long-established European landscape traditions. His direct treatment of the storm above the ocean flattened the pictorial space, and his pervasive gray tones minimized the beauty of nature. He concentrated the viewer's attention on the crashing waves in the foreground, where sea spray and angry white foam rise powerfully against the rocks.

Courbet was the foremost artist in the development of Realism, an aesthetic that called for artists to represent objective truths. He encouraged his peers to "reproduce objects as chance offers them, without choice, without arrangement."[32] This philosophy marked a rupture with the academic tradition that celebrated history painting and idyllic, pastoral, or allegorical landscapes. Courbet's painting technique, too, affirmed his break with the high-finished elegance of the academic style. He applied his paint to his canvases in innovative ways, even using his palette knife, rags, and sponges to animate the surface with a raw, physical force.

Courbet's Realism was politically charged in its denunciation of the academic mode, which was associated with the Catholic Church and the French monarchy.[33] Courbet spurned this entrenched style and everything it represented, instead challenging his contemporaries to draw inspiration from the everyday lives of ordinary people. He believed that in painting the quotidian circumstances of the age—and objective views of nature—he was making a democratic intervention into France's sociopolitical culture. AJE

EADWEARD MUYBRIDGE

United States, born England, 1830–1904

27 **Wildcat Falls** 1872

Albumen print from wet-plate collodion negative on board

16 1/2 x 21 inches

Museum purchase with support from the Friends of the Collection and the Photography Fund, 1999.61

Best known for his scientific studies of animal and human locomotion made using his new techniques of instantaneous, stop-motion photography, Eadweard Muybridge also produced scenic views of the American landscape, like this image of Wildcat Falls located in what is now Yosemite National Park. Muybridge, an emigrant from England, settled in San Francisco in 1856, towards the end of the California gold rush. By 1867, he had committed himself to a career as a photographer. Dubbing himself "Helios" after the ancient Greek sun god, he traveled with his horse-drawn "Flying Studio," a mobile darkroom stocked with glass-plate negatives and developing chemicals. Such bulky equipment was necessary, as the wet-collodion emulsion used for early glass-plate photography needed to be exposed and developed before it dried. Over the next five years, Muybridge produced thousands of pictures of San Francisco and the California landscape.

This image, captured in the summer of 1872 on Muybridge's second major photography expedition to Yosemite, depicts Wildcat Falls, a cascade on the Merced River.[34] In the photograph, the gushing water of the falls surges through the rocky landscape and over sharp, angular cliffs. While many of Muybridge's Yosemite prints emphasize the expansive grandeur of the American wilderness, *Wildcat Falls* is more intimate, as most of the scene appears to be just a few yards away from the camera. A bold diagonal formed by the cascades and surrounding boulders demonstrates Muybridge's ability to create dramatic compositions. The contrast between the immobile cliffs and the rushing water gives the scene a sense of energy, enhanced by the photograph's tonal variations. Due to the exposure time of a few seconds, the waterfall reads as an undefined white mass.

Muybridge's hugely popular photographs depicted natural wonders that were still largely unknown to most Americans. During the nineteenth century, scores of artists, including Albert Bierstadt, Thomas Moran, and Carleton Watkins, flocked to Yosemite to paint and photograph the valley's majestic scenery. The resulting images contributed significantly to the public's view of the American West as a place of strange and mysterious beauty and vast open spaces. Watkins' photographs even helped secure the valley's status as a state park in 1864.[35] *Wildcat Falls* was included in a portfolio of mammoth-size photographs sold to subscribers, who each paid one hundred dollars to receive forty prints from the series.[36] A savvy businessman, Muybridge also created stereo cards of Yosemite for the commercial market. When viewed through an optical device known as a stereograph, these small-scale photographs produced the illusion of three-dimensional images. With both the stereo cards and the portfolio, Muybridge capitalized on the American public's growing interest in the faraway wonders of the West at a time when the United States was expanding as a nation. MRA

JAMES ABBOTT MCNEILL WHISTLER

United States, 1834–1903

28 **Miss Florence Leyland** circa 1874–92

Oil on canvas

75 1/2 x 36 1/8 inches

Gift of Mr. and Mrs. Benjamin Strouse, 1968.1

This ethereal portrait depicts the stylishly attired figure of Florence Leyland (1859–1921), daughter of the Liverpool shipping magnate Frederick R. Leyland. The artist, James Abbott McNeill Whistler, used diaphanous washes of paint and a monochromatic palette to envelop the young woman in a gauzy haze of gray and black tones. The bottom of her skirt, in particular, seems to dematerialize into the surrounding space. Descriptive details are minimal, and the textured weave of the canvas is clearly visible through the thin paint layers. When Whistler exhibited portraits painted in a similar manner at London's Grosvenor Gallery in 1877, Oscar Wilde claimed that the sitters appeared "caught in a black London fog," a description that aptly captures the softly focused, indistinct quality of this work.[37]

In its style and history, *Miss Florence Leyland* exemplifies the art and combative persona of Whistler, an American expatriate living in London and a leading proponent of Aestheticism. This movement emerged in British and American fine and decorative arts in the 1870s with the guiding tenet of "art for art's sake," a belief that a work of art should privilege beauty above traditional aims of representation and narrative. Through his insistence on the autonomy of art, Whistler had a profound impact on the development of modernism. In the 1860s, he began rejecting the realism of his earlier career in France to develop his mature style of reductive forms and subtle tonal arrangements, as seen in the Leyland portrait. He frequently titled his paintings with terms such as symphony, nocturne, or harmony to draw analogies between music and his pictorial emphasis on color, tone, and mood.

Whistler likely began this portrait around 1874 and then reworked it several times over the ensuing fifteen years, due to various troubles.[38] In 1877, he fell out with Frederick Leyland, the sitter's father, over payment for his interior decoration work on the dining room of his patron's London home (the Peacock Room, now at the Freer Gallery of Art, Washington, D.C.). To avoid giving up the portrait, the artist altered the sitter's face to that of his mistress, Maud Franklin. The following year, this painting (which Whistler claimed was unfinished) was used as evidence and then collateral in his famous libel suit against art critic John Ruskin, who had publicly derided the painter's style. Whistler won, but went bankrupt in the process. Eventually, the painting was returned to the artist, who reworked it again before finally delivering it to Mr. Leyland in 1892. KAS

PIERRE-AUGUSTE RENOIR

France, 1841–1919

29 **Confidences (Secrets)** circa 1874

Oil on canvas

32 x 23 ¾ inches

The Joan Whitney Payson Collection
at the Portland Museum of Art, Maine.
Gift of John Whitney Payson, 1991.62

Pierre-Auguste Renoir's *Confidences* is a provocative painting of a couple reading a newspaper beneath the secluded cover of trees. The woman leans against her companion's left shoulder, crossing her ankles just in front of—or perhaps against—his left foot. In this moment of gentle intimacy, the figures seem to meld into each other and into the natural world. Renoir's airy brushwork, harmonious blending of colors, and attention to a dappled effect of light accentuate the tenderness of the scene. Yet even as the painter created these signs of idyllic pleasure and romance, he undermined this narrative through allusions to sexual promiscuity. The woman's lack of a wedding ring suggests that the pair is unmarried, and their unchaperoned rendezvous in the wooded niche violates bourgeois social norms. Moreover, her exposed pink shoes accent the painting with a coquettish undertone, which Renoir amplified by including a small dog—a frequent attribute of the period's courtesans.

Confidences alludes to the tensions of late nineteenth-century France. In this period, insecurities about changing social rules and structures preoccupied the society as class and cultural barriers became more permeable. The transitioning role of women prompted further angst about modernity's impact on traditional values and mores. Renoir pressed on these anxieties through the formal and thematic ambiguity of his painting. Indeed, nothing in the picture is secure. The effect of the light is fleeting, the couple's location is vague, and their tender touch suggests both pure affection and impropriety.

Born in southwest France, Renoir began his career as a decorative artist, painting porcelain in Limoges. He came to Paris in the early 1860s and, like Claude Monet and Alfred Sisley (see CATS. 33 and 39), trained in the studio of Charles Gleyre, who encouraged his students to paint *en plein air* (outdoors). As a leading contributor to the Impressionist movement, Renoir was committed to depicting modern life. At the same time, he was also deeply invested in the tradition of eighteenth-century French painting. He frequently made copies after Rococo masters such as Jean-Antoine Watteau and Jean-Honoré Fragonard, who often played with the representation of indecorous liaisons. *Confidences* shows how Renoir navigated the aesthetic and social concerns of his influences in a work that fits within the canon of French art, but also pushes modern boundaries. AJE

HILAIRE-GERMAIN-EDGAR DEGAS

France, 1834–1917

30 La leçon de danse
(The Dancing Lesson) circa 1877

Pastel monoprint on paper

23 x 28 ⅝ inches

The Joan Whitney Payson Collection
at the Portland Museum of Art, Maine.
Gift of John Whitney Payson, 1991.86

French painter Edgar Degas reputedly told his friend and art dealer Ambroise Vollard: "People call me the painter of dancing girls. It has never occurred to them that my chief interest in dancers lies in rendering movement and painting pretty clothes."[39] *The Dancing Lesson* affirms this interest. The powdery surface of the pastel gives texture to the fabric of the dancers' costumes and dynamism to the evanescent light coming through the window. Yet Degas' paintings, prints, and drawings of ballerinas also offer cultural commentary, as the artist probed the intersection of spectacle, class, and modernity.

In *The Dancing Lesson*, Degas represented two ballerinas and their teacher in a practice room. The large windows in the center of the background frame the first dancer, who plants her left foot firmly on the ground and raises her arms above her head. With this pose, Degas focused on the tension between movement and stasis. The viewer anticipates an ephemeral gesture, but Degas offered a static posture rather than a transient action. The artist amplified the sense of stability with his depiction of the other two figures in the room. The ballet master stands still, resting his timing stick on the floor while the second ballerina relaxes. She turns her right leg out and rests one hand against her hip. She reaches her other hand up, placing it on the adjacent pillar. Like the central figure, she is motionless, and her pose lacks the grace typically associated with ballerinas.

Degas was born into an upper-class banking family in 1834. His elevated social position gave him extensive access to the world of the opera, where he assiduously studied dancers onstage, offstage, and in their training regimens. In this pastel, as in many of the artist's contemporary pictures such as *Seated Dancer* (FIG. 12), Degas created an image of the ballerina's life that undermines cultural assumptions about the glamour and excitement of the stage, revealing instead a sense of repetition and fatigue. Images such as this challenged public expectations about the beauty and sexuality of the young women by marginalizing the effects of spontaneity, polish, and energy in favor of a focus on mundane practice and inelegant postures. In the process, the pictures focus on the dancers' labors, and the ballerinas emerge as working-class figures whose performances allow them to transform, if only briefly, into symbols of bourgeois culture and refinement. AJE

FIG. 12
Hilaire-Germain-Edgar Degas (France, 1834–1917), *Danseuse assise (Seated Dancer)*, 1895–1900, pastel on joined paper mounted on board, 22 ¾ x 17 ¾ inches. Isabelle and Scott Black Collection

EASTMAN JOHNSON

United States, 1824–1906

31 **The Quiet Hour** circa 1877

Oil on canvas

19 x 21 1/2 inches

Museum purchase with support from the Freddie and Regina Homburger Endowment for Acquisitions, the Friends of the Collection, and the W. D. and M. L. Hamill Fund for American Art, 2013.18

In this warm scene of a woman and small child enjoying a leisurely moment in a hayloft, Eastman Johnson explored themes that preoccupied him throughout his career, particularly rural subjects and the pictorial effects of strong lighting. *The Quiet Hour* is one of several paintings of figures in a barn interior inspired by Johnson's summertime visits in 1877 and 1878 to the farmhouse of his sister and brother-in-law, Harriet and Joseph May, in Kennebunkport, Maine.[40] Lounging against bales of hay, the young girl reads from an open book in her lap while her companion looks on, her head contentedly resting on her hand. Johnson loosely described the figures and setting with churning, scumbled brushwork and touches of pure, unmodulated pigment. He also scratched lines into the paint to suggest individual stalks of hay. The limited palette of rich browns, golds, and greens heightens the painting's languorous mood. A beam of sunlight streaming into the darkened hayloft provides the primary drama in *The Quiet Hour* in the form of strong shadows and tonal contrasts. Coupled with the title, the angle of light suggests a late afternoon setting.

At the time Eastman Johnson painted this canvas, he was a mature artist and highly acclaimed as America's foremost genre painter. As seen in *The Quiet Hour*, his art was also undergoing a stylistic shift from the detailed realism that characterized his earlier works to the more freely brushed, painterly style favored by progressive artists. This work's tenebrous lighting effects show Johnson's enduring admiration for the art of Rembrandt and other seventeenth-century Dutch masters, whom he had studied in Holland as a young man.

Born and raised in Maine, Johnson began his career making crayon and pastel portraits in Maine, Boston, and Washington, D.C. He spent six years in Europe between 1849 and 1855, pursuing formal training at the Royal Art Academy in Düsseldorf, Germany, and informal study in The Hague and Paris. By the end of the decade, he had settled in New York City and was quickly rising to national prominence as a figure painter. While he depicted a range of genre subjects, Johnson is best known for scenes of rural American life, particularly such quintessentially New England activities as maple sugaring and the cranberry harvest. Such themes resonated with American audiences for their nostalgic evocation of simpler ways of life during a period of rapid industrialization. KAS

THEODORE DAVIS

United States, 1840–1894

HAVILAND & COMPANY

United States, established 1842

32 Seafood Salad Plate 1880

Porcelain with transfer-printed, enameled, and gilded decoration

9 x 7 1/2 x 1 1/2 inches

Gift of Christopher Monkhouse in honor of Marjorie Linder Monkhouse, 2004.43

In 1879, *Harper's Weekly* illustrator Theodore Davis embarked on an unusual assignment at the request of First Lady Lucy Hayes, wife of President Rutherford B. Hayes. A seasoned war correspondent, Davis had never designed ceramics before, but Mrs. Hayes nonetheless requested that he partner with the American-owned ceramics firm of Haviland & Company, based in Limoges, France, to create a china service for the White House. Working with French ceramicists, Davis spent months designing more than 130 individual patterns in novel shapes and bright colors. The resulting set became the first White House porcelain produced by an American company that celebrated the natural abundance of the North American continent. Like the sublime landscapes of painters such as Frederic Edwin Church (CAT. 43) or the Niagara Falls pitcher of the United States Pottery Company (CAT. 16), Davis and Haviland's collaboration highlighted species of fish, fowl, and mammals unique to North America in the environments in which they thrived. This seafood plate, for instance, pictures lobster and crab as the ocean's bounty and situates the crustaceans against a backdrop of crashing waves on the Atlantic coast.

While some critics balked at the service's bold tones and unorthodox shapes, Mrs. Hayes cherished the finished product, writing to Davis, "It is a delight to study beautiful forms and paintings. One almost feels as if such Ceramic Art should be used for no other purpose except to gratify the eye. I congratulate you in the accomplishment of the task which you so kindly imposed upon yourself in the production of the beautiful designs which have added fresh laurels to American Art."[41]

In 1880, hoping to capitalize on the fame of the presidential set, Haviland repurposed Davis' White House designs for a general audience. This seafood plate comes from the commercial set, which differs in some ways from the original service. Haviland retained the unique horseshoe crab shape of the plate, as well as the three crab claws and the White House seal on its obverse. The lobster, crab, and conch shells in this version appear in the same position as on Davis' original, but as flat, transfer-printed, and hand-decorated designs, rather than low-relief affixed forms. In Haviland's second iteration, the colorful sea creatures appear outsized and marooned against the illusionistic background of frothy surf. When translated into popular form, Davis' design appears somewhat clumsy, yet the service retains its whimsical appeal. The White House dishes and the more widely available sets both reflect a larger artistic turn away from European decorative precedents, as Americans embraced their own landscapes and homegrown artists. DJG

CLAUDE MONET

France, 1840–1926

33 La Seine à Vétheuil
(The Seine at Vétheuil) circa 1880

Oil on canvas

23 x 28 ¾ inches

Gift of Mrs. Stuart Symington, 1998.95

Facing significant economic and personal difficulties in the late 1870s, French Impressionist Claude Monet moved to the town of Vétheuil in the summer of 1878. Over the next three years, he painted more than two hundred works, many depicting the rural landscapes around his new home and the neighboring village of Lavacourt. In this composition, Monet portrayed a stretch of the Seine River with two large groups of trees to the right and the buildings of the town, including its thirteenth-century church of Notre-Dame de Vétheuil, spreading across the river's far bank. Throughout the painting, Monet varied his brushstrokes and his palette, creating a range of textures to suggest the effects of light on water, landscape, and architecture. Flat horizontal brushstrokes at the point where the river meets the shore differentiate the water's reflective surface from the land above, and cross-hatched marks create a pictorial texture that animates the foliage and the sense of the Seine's current.

The landscapes Monet painted in Vétheuil and Lavacourt (see, for example, FIG. 13) suggest a shift in the painter's œuvre. In previous years, Monet had rendered Parisian and suburban scenes of bourgeois leisure, painting canvases filled with men and women engaging with the modern landscape and urban environment. In Vétheuil, however, Monet largely erased the human component from his compositions (even though contemporary photographs show the banks full of riverside activities). The lack of people suggests a timeless landscape removed from the actions of the contemporary world, a notion that the painter complemented with his treatment of the town's buildings. These structures suggest endurance,

not change, and the medieval church, in particular, conveys a deep-seated connection between France's past and its present.

Claude Monet was one of the most significant figures in the development of French Impressionism during the late nineteenth century. At the age of twenty-two, he left Normandy where he had been raised and moved to Paris to train as a painter. Monet earned only limited success as a Salon artist, as many critics felt that his works were incomplete. Nevertheless, he embraced the term "Impressionism," even though critics had first used it in 1874 to mock the unfinished look of his canvases. As seen here, this aesthetic depended on energetic brushstrokes and inventive colors to depict the ephemeral and fleeting effects of light in nature. Following his stay in Vétheuil, Monet increasingly spent time back in Normandy, eventually settling in the town of Giverny where he lived out his last decades. AJE

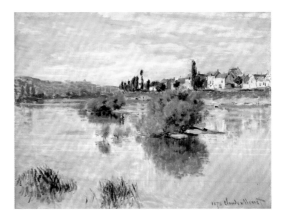

FIG. 13
Claude Monet (France, 1840–1926), *La Seine à Lavacourt (The Seine at Lavacourt)*, 1878, oil on canvas, 22 ⅛ x 28 ⅞ inches. Isabelle and Scott Black Collection

FREDERIC GOTH

United States, 1832–1887

34 **Milk Str. Market before Thanksgiving, Portland, Me., Nov. 26, 1884** 1884

Ink on paper mounted on canvas

28 x 40 ¼ inches

Gift of Charles E. Mason, Jr., 1976.227

This scene of Portland in the autumn of 1884 depicts the bustling Milk Street Market before Thanksgiving. The fish market is pictured on the right of the drawing, while butchered meat hangs in the marketplace windows on the left. Jovial shoppers converse outside the market, bundled in scarves and coats to shield them from the chill November air. The smiling city folk load their poultry and other supplies for the holiday meal into their carts, as their blanket-clad horses wait patiently.

This neighborhood is still in the heart of Portland's Old Port district, although it looks very different now. While the site of the nineteenth-century market is now a parking lot, the smokestack remains today. The tall building at the top left of the drawing is also part of Portland's current streetscape, home to twenty-first-century businesses. Close examination reveals the flag-flying tip of the Portland Observatory (see CAT. 5), now a historic landmark in Portland's East End, at the center of the drawing above the Livery Stable.

The artist, Frederic Goth, was a gunsmith who had a shop on Market Street (formerly known as Lime Street), near the site depicted here. His workshop was located near Milk Street Market and the State of Maine Armory (now the Portland Regency Hotel and Spa). Both Milk Street and Goth's business were included in the area burned in the great Portland fire of July 4, 1866, which destroyed many structures on the peninsula. In addition to Goth's primary trade as a gunsmith, he was a skilled artist. This drawing, which he made eighteen years after the fire, shows the city rebuilt and buzzing with activity. During this time, Goth's sons Richard and Fred worked with him in the gun shop, and they carried on the family business after their father's death in 1887.

During the 1880s, Portland was experiencing an era of prosperity, thanks to railroad access and its deep, sheltered harbor. The abundance of food and goods available at the market, combined with the cheerful mood of the shoppers, conveys this thriving state. In 1882, just two years before Goth portrayed the Milk Street Market, a group of local artists established the Portland Society of Art, the precursor to the Portland Museum of Art. The city was a hub of commerce and industry, known for its trade and manufacturing and its fishing and lumber industries. The first telephone was installed in 1878 and electricity arrived five years later, in 1883. The newly installed wires strung above the market in Goth's image are a sign of the change and growing energy of this modern city. AHE

MILK STR. MARKET BEFORE THANKSGIVING.

PORTLAND. ME. NOV. 26. 1884.

PIERRE-AUGUSTE RENOIR

France, 1841–1919

35 **L'Estaque** 1885–1890

Oil on canvas

18 3/8 x 21 7/8 inches

Gift of Mr. and Mrs. A. Varick Stout in memory
of Mr. and Mrs. Phineas W. Sprague, 1975.451

On his return from a vacation in Italy in 1882, Pierre-Auguste Renoir paid a visit to the painter Paul Cézanne in the French fishing village of L'Estaque on the Mediterranean coast. Cézanne, a leading artist of the period, had been coming to paint in the small town next to Marseille off and on since the 1860s, embracing the pictorial possibilities of the light and seaside of the Riviera. In the next half-century, other avant-garde artists also descended on the village, making it a key subject in the reimagination of modernist landscape painting.

Renoir painted this view of the sea several years after his initial visit. The deep blue water divides the hill in the foreground from the opposite shore, where buildings sit on the banks and mountains rise in the distance. The limited human activity in the picture—including a small white-sailed boat near the far bank and a fisherman in the center of the composition—conveys notions of tranquility, signaling this place as a refuge from the bustle of fin-de-siècle Paris. Despite these vignettes of human action, the painting focuses on the effect of light and color. Renoir used a bright palette of deep and lively reds, blues, greens, and yellows with energetic brushwork. In the foreground, he filled the canvas with short, almost spiky dashes of paint to suggest the animation of the leaves of the trees. He also enlivened the hills and mountains of the landscape, layering different tones of paint with thick impasto marks. The juxtaposition of bold dashes of pure colors amplifies the visual energy of the picture, marking a significant departure from the darker hues and more restrained paint handling of works like *Confidences* (see CAT. 29).

The late 1880s were a period of transition for Renoir. Long a stalwart of the Impressionist coterie, the painter began working in styles that departed from his famed aesthetic. He also sought solace beyond Paris, distancing himself from the pressures and intensity of urban modernity. The themes of tranquility in *L'Estaque* speak to these preoccupations, while its formal style suggests a brief experiment between his Impressionist works and his late-career interest in mythological scenes and full-figured bathers. Though distinct from those later modes, this bold and vigorous composition showcases Renoir's efforts to negotiate new visual priorities. AJE

JOHN HABERLE

United States, 1856–1933

36 **Reproduction** circa 1886

Oil on canvas

10 x 14 inches

Gift of Walter B. and Marcia F. Goldfarb, 2009.34

In the United States, the late nineteenth century witnessed a flowering of still-life painting called trompe l'œil (French for "fool the eye") or deception pictures. These highly illusionistic works created playful ambiguities between representations of objects and the real things. John Haberle was one of the masters of this genre, and his *Reproduction* is a bravura example of the type of currency imagery for which he was best known. This painting represents the visual deceit of a well-worn ten-dollar silver certificate of deposit affixed to a board, along with newspaper clippings, postage stamps, and a small photograph. (The painted tintype, which portrays Haberle, serves as his signature.) Each item is described with meticulous detail and accuracy. For example, the newspaper texts are clearly legible, and the ten-dollar note mimics the elaborate printed designs of the real item, with decorative tracery, varied fonts, a serial number, and a portrait of U.S. Treasury Secretary Robert Morris. Haberle enhanced the illusionism by building up the painted documents with an underlying layer of gesso to create three-dimensionality, particularly in areas where papers appear to overlap and their edges to curl up. Yet, despite the astonishing verisimilitude of this painting, "It is done entirely with a brush," as the artist reminds the viewer in one of the pictured newspaper clippings.

Reproduction contains additional self-referential allusions to both Haberle's practice and contemporary concerns about trompe l'œil painting. The newspaper texts make the pictorial trickery explicit. The larger clipping, with an illustration of a man working at a desk, includes the phrases "John Haberle the Counter[feiter]" and "[de]ceives the eye into the belief that," while the smaller one reads, "A Counterfeit. A remarkable Painting of a ten-dollar sil[ver Uni]ted States' bill . . . that would humbug Barnum." (P. T. Barnum was the nineteenth-century showman and circus impresario who famously exhibited hoaxes such as the Fiji mermaid to American audiences.) These words anticipate viewers' responses of disbelief. Indeed, some skeptical observers accused Haberle of Barnum-like bamboozlement, claiming that he made his currency pictures by gluing actual bills to a canvas.[42] The counterfeiting references also allude to a particular problem artists encountered with trompe l'œil representations of money. In 1886, Haberle's colleague William Harnett was briefly arrested by the U.S. Secret Service on charges of counterfeiting for his trompe l'œil painting *Still Life—Five Dollar Bill* (1877, Philadelphia Museum of Art). In *Reproduction*, Haberle, who also received warnings from federal authorities, "upped the ante" on Harnett by painting a larger-value bill with greater degrees of virtuosic illusionism. KAS

EDWIN LORD WEEKS

United States, 1849–1903

37 The Great Mogul and His Court
Returning from the Great Mosque
at Delhi, India circa 1886

Oil on canvas

33 5/8 x 54 1/4 inches

Gift of Marion R. Weeks in memory of her
father, Dr. Stephen Holmes Weeks, 1918.1

An intrepid traveler, Edwin Lord Weeks achieved success as a painter of distant lands and foreign cultures, participating in a broad cultural phenomenon known as Orientalism. During the nineteenth century, expanding global trade, travel networks, and colonialism sparked Western fascination with the supposedly "exotic" peoples and landscapes of Asia, Africa, and the Middle East. American and European artists, and their audiences, embraced depictions of these foreign cultures, although the pictures were often more fanciful than accurate.

Born in Boston, Weeks developed a taste for travel early in life, voyaging to the Florida Keys and South America as a young adult. In the early 1870s, he went to Paris and studied at the studio of Léon Bonnat and the École des Beaux-Arts under Jean-Léon Gérôme, who was renowned for his meticulously detailed Orientalist pictures. Over the next three decades, Weeks made numerous trips to North Africa and the Middle and Far East, visiting Egypt, Morocco, Algeria, Palestine, Persia, and Turkey. The artist-explorer was also particularly drawn to India, which he visited three times between 1882 and 1893.

In this elaborate scene, informed by firsthand obser-vations of architecture and romanticized accounts of historic events, the caravan of Shah Jahan, the seventeenth-century Mughal (or Mogul) king who built the Taj Mahal, parades through the streets of Delhi. In a display of opulence, the imperial court is extravagantly dressed in ornate fabrics and luxurious materials, all rendered with Weeks' characteristic exacting detail. The emperor, hidden in the shadows of a *howdah* (an elephant-mounted carriage), processes past one of his architectural marvels: the Jama Masjid (Great Mosque) of Delhi, completed in 1656. Deeply enthralled by Islamic architecture, Weeks depicted the mosque's intricate moldings, incised decorations, and onion domes. The photo-like precision of these details likely stems from his use of photography to create studies.[43] Weeks' recent adoption of photographic source material is also apparent in his delicate paint handling and crisp treatment of light. Prior to the 1880s, his work was more painterly, with a greater emphasis on the texture of paint and soft effects of light.[44] In contrast, the bright midday sun in *The Great Mogul and His Court* illuminates the subjects with brilliance and meticulous clarity.

A critically acclaimed artist, Weeks exhibited regularly in the annual Paris Salon, receiving medals for his entries in 1884 and 1889. In addition to recording foreign vistas and cultures in paintings, he was a prolific illustrator and writer. He contributed essays and illustrations to *Harper's Weekly* and *Scribner's Magazine*, satisfying America's appetite for the "exotic." His 1896 book, titled *From the Black Sea through Persia and India*, details his adventures. MRA

PETER HENRY EMERSON

England, born Cuba, 1856–1936

38 **Taking Up the Eel Net** 1886

Platinum print

7 7/16 x 16 3/16 inches

Museum purchase with support from the
Friends of the Collection, 2008.26.4

In *Taking Up the Eel Net*, Peter Henry (also known as P. H.) Emerson depicted a scene of everyday life within a timeless, Romantic setting. The two men stand on a small craft, raising a fishing net as part of their daily labors on the waters of County Norfolk, England. The figures' absorption in their mundane actions shows Emerson's effort to distance his art from the poses and artificiality common in the high art photography of the period. Instead, Emerson recalled the styles of Realist and Naturalist painters by composing his pictures with a sharp focus on the central vignette and a softer, more atmospheric rendering of the surrounding environment. This aesthetic was central to Emerson's sympathetic, and at times melancholy, depiction of country life. It conveyed a sense of authenticity and immutability in rural England, operating as a foil to the forces of rapid industrialization. In the second half of the 1880s, Emerson worked prolifically in this mode, publishing several portfolios of photographs, including *Life and Landscape on the Norfolk Broads* (1886), which featured this image, and *Idylls of the Norfolk Broads* (1887).

In addition to his work as an artist, Emerson was an influential author, disseminating his ideas in an important 1889 volume titled *Naturalistic Photography*. In this treatise, he defended photography's status as a form of art, which was a hotly contested issue in the decades following its advent in 1839. Emerson claimed that the medium allowed artists to create an impression of nature, rather than a straightforward reproduction of the natural world. A year later, however, Emerson reversed course in a book titled *The Death of Naturalist Photography*. In this 1890 essay, he declared that photography was not an art, arguing instead that practitioners had little creative control over their works and that the medium was a mechanically driven process.

Despite Emerson's ambivalence about the relationship between photography and art, his original publication was immensely influential in both Europe and America. American photographers such as Alfred Stieglitz and the members of the Photo-Secession movement drew inspiration from Emerson as they affirmed photography's place among the fine arts. The painterly quality of Emerson's *Taking Up the Eel Net* and other works anticipates this later generation's Pictorialism and commitment to manipulating photographic images for emotional effect. AJE

ALFRED SISLEY

England, born France, 1839–1899

39 Moret-sur-Loing 1888

Oil on canvas

15 1/8 x 22 1/8 inches

The Joan Whitney Payson Collection
at the Portland Museum of Art, Maine.
Gift of John Whitney Payson, 1992.40

In this painting, British Impressionist Alfred Sisley depicted a quiet moment at the bend of the Loing River as it passes through the French village of Moret-sur-Loing. Though a tranquil scene, the work shows a central tension of Impressionist landscape painting. Sisley and his colleagues strove to represent the timeless and iconic French countryside while capturing the fleeting and ephemeral quality of nature. Here, Sisley used short, quick brushstrokes to create the effect of the animated waterside grasses and the leaves in the trees. The artist's vigorous marks insist that the representation of the verdant landscape came from firsthand observation of the riverside environment. Despite the energy of the paint handling and Sisley's varied palette, he was careful to establish boundaries between the spaces and elements of his composition. The painting is organized to prevent any structural breakdown between the riverbanks and the water in the foreground or between the sky and the horizon on the opposite shore. Moreover, in Sisley's treatment of the buildings at the rear of the picture plane, he emphasized the solidity of the structures. The integrity of the architecture itself never dissolves into a mere play of color and reflection.

After studying business in London between 1857 and 1861, Sisley returned to Paris, the city of his birth, to train as an artist. He found a place in the studio of Charles Gleyre, where he worked alongside contemporaries including Claude Monet (see CAT. 33), Pierre-Auguste Renoir (see CATS. 29 and 35), and Frédéric Bazille. With their teacher's encouragement, the cohort of young painters made pilgrimages to the Forest of Fontainebleau, thirty-five miles southeast of Paris, to paint outdoors and to draw inspiration from nature. They were following the example of the artists of the Barbizon School, who were vital forerunners of the Impressionist movement, renewing the French landscape tradition with plein air painting and a realistic approach to representing the natural world.

Despite living in France and multiple efforts to gain French citizenship, Sisley remained a British subject throughout his life. He was nevertheless a central figure in French painting of the 1870s and 1880s, participating in four of the eight Impressionist exhibitions between 1874 and 1886. Though this painting postdates the final Impressionist show, it manifests Sisley's continuing attention to depicting light and landscape. In this case, his subject was a location that he knew intimately, as he lived in Moret-sur-Loing and the neighboring villages just outside the Forest of Fontainebleau for the last two decades of his life. AJE

MARY CASSATT

United States, 1844–1926

40 **Hélène Is Restless** circa 1890

Oil on canvas

25 7/8 x 21 1/2 inches

Bequest of Margaret Payson, 2005.36.2

Following a horseback riding accident in the summer of 1889, the American expatriate artist Mary Cassatt spent several months recuperating in the French town of Septeuil, forty miles west of Paris. During her period of convalescence, she began using a young model named Hélène for a number of pictures. In this painting, Cassatt created an engaging image with a quiet but palpable tension. Hélène twists in the arms of an adult woman, pressing her right arm awkwardly against the woman's right shoulder. The gesture creates a barrier between the two figures and challenges the intimacy of their embrace. Hélène's enigmatic expression compounds this movement, undermining any presumption that the picture is a straightforward narrative about idyllic maternal tenderness. Instead, the viewer focuses on the independent personality of the child, whose face is the most fully realized section of the composition.

While representations of women and children had always been a key subject for Cassatt, the painter increased her focus on this theme around 1890. Many of the mother-and-child images of this era, and those that Cassatt created over the next three decades, highlight the tenderness between figures in scenes of bathing, nursing, or hugging. In this work, however, and in a more fully realized pastel of Hélène (FIG. 14), Cassatt complicated the embrace, encouraging a focus on the child as a unique protagonist whose independence and restlessness reveal the small frictions common in the daily lives of children and their guardians.

Cassatt, who is best known for her work in Paris in the time of the Impressionists, was born in Pennsylvania and received her first formal training at the Pennsylvania Academy of the Fine Arts in Philadelphia. She later traveled throughout Europe before settling in the French capital in the 1870s. There, she became a central figure in the Parisian art community, exhibiting in several of the Impressionist exhibitions. Despite her participation in the group, Cassatt—like her close friend and collaborator Edgar Degas (see CAT. 30)—considered herself to be an Independent, free from the strictures of academic conventions but also not bound by any specific modern doctrine. The human figure was her most frequent subject and she was prolific in her treatment of themes of modern womanhood, including elegant and challenging explorations of women at the new Paris Opéra. AJE

FIG. 14
Mary Cassatt (United States, 1844–1926), *Hélène de Septeuil*, 1890, pastel on beige paper, 25 7/8 x 16 1/2 inches. The William Benton Museum of Art, University of Connecticut, Storrs, Connecticut, The Louise Crombie Beach Memorial Fund, 1948.1

MOUNT WASHINGTON GLASS COMPANY

United States, 1837–1958

41 **Vase** 1891–95

Blown enameled and gilded Crown Milano glass

14 3/4 x 6 1/4 x 3 1/4 inches

Bequest of Sylvia D. Greenberg, 2002.11.89

The Mount Washington Glass Company produced this vase between 1891 and 1895 as part of its popular Crown Milano line, characterized by semi-translucent white bodies and effusive decoration. The company debuted the series for American collectors as a less expensive alternative to imported European art glass. By re-branding its moderately successful Albertine wares as Crown Milano and adding more exotic shapes and ornamentation to its repertoire, the firm cemented its national reputation. This vase represents the fine craftsmanship and creative merging of diverse artistic sources that define the company's most elaborate turn-of-the-century work.

The firm, founded in 1837 in South Boston, initially produced utilitarian lamps and lighting fixtures before expanding into decorative wares. Named for a hill adjacent to the factory, the company grew quickly and retained "Mount Washington" in its name even after moving to New Bedford, Massachusetts, in 1870. Frederick S. Shirley became an agent of the company in 1874 and pioneered many of its formulas and processes for creating glassware. By mixing minerals and adjusting oxidation levels, Shirley achieved new and startling color and surface effects that he marketed with vigor. Mount Washington released objects with evocative names such as black Lava, pink and orange Burmese, translucent red Rose Amber, and softly modulated Peach Blow glass. Shirley was a deft promoter and litigious defender of his firm's innovations. He acquired several patents for formulas and machinery and sued rival firms to protect the company's copyrights.

In creating objects such as this vase, Mount Washington's designers readily embraced late nineteenth-century eclectic tastes as they freely mixed and matched multiple sources with glorious abandon, even within individual objects. Crown Milano wares appeared in a wide variety of shapes drawn from Islamic, medieval, and Asian sources. The line's white color and chalky finish even echo Asian porcelain's semi-translucent quality and satiny feel.

This tall vase appears impossibly delicate, with its bulbous bottom and slim neck that evoke the silhouette of an Islamic ceramic vessel. The vase is adorned with medieval European crests beneath Japanese-inspired abstract floral designs applied in raised gold lines and beading. The result of the decorative mélange is not, however, a clumsy hodge-podge. Rather, the work's multiple sources blend seamlessly to create a sophisticated example of American turn-of-the-century glass production. DJG

FRANKLIN B. SIMMONS

United States, 1839–1913

42 **Ulysses S. Grant** 1894

Marble

90 ½ x 43 x 27 inches

Gift of the City of Portland from the
Estate of Franklin B. Simmons,
1921.26

In this over life-size marble portrait, Maine-born sculptor Franklin B. Simmons depicted Civil War hero and eighteenth American president Ulysses S. Grant (1822–1885) as a sober and commanding figure. Dressed in his general's coat, Grant steps forward and raises his left hand in a traditional orator's gesture. He drops his right arm softly to his side, laying his sword on a pedestal that Simmons ornamented with a beautifully carved American flag and an olive branch. In putting down his weapon and making a rhetorical sign, the general becomes a harbinger of peace.

Simmons created this portrait on commission from the Grand Army of the Republic (GAR), an organization of Union veterans of the Civil War. The group intended to install the monument in the rotunda of the U.S. Capitol building in Washington, D.C., among portraits of other American heroes. The GAR, however, was disappointed after seeing Simmons' sculpture and ultimately rejected the statue because it did not fulfill its vision of Grant as a dynamic military hero.[45] In response, Simmons created a new portrait of the general in riding boots and leaning on his sword (FIG. 15). This statue has a greater focus on Grant's military persona and marks a departure from Simmons' original conception. The second version fit the committee's wishes more directly, and the GAR had the work installed in the Capitol rotunda, where it remains to the present day.

In addition to Grant, Simmons depicted many other American icons throughout his career. During the second half of the nineteenth century, the sculptor created medallions, busts, and full-sized representations of men such as Rhode Island founder Roger Williams, Abraham Lincoln, and the Mainer Hannibal Hamlin,

Lincoln's vice president. Despite his Maine roots, Simmons spent his most productive years in Rome (1866–1913). There, he was one of many American and European sculptors who worked in a Neoclassical style that drew inspiration from ancient sources. During these years, Simmons frequently visited his home state, designing several prominent commemorations of Maine's Civil War history, including *Our Lady of Victories* (The Soldiers and Sailors Monument) in Portland's Monument Square. That ensemble, like the Grant portraits, demonstrates the American taste for the idealization and smooth surfaces of the Neoclassical idiom in public sculpture, underscoring long-standing associations between the United States and the Greco-Roman republics of antiquity. AJE

FIG. 15
Franklin B. Simmons
(United States, 1839–1913),
Ulysses S. Grant, 1899,
marble, 88 ⅝ x 40 x 29 inches.
U.S. Capitol Rotunda,
Washington, D.C., Architect
of the Capitol

FREDERIC EDWIN CHURCH

United States, 1826–1900

43 **Mount Katahdin from Millinocket Camp** 1895

Oil on canvas

26 1/2 x 42 1/4 inches

Gift of Owen W. and Anna H. Wells in memory of Elizabeth B. Noyce, 1998.96

This panoramic view of Maine's Mount Katahdin is the last dated canvas by one of the most celebrated American landscapists of the nineteenth century. Frederic Edwin Church was renowned for dramatic pictures of the American wilderness that emphasized nature's brilliant coloristic effects and sublime dramas. Like other painters of the Hudson River School, Church embraced landscape subjects as manifestations of God's presence in the world, symbols of America's destiny, and places for spiritual transcendence. Following in the footsteps of his mentor, Thomas Cole, and drawn by the rugged beauty of Maine, Church made the first of more than a dozen excursions to the state in 1850. Over the next several decades, he regularly visited Mount Desert Island along the coast and the inland region around Mount Katahdin (one of New England's highest peaks), where he spent his time hiking, camping, and fishing, as well as making preparatory sketches for paintings. While Niagara Falls, South America, the Arctic, and other scenic sites captured the artistic imagination of this intrepid traveler, Maine subjects occupy a significant portion of Church's œuvre.

His *Mount Katahdin from Millinocket Camp* simultaneously recapitulates and departs from career-long artistic preoccupations. Depicted from the vantage point of the lakeside camp Church had purchased in 1878, the mountain peak rises in the distance over a broad, calm expanse of Lake Millinocket. In the foreground, a lone man in a canoe paddles toward long shadows cast by two towering pine trees. Although painful arthritis had curtailed his painting activities late in life, Church still captured the scene with his characteristic combination of precise details and radiant light. As in many of his Maine pictures, Church chose twilight as the time of day. Here, streaks of bright yellows and pinks accent the horizon, while a rosy glow suffuses the entire composition. Yet these atmospheric effects are far more subdued than those in a series of sunrise and sunset pictures he made in the late 1850s and 1860s, which use natural dramas to symbolize the turmoil of a nation on the brink of civil war.[46] In contrast to such impassioned canvases as *Our Banner in the Sky* of 1861 (private collection), Church's 1895 canvas is calm and elegiac in mood and personal in significance. He gave this painting to his wife as a birthday present, along with a poignant note that alludes to his own mortality: "Your old guide is paddling his canoe in the shadow, but he knows that the glories of the heavens and the earth are seen more appreciatively when the observer rests in the shade."[47] K A S

MAURICE BRAZIL PRENDERGAST

United States, born Canada, 1858–1924

44 **Rhododendrons, Boston Public Garden** 1899

Watercolor and graphite on paper

14 1/16 x 20 3/4 inches

The Joan Whitney Payson Collection at the Portland Museum of Art, Maine. Museum purchase with support from Susan Mary Alsop, Robert D. Barton and Nancy Hemenway Barton, Deborah and George Brett, Mrs. Howard S. Cowan, Mr. and Mrs. Charles W. H. Dodge, Leon Gorman, Mrs. Hugh G. Hallward, Austin and Ellen Higgins, Mr. and Mrs. Henry L. McCorkle, Elizabeth B. Noyce, John G. Ordway, Parker Poe Charitable Trust, Mrs. Jefferson Patterson, Mr. and Mrs. William H. Risley, Phineas W. Sprague Memorial Foundation, Mrs. Nicholas Strekalovsky, Mrs. Stuart Symington, UNUM Charitable Foundation, Friends of the Collection, five anonymous donors, and through funds generated by a gift from the estate of Francis and Marion Libby, 1991.61

In this scene of Boston's Public Garden, pink and red rhododendrons twist through the foreground as a crowd of well-dressed ladies and dapper men congregate just beyond the garden gates. Such images of genteel urban leisure are typical for Maurice Prendergast, who is best known for his scenes of beachgoers, promenaders, and gardens rendered in a Post-Impressionist style of loose dabs of color. One of the first American artists to embrace this French avant-garde manner, Prendergast was highly acclaimed for his experimental work in both oil and watercolor.

Born in Newfoundland, Canada, Prendergast began his career as a commercial artist in Boston by 1879. At age thirty-two, already a mature, well-established artist, he took his first trip to Paris. There, he trained at the Académie Julian and the Académie Colarossi and studied the Louvre's artistic treasures. Long walks through the city, however, along with frequent visits to local galleries where he encountered the latest modernist movements, proved to be more influential. In particular, the Nabis, a group of artists including Maurice Denis, Pierre Bonnard, and Édouard Vuillard, left a strong impression on the American. Known for their highly patterned canvases, the Nabis sought to liberate painting from its traditional representational function by concentrating on formal arrangements of line, shape, and color. The impact of the Nabis appears in the abstract and highly decorative pattern of *Rhododendrons, Boston Public Garden*. With little spatial depth and a lack of defined perspective, the watercolor dissolves into an ornamental study of color.

Rhododendrons, with its focus on shimmering light and colors, also recalls the plein air garden pictures of French Impressionists. Prendergast, however, was not painting directly from life; rather, the watercolor is a composite, created in the artist's studio from multiple sketches. Visual inconsistencies in the work support this interpretation (as do Prendergast's letters, which place him in Europe in the spring of 1899). Tonal variations between the more muted foliage on the left and the vivid greens on the right divide the composition, while the line of people and iron fence in the top left corner abruptly disappear at a central tree. These discrepancies accentuate the watercolor's formal elements and diminish any possible narrative. MRA

JOHN SINGER SARGENT

United States, born Italy, 1856–1925

Ellen Sears Amory Anderson Curtis (Mrs. Charles Pelham Curtis) 1903

Oil on canvas

59 $\frac{7}{8}$ x 35 $\frac{1}{4}$ inches

Gift of Sally Cary Curtis Iselin in memory of Charles Pelham Curtis, 1982.275

Renowned for his dashing impressionistic technique and his ability to endow sitters with fashionable elegance, John Singer Sargent was the preeminent portraitist of high society on both sides of the Atlantic in the late nineteenth century. His skills are abundantly evident in this portrait of Ellen Sears Amory Anderson Curtis (1868–1952), wife of Charles Pelham Curtis. A member of Boston's Gilded Age elite, she was known for her wit, independent spirit, and liberal views. Sargent captured her engaging personality partly through her pose. Ellen Curtis gazes directly at the viewer and appears to lean forward slightly, as if in motion. Standing next to an ornately carved, gilded chair, she wears a cream-colored evening gown trimmed with gold embroidery and aquamarine ribbons, along with a matching headpiece. A large turquoise pendant hangs against her neck, accenting her low décolletage.

With an assured hand, Sargent used loose, fluid brushstrokes that broadly describe forms and animate the picture's surface. He varied the paint application, from thin, diaphanous layers for the transparent sleeves of the sitter's dress, to thick touches of impasto for highlights on the folds of fabric. The solidly modeled figure is set off tonally from the dark brown, nondescript background. Sargent's characteristic bravura paint handling and strong tonal contrasts reveal his lifelong admiration for the works of the Old Masters Diego Velázquez and Frans Hals.

Born in Italy to American parents, Sargent lived a cosmopolitan existence. He grew up traveling around Europe, gaining exposure to its great cultural riches, and received formal artistic training in Florence and Paris. In 1886, he settled permanently in London, where he was in high demand and critically acclaimed for his portraiture. Sargent traveled extensively throughout his career, often using his annual summer sojourns to explore landscape and figure subjects, as well as the medium of watercolor. Although he lived abroad, he maintained strong ties with the American art world through commissions, exhibitions, and professional affiliations. A major mural project for the Boston Public Library (1890–1919) required regular trips to Boston. On one such visit in the spring of 1903, he set up a temporary studio in the Gothic Room of the private museum of his friend Isabella Stewart Gardner (still in operation today), where he painted this portrait of Ellen Curtis. According to Curtis family history, Ellen had three or four sittings with Sargent. He completed most of the portrait quickly, but struggled to resolve the placement of her right arm.[48] KAS

TIFFANY FURNACES

United States, 1892–1924

46 **Jonquil Vase** 1903–17

Blown Favrile glass

9 5/8 x 5 x 5 inches

Bequest of Sylvia D. Greenberg, 2002.11.248

Tiffany Furnaces' *Jonquil Vase* is a refined example of designer Louis Comfort Tiffany's visionary approach to the medium of glass. Tiffany was a tireless innovator whose keen eye for the colors and shapes of the natural world helped define the Art Nouveau style in the early twentieth century. Early in his career, Tiffany fused multihued flat glass panels together to create single sheets of stained glass in a wide array of colors and degrees of opacity. His advances provided an endless new palette for representing the forms of nature in stained glass.

In 1893, Tiffany recruited skilled European practitioners, including Englishman Arthur J. Nash, to operate the Tiffany Furnaces in Corona, Queens, New York, and to extend his experiments in stained glass to the realm of blown glass. The Furnaces created gracefully shaped and boldly colored vases that Tiffany called Favrile glass (from *fabrile*, meaning "hand-wrought" in Old English). By fuming his glass with metal oxides, Tiffany produced objects such as the *Jonquil Vase* with lustrous finishes that made the works appear to glow from within. Favrile glass items mimicked the opalescent surfaces that Tiffany admired in ancient Roman glass, while their shapes often harkened back to Venetian or Islamic precedents. Tiffany also relied on techniques gleaned from his European peers, such as Thomas Webb and Émile Gallé, to create Favrile's iridescent finishes.

Tiffany was a lifelong student of the natural world and produced an array of "floriform" vases in the shape of blossoms. He was an avid gardener at Laurelton Hall, his Long Island home, and his works often refer to particular varieties of flowers, which he rendered with careful attention. The *Jonquil Vase*, named after the late spring flower, rises in a fluid continuum from base, to stem, to shallow blossom bowl composed of five iridescent white petals. Tiffany's glass artists joined threads of white and green glass to form the stem that opens out into a flower accented with pink, yellow, and orange. With its shimmering gold interior and subtly cracked finish, the bowl evokes the vein-like surfaces of living petals. As Tiffany's Paris dealer Siegfried Bing reverentially explained, "Never, perhaps, has any man carried to greater perfection the art of faithfully rendering Nature in her most seductive aspects."[49] While Tiffany was not the first to produce such luminous effects in glass, he and the craftsmen of Tiffany Furnaces popularized the technique and took it to new heights. DJG

JOHN FREDERICK PETO

United States, 1854–1907

47 **Rack Picture with Portrait of Lincoln**
circa 1904
Oil on canvas
30 x 25 inches
Gift of Walter B. and Marcia F. Goldfarb, 2000.47

Although he worked in obscurity for much of his career (first in his native Philadelphia and, after 1889, in Island Heights, New Jersey), John Frederick Peto is now recognized as one of the masters of illusionistic trompe l'œil ("fool the eye") still-life painting that thrived in American art during the post–Civil War period.[50] He devoted much of his time to painting rack pictures or office boards that simulate newspaper clippings, photographs, advertising cards, and other ephemera affixed to a wall with ribbon or hide. *Rack Picture with Portrait of Lincoln* is one of approximately twelve works Peto made at the turn of the century that feature a portrait of the late president.[51]

Unlike his earlier commissioned rack pictures, which depicted papers specifically related to the patron's business, Peto's Lincoln works are more personal and metaphorical. He began incorporating the slain president in his canvases around the time of the 1895 death of his beloved father, a Civil War veteran. The appearance of Lincoln—another fallen father figure—in Peto's art during this period suggests an analogy between the national tragedy and his own familial loss.[52] The "1864" apparently carved into the wall references the year of Lincoln's reelection, reminding the viewer of the unfulfilled promise of his presidency. Balancing on the spine of the book, the burnt-out matchstick is a long-standing symbol of mortality—of a life snuffed out—dating back to seventeenth-century Dutch still lifes. In *Rack Picture with Portrait of Lincoln*, the depicted items show wear and tear; the ribbon has broken, the wood is scratched, and papers are creased, torn, and missing. Such signs of decay also allude to the transience of life and to the malaise of postwar American society. (The significance of other legible texts, including "48" and "DINNE[R]," remains unknown.)

Peto adopted certain trompe l'œil conceits for this rack picture—for example, objects seem to cast shadows—yet the degree of illusionism is limited. In contrast to the meticulous level of detail and textural mimicry found in the works of John Haberle (CAT. 36) and other painters of this genre, Peto used a broader, more painterly approach to representation. His brushstrokes are visible, particularly in the torn edges of the blue paper fragments at left, and his compositions display a sensitivity to the formal relationships of varying shapes and colors. As art historian John Wilmerding notes, "Peto brings us to the verge of illusionism, only to assert ultimately the primacy of paint, color, design, perception—in other words, the reality of artifice itself."[53] KAS

ELIE NADELMAN

United States, born Poland, 1885–1946

48 **Head, Side View** 1906–7

Ink and graphite on paper

10 1/4 x 7 7/8 inches

Museum purchase with a gift from
Dr. and Mrs. Delvyn C. Case, Jr., 1982.127

Drawing always played a vital role in the artistic practice of modernist sculptor Elie Nadelman, who established his career in Paris before moving to the United States at the outbreak of World War I. In his graphic work, he rejected straight lines as lacking expressive quality, explaining in 1910: "I employ no other line than the curve, which possesses freshness and force. I compose these curves so as to bring them in accord or opposition to one another. In that way I obtain the life form, i.e. harmony."[54] This early pen-and-ink drawing of a female head seen in profile embodies this dynamism and harmonious opposition of curving forms. Arcing and looping lines describe forms and passages of cross-hatching suggest shading. Nadelman's strokes are quick and flowing, although he did go over certain passages to make adjustments or add emphasis to his line. He distilled the woman's facial features into stylized, abstracted shapes, including a curving triangle for her nose and two ovals for her hair pulled into a chignon.

Head belongs to a series of drawings Nadelman began in 1905 as part of his focused exploration of the relationship between geometry and sculptural volume. Its sophisticated interplay of line, shading, and blank areas of paper echoes the shifting planes and complex volumes of human anatomy. He published his ideas in *Toward a Sculptural Unity* (1914), which was heavily illustrated with his drawings.

Throughout his career in Europe and America, Nadelman's graphic work generally paralleled his sculpture in both subject matter and style. The human body, including heads and full-length figures, dominates his œuvre. Around the time *Head* was made, the artist had recently arrived in Paris after artistic training in his native Warsaw and a brief stay in Munich. His early works display a range of stylistic approaches, from a faceted, proto-Cubist treatment of form (as seen in this drawing) to a more classicizing style. Nadelman drew inspiration from a variety of sources, including ancient Greco-Roman statuary, prehistoric art, and modern art. He exhibited his sculpture to great acclaim and was a leading figure in international avant-garde circles, garnering support from important patrons such as Alfred Stieglitz and Gertrude and Leo Stein. In the 1910s and 1920s, Nadelman found similar success in the United States, where he further refined his figural style into more attenuated, stylized, and tubular forms. This shift was informed, in part, by his fascination with folk art. While he continued to produce sculpture in a range of media, he increasingly devoted his efforts to amassing a large collection of folk art. From 1926 to 1937, Nadelman and his wife, heiress Viola Flannery Nadelman, exhibited their holdings on their New York estate in the Riverdale neighborhood of the Bronx, in the first museum devoted exclusively to this type of art.[55] KAS

HARRY WILLSON WATROUS

United States, 1857–1940

49 **The Drop Sinister—What Shall We Do with It?** circa 1913

Oil on canvas

37 x 50 ¼ inches

Gift of the artist, 1919.18

When the academic painter Harry Willson Watrous exhibited this domestic scene in New York City in 1914, one art critic noted, "always in front of it there is a crowd; always there are whispering voices discussing it. And the reason is plain: The picture has a lesson for humanity."[56] Indeed, *The Drop Sinister—What Shall We Do with It?* is one of the artist's most moralizing and socially pointed paintings and a departure from his typical subject of idealized women. The title refers to the contemporaneous belief that a single drop of African blood in a person's heritage classified him as black in American society. During the eighteenth and nineteenth centuries under slavery, authorities used varying fractional blood amounts to calculate racial identity and, by extension, socio-legal status. Beginning in 1910 in the era of Jim Crow segregation, several Southern states began codifying versions of a "one-drop rule" into law.

Watrous' painting confronts the viewer with the human cost and inherent injustices of such racist concepts. Seated around a table in their elegantly appointed, middle-class home, a white woman and a dark-skinned man (presumably of African descent) ponder the fate of their mixed-race child, who gazes with uncomprehending concern at her mother. The daughter's blue eyes, blond hair, and fair complexion suggest that she would be able to "pass" as white and escape the ubiquitous discrimination suffered by blacks in American society. By passing, however, she would have to deny her father's ancestry. The painting's imploring subtitle—"what shall we do with it?"—and the parents' body language indicate the difficulty of this family dilemma. Watrous clearly identified this household as Christian: the father is a minister who wears a clerical collar and holds a religious newspaper; there are crosses on the mantelpiece; and a biblical quote inscribed on the wall reads, "And God said, Let us make man in our image after our Likeness." These carefully described details, along with the portrait of President Abraham Lincoln in the background, underscore the hypocrisy contained in racialized classifications that contradict Christian and American ideals of universal equality.[57]

Born in San Francisco and trained in France, Watrous had a long and distinguished career in New York City, painting genre scenes, figure subjects, still lifes, and landscapes and holding administrative posts at the National Academy of Design. *The Drop Sinister* exemplifies his style, which combined academic naturalism, smooth brushwork, and crisp contours with a modernist interest in flattened patterns—particularly evident in the mother's floral-print robe and graceful profile. The contrast between the painting's beautiful execution and its hard-hitting social critique seem to suggest a broader progressive argument that physical appearance does not reflect personal character. KAS

GERTRUDE KÄSEBIER

United States, 1852–1934

50 **The Widow** 1913

Gum bichromate print

11 x 8 ½ inches

Museum purchase with support from
the Photography Fund, 2006.14.2

Gertrude Käsebier was one of the most successful portraitists of her day and a founding member of the avant-garde Photo-Secession movement, along with the photographer and promoter Alfred Stieglitz. Käsebier was a prolific photographer whose images appeared in the first issue of Stieglitz's influential magazine, *Camera Work*. Along with photographers such as F. Holland Day and Clarence H. White, Käsebier championed an artistic approach to the medium, in which photographers manipulated negatives and prints in the darkroom to produce toned or seemingly painted surfaces. Photo-Secession members argued that the photographer was an artist and the photograph a work of art.

Käsebier studied painting in Paris before taking up photography at the Pratt Institute in Brooklyn, New York. In 1893, she opened her New York City studio and gained immediate attention from patrons who cherished the seemingly spontaneous expressions and postures she managed to coax from her sitters. Throughout her career, Käsebier returned again and again to scenes of mothers and children, enlisting her friends as models for photographs that often bore social messages.

The Widow of 1913 is one such photograph featuring Käsebier's friend, illustrator Beatrice Baxter Ruyl, in the Maine home of fellow photographer and mutual friend F. Holland Day. The two women visited Day together in Georgetown, Maine, in 1905, 1909, and 1913. In this vertical image, Ruyl and her baby Barbara stand in as a modern-day and earthbound Madonna and Child, surrounded not by putti and halos, but by ceramic bowls, a set table, and a curtained window. Käsebier masterfully altered the wet print to obscure the details of the interior scene and to isolate the pair, wrapped in virginal white, against a dark and ominously indistinct background. In the picture, Käsebier captured the widow's trepidation as she confronts an uncertain future; Ruyl holds her child protectively to her chest and casts a wary glance at the photographer.

During her stay at Day's home, Käsebier also captured Ruyl and her daughter in a strikingly different manner than she had in *The Widow*. *The Ruyl Family* is an idyllic glimpse of mother and daughter, seated at the same table as *The Widow*, but this time across from Ruyl's husband Louis and their older daughter, Ruth (FIG. 16). The baby looks at her doting father while Ruth meets Käsebier's gaze. Here, the photographer refrained from extensive retouching, producing a sharply detailed print that is cropped to create a comfortable domestic tableau. Taken together, the two prints exhibit Käsebier's sensitive eye and skillful hand in the darkroom. With cropping, retouching, and timing, the photographer transformed a tender portrait of a family at rest into a darker vision of a young mother and child facing the world alone. DJG

FIG. 16
Gertrude Käsebier
(United States, 1852–1934), *The Ruyl Family*, 1913, platinum print, 9 x 7 ⅜ inches. Portland Museum of Art, Maine, Museum purchase with support from the Photography Fund, 2006.14.3

GEORGE BELLOWS

United States, 1882–1925

51 **Matinicus** 1916

Oil on canvas

32 x 40 inches

Bequest of Elizabeth B. Noyce, 1996.38.1

Realist painter George Bellows, famed for his gritty images of life in New York City, also produced a large body of coastal scenes based on his travels in Maine between 1911 and 1916. He first visited Monhegan Island at the invitation of Robert Henri, the charismatic leader of the so-called Ashcan School of urban realists and one of Bellows' teachers from his student days at the New York School of Art. Like many artists of his generation (including Henri), Bellows was drawn to Maine by the example of Winslow Homer, whose powerful seascapes he greatly admired and emulated (see CAT. 23). The natural beauty of Maine's coast and the pictorial interest of its working waterfronts captivated Bellows' attention for several summers to follow.

This painting resulted from a monthlong stay in 1916 on the small island of Matinicus, offshore from Camden, where Bellows found "a large fishing village, and fine landscape. No summer people whatever."[58] He depicted a compressed vista of the busy wharves, dominated by a cluster of dilapidated fishing shacks raised up on wooden pilings. Below, in the foreground, the rocky shore is cluttered with lobster traps, buoys, and moored boats, in which several fishermen sit, working on their gear and conversing. At left, a pair of geese and a cow also animate the scene and add a humorous note. Additional shacks, boats, and a stone pier extend into the background at right.

With its teetering forms, jumbled angles, and high-keyed palette, *Matinicus* conveys an overall effect of vibrant, almost chaotic activity. Bellows applied paint with a thickly loaded brush. His brushstrokes help to describe objects (as in the parallel vertical strokes he used in the siding of the shacks), while simultaneously creating surface texture. Particularly striking are his lurid, nonnaturalistic colors, including chartreuse for the centermost dory, yellow for the cow, and purple for the coastal grasses. These formal distortions of space and appearance show Bellows' engagement with European modernists, particularly Paul Cézanne and the Fauves, and his familiarity with the color theories of Hardesty Gillmore Maratta, who developed a palette and system of color relationships by assigning hues to notes on a musical scale. With such bold and sophisticated paintings, Bellows earned widespread acclaim from both conservative and progressive factions in the American art world. His successful career was cut short by his death at the age of forty-two. KAS

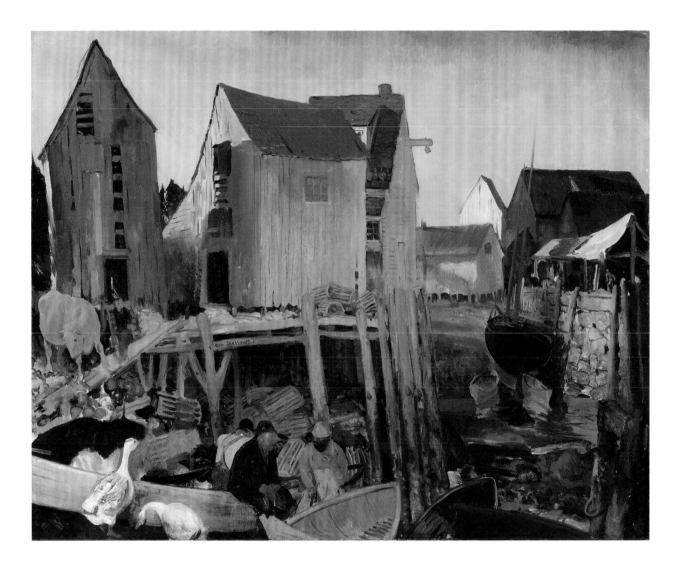

CHARLES BURCHFIELD

United States, 1893–1967

52 **A Fallen Tree** 1917

Gouache on paper

17 1/2 x 20 1/2 inches

Gift of the Alex Katz Foundation, 2014.1.1

Charles Burchfield devoted his career to memorializing the natural and man-made environments in and around his childhood home in Salem, Ohio, and his adopted city of Buffalo, New York. Burchfield gained national recognition in the 1920s and 1930s for his expressive, anthropomorphic landscapes. He was acclaimed as one of the leading watercolorists of the day, particularly after 1930, when curator Alfred Barr promoted the artist's early work with a show at the Museum of Modern Art in New York. Barr called Burchfield "one of the most isolated and original phenomena in American Art."[59]

Burchfield's brooding, gestural watercolors are at once portraits of places and abstract expressions of the moods and emotions these locations evoked for the artist. He created this watercolor of the woods around Salem in 1917, his self-proclaimed "golden year." Returning home from the Cleveland School of Art, the young and naturally reclusive artist worked as a clerk and spent all his spare time painting hundreds of local scenes.

Throughout his career, Burchfield conveyed the desolate beauty of the Midwest with dexterous applications of pigment onto wet paper and bold dry-brush technique. In *A Fallen Tree,* the artist conjured a profound sense of melancholy in a cracked sycamore trunk through his palette of whites, muted blues, and blacks, with one swath of pure cobalt blue. Burchfield called winter trees "huge, black, scrawny hideous things." He described the subject of this watercolor as "a fallen sycamore tree sprawling over a frozen swamp pond with a wild haunted marsh tangle behind."[60] The mottled trunk runs the length of the composition, slashing diagonally across the canvas. The tree, with the roots of its shattered base still embedded in the soil, appears to straddle the world of the living and the dead. Its finger-like branches grasp at the stagnant pools of water in the foreground and reach backwards into the scrim of trees with narrow, arched window-like apertures. Burchfield repeated shapes such as the arched window in many subsequent images and developed a codified symbolic language in his work. Recurring subjects and forms helped the artist represent the sights and sounds of the world in increasingly fantastic and expressive colors and compositions. DJG

GEORGE GROSZ

Germany, 1893–1959

53 **Löwen und Leoparden füttern ihre Jungen, Raben tischen ihren Kleinen auf . . . (Lions and tigers nourish their young, Ravens feast their brood on carrion . . .)**

From the portfolio *Die Räuber (The Robbers)* 1922

Photolithograph on paper

27 1/2 x 19 3/4 inches

Gift of David and Eva Bradford, 2002.53.6.5

After World War I, many German artists responded with biting social satire to the trauma of the conflict and the widespread economic and cultural instability that occurred in its wake. In this print, George Grosz exposed the extreme inequalities of the 1920s in Germany. He based the title of his portfolio and the names of the individual prints on Friedrich Schiller's late eighteenth-century play *The Robbers*, which had offered powerful critiques of injustice in Germany in its own time. These references allowed the artist to broadcast contemporary commentary while establishing a link to the social consciousness of Germany's artistic traditions.

In the foreground, a starving young child approaches a greedy industrialist. Her nudity and slight frame contrast with his elegant clothing and ample body. She appears to be asking for charity as the industrialist avariciously pulls an overflowing pile of money to his chest. Behind him, smokestacks plume in the modern industrial city that appears through the window at the right. The composition, with its figural and spatial distortions, rendered in spare lines with an effective use of empty space, amplifies the stark inequality between the figures.

During the first decades of the twentieth century, such prints emerged as a major vehicle for artistic experimentation within German Expressionism. This broad-based movement rejected academic conventions in favor of exploring personal and political aims. Some Expressionists were interested in the aesthetic possibilities of various print media. Others, like Grosz, valued printmaking because it allowed a wide distribution of images that shaped and reflected the era's social debates.

A native of Berlin, Grosz served two tours of duty in World War I. Throughout his career, he worked in a variety of modernist styles, including Expressionism, Futurism, and *Neue Sachlichkeit* (New Objectivity). He was also involved in Berlin's Dada group. The 1920s were a particularly rich period in his career. In addition to publishing the *Robbers* portfolio, Grosz created several other damning social commentaries on interwar Germany, including his *Ecce Homo* portfolio of 1923, for which the government prosecuted him as a creator of vulgar and offensive images. Later in the decade, Grosz, an avowed Communist, felt increasingly estranged from the fundamentalist tone of the German Communist party and grew wary of the developing National Socialist movement. As a result, he left Germany in 1933 and immigrated to the United States, where he became a citizen and taught at the Art Students League of New York until 1955. AJE

YASUO KUNIYOSHI

United States, born Japan, 1889–1953

54 **After the Bath** 1923

Oil on canvas

30 1/8 x 24 1/8 inches

Hamilton Easter Field Art Foundation
Collection, Gift of Barn Gallery Associates, Inc.,
Ogunquit, Maine, 1979.13.26

In an artist's statement published in 1940, Japanese-born, New York City–based modernist Yasuo Kuniyoshi declared that his artistic aim was "to combine the rich traditions of the East with my accumulative experience of the West."[61] This dynamic blending of cultures is evident from his early career in such works as *After the Bath*. Here, a partially nude young woman combs her hair in front of a window overlooking a three-masted schooner sailing on a dark sea. The composition, complete with a red curtain framing the window, evokes Western grand-style portraiture in general, and eighteenth- and nineteenth-century portraits of seafarers in particular (see FIG. 17). Such images typically included a harbor scene in the background and surrounded the sitter with tools of his trade, such as a map, spyglass, and other nautical instruments. Kuniyoshi's slyly humorous, modernist take on this portrait type substitutes a woman at her toilette for a male sea captain and a curling iron for maritime tools. In the early 1920s, when this painting was made, the artist was actively involved in Hamilton Easter Field's circle of American modernists, which had a summer colony in Ogunquit, on the southern coast of Maine. In addition to embracing marine themes, Kuniyoshi, like other members of Field's group, avidly collected American antiques and folk art during his summer sojourns.

Another Western feature of *After the Bath* is the nude subject, which recalls images of Venus and other goddesses by Renaissance and Baroque masters such as Titian and Rubens. From 1916 to 1920, Kuniyoshi studied at the Art Students League of New York with Kenneth Hayes Miller, an influential teacher who fostered a deep appreciation for European Old Masters. Throughout the 1920s, the female figure was one of

Kuniyoshi's favorite subjects, along with children. Yet the "bathing beauty" in *After the Bath* lacks the idealized naturalism of a traditional female nude. Instead, she is rendered with simplified anatomy, limited modeling, and distorted proportions, evident in her large head and distended wrist. While decidedly modernist, the artist's approach to human form and spatial perspective is also indebted to Eastern art. The popular Japanese ukiyo-e prints, for instance, are characterized by flattened figures, strong outlines, and compressed distances between foregrounds and backgrounds. Kuniyoshi's hybridized yet original style, which combined modernist tendencies, folk art traditions, and Western and Eastern conventions, earned him high critical regard throughout his career. KAS

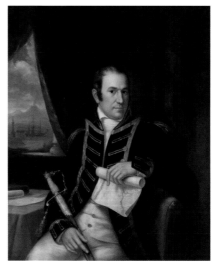

FIG. 17
Henry Cheever Pratt (United States, 1803–1880), *Commodore Edward Preble*, 1830, oil on canvas, 43 7/8 x 36 inches. Portland Museum of Art, Maine, Gift of Mr. and Mrs. Charlton H. Ames, 2001.37

GEORGE COPELAND AULT

United States, 1891–1948

55 **House in Brittany** 1925

Oil on canvas

21 3/4 x 18 1/4 inches

Hamilton Easter Field Art Foundation Collection, Gift of Barn Gallery Associates, Inc., Ogunquit, Maine, 1979.13.1

Throughout his career, George Copeland Ault drew artistic inspiration from the landscapes around him. These ranged from the buildings and bridges of New York City, where he first garnered critical attention; to the rural scenery of Woodstock, New York, where he settled in the 1930s; and to the small villages of the French countryside, where he visited in 1924—the subject of *House in Brittany* and a related drawing (FIG. 18). Ault portrayed these diverse landscapes in the spare, modernist style known as Precisionism, characterized by simplified geometries and flat planes of color. In this tightly compressed, vertically oriented scene of two small houses connected by a path and framed by trees, the architectural features are distilled into hard-edged shapes rendered with minimal shading and smooth brushwork. Ault described the natural elements in a similar manner, although with a greater modulation of hues in the leaves and cloud-filled sky. The red-orange gate in the foreground adds a bright note of color to a limited, low-keyed palette.

The drawing shows a more expansive and less severe view of the scene. The same white house with the chimney and prominent quoins (the stonework on the corners) appears at left, but it is seen from a different vantage point that includes several neighboring structures. Here, Ault defined the key shapes with a thin outline and then modeled forms tonally by rubbing the paper with the side of his pencil. The notable differences in conception of this site between the two different media suggest that the drawing did not function as a preparatory study for *Houses in Brittany*. This approach is consistent with Ault's treatment of drawing as a practice separate from painting.[62]

Born in Cleveland, Ohio, Ault spent much of his youth in London, where his father had a printing ink business. He received academic art training in England and returned with his family to the United States at age twenty. By the 1920s, he was painting the New York skyline and other landscapes in the reductive, geometric style seen in *House in Brittany* and exhibiting his works to favorable reviews. Although his stylistic approach and interest in urban architecture are similar to other Precisionist artists, including Charles Demuth, Charles Sheeler, and Ralston Crawford, Ault's pictures are distinctive for a pervasive mood of melancholy and disquiet. His irascible nature, exacerbated by alcoholism, family tragedies, and financial struggles, led to his increasing withdrawal from the New York art world. In 1937, Ault moved to Woodstock, where he lived the remainder of his life in relative isolation. KAS

FIG. 18
George Copeland Ault (United States, 1891–1948), *In St.-Jean-du-Doigt, Brittany*, 1924, graphite on paper, 10 x 13 7/8 inches. Portland Museum of Art, Maine. Museum purchase with support from the Friends of the Collection, 1997.8

Graphite on paper

19 ⅝ x 16 ¾ inches

Museum purchase with support from the Freddie and Regina Homburger Endowment for Acquisitions, 2013.1

ROBERT LAURENT

United States, born France, 1890–1970

A pioneer of direct carving in American sculpture, the modernist artist Robert Laurent was also a talented draftsman. *Seagulls, Ogunquit, Maine* of 1925 presents two birds in contrasting though complementary poses—one upright, one crouching—and in the abstracted realism that was typical of his style. Reducing forms to simplified shapes, Laurent delineated bold outlines with the point of his pencil and then enhanced these contours with carefully controlled rubbings. This approach creates volume through a range of subtle tonalities, while also incorporating blank areas of the paper support into the design. The birds stand on a platform of stylized waves that evokes a sculpture's base, though a related sculptural work is not known.

Born in Concarneau, France, Laurent came to the attention of the painter, art critic, and patron Hamilton Easter Field at age eleven. Field adopted the boy as a protégé, directing his art education through formal and informal study around Europe. Laurent moved permanently to the United States in 1910, joining his mentor in Brooklyn, New York. During the early decades of the twentieth century, when Field's Brooklyn residence served as a vital center for the development of modernism in America, Laurent was an active partner in this endeavor. Field supported artists by giving them living and working space in his home, access to his personal art collection, exhibition opportunities, and critical advocacy. Marsden Hartley, Yasuo Kuniyoshi, Gaston Lachaise, John Marin, and William and Marguerite Zorach were among the many artists associated with Field's circle (see CATS. 54, 58, 60, 62, and 67). In 1914, Laurent and Field founded the Ogunquit School of Painting and Sculpture, which became a thriving summer artists' colony on the

Maine coast.[63] Laurent continued to summer in Maine for the remainder of his life.

By the end of the 1910s, Laurent had established his reputation as the leading modernist sculptor in America. A staunch advocate of the direct carving method, he depicted figural, botanical, and animal subjects in wood and stone (see CAT. 65). Throughout his career, Laurent exhibited regularly and earned widespread critical acclaim, prestigious commissions, and awards. His direct-carving approach and reductive realist style (evident in *Seagulls*) demonstrate the influence of his early exposure to African art, the primitivizing sculptures of Paul Gauguin and Aristide Maillol, and American vernacular traditions. Like other members of the Field circle, Laurent avidly collected American folk art and antiques. The bold outlines and simplified forms of *Seagulls* evoke nineteenth-century theorem painting, a type of image-making with stencils that was practiced by schoolchildren and other amateur artists (FIG. 19). KAS

FIG. 19

Emma Jane Cady (United States, 1854–1933), *Fruit in Glass Compote*, circa 1895, watercolor, gouache, graphite, and mica flakes on paper, 14 ¾ x 18 ¾ inches. Collection American Folk Art Museum, New York, Gift of Ralph Esmerian, 2013.1.38

CONRAD FELIXMÜLLER

Germany, 1897–1977

57 **Bedrücktsein im Atelier (Depression in the Studio)** 1927

Lithograph on paper

10 ³/₈ x 8 inches

Gift of David and Eva Bradford, 2006.30.5

In this image of an artist in his studio, German print-maker Conrad Felixmüller captured a sense of angst and creative torment through a provocative portrait. In the immediate foreground, the artist confronts the viewer with sorrowful, anguished eyes. His fingers press into his head as wrinkles dance in waves across his brow. By setting the figure so close to the front of the picture plane, Felixmüller suggests that the sitter is trapped in his environment, or perhaps metaphorically imprisoned in the painful depths of his own psyche.

While both the sitter and the easel in the lithograph's middle ground align with the picture plane, the window in the background is angled sharply to the right. This distortion creates a disarming imbalance, encouraging the viewer to question whether the sitter or the structure is off-kilter. The destabilized environment suggests the artist's torment in the creative process, but could be equally applicable to the complicated social conditions of 1920s Germany. In this era, postwar liberalism allowed intellectualism, science, art, and technology to flourish, while reactionary currents of nationalist ideologies and antimodernist principles also gained strength.

Like his compatriot George Grosz (see CAT. 53), Felixmüller was a significant figure in the development of German Expressionism during the first half of the twentieth century. Felixmüller began to study painting in 1912 in his native Dresden, where he also taught himself printmaking. *Depression in the Studio* reveals the artist's adept manipulation of the lithographic process. The lines in the image are crisp and detailed, but he also varied the tonality of the darker spaces in the composition so that visually engaging passages of light and shadow amplify the narrative.

The self-conscious representation of the artist's depression highlights Felixmüller's belief that people needed to respect their feelings. In his view, a better understanding of their emotional selves would allow men and women to recognize the bonds that united them, thus creating a better community. This rhetoric was intimately tied to the artist's social and political concerns for the European proletariat, which he demonstrated in many works published in left-wing journals and by his own membership in the Communist Party. Because of his politics, Felixmüller faced strong denunciations and censorship during the Third Reich and saw some of his works destroyed as "degenerate art." After the fall of Adolf Hitler's regime, Felixmüller enjoyed renewed prominence in his homeland until his death in 1977. AJE

Lithographie C. Felixmüller 27

MARSDEN HARTLEY

United States, 1877–1943

58 **Gattières** 1927
Graphite on paper
18 3/4 x 23 3/8 inches
Gift of Owen W. and Anna H. Wells, 2014.7.1

Throughout his career, Marsden Hartley acknowledged the formative role of Paul Cézanne on his artwork, calling the older artist "a prophet of the new time."[64] Hartley's work often reflects Cézanne's profound influence in both subject matter and style. In this drawing, the small French town of Gattières is seen through the trees from a nearby hill. Recognizable by its distinctive clock tower, the medieval village is located among the Baous hills in the region of Provence-Alpes-Côte d'Azur in southern France. Hartley traveled to the region in 1926 and 1927 and developed a deep connection to the area, commenting that it was "the first spot on earth where I have felt right—in harmony—body, soul, and mind."[65] With a studio rented in Aix-en-Provence, the same town where Paul Cézanne had lived and worked, Hartley embarked on an artistic pilgrimage, visiting the places the Post-Impressionist artist had painted and directly engaging with his style.

In numerous depictions of the French landscape and quaint towns like Gattières, the American used parallel hatching lines to give his compositions a rhythmic quality and to mimic Cézanne's brushstrokes. Sparsely rendered, *Gattières* is a study of geometric structures and faceted forms. Only a few sharp details—a balcony railing, the clock face, a row of architectural columns, and a set of shutters—stand out in the highly schematic drawing. Despite this simplicity, Hartley successfully captured the three-dimensionality of the hilltop town. Graphic lines of varying shades add depth to the trees and background, while vast areas of white paper feature prominently in the scene. The interplay between the page's empty space and Hartley's graphite marks enhances the image's volume. Cézanne's deep impact on Hartley's approach to form continued throughout the artist's career, particularly in later depictions of Mount Katahdin and the Maine landscape.

An eclectic artist, Hartley was one of the first Americans to fully absorb the visual language of European modernism. He developed a highly personalized style that drew from a range of movements, including Cubism, Fauvism, and German Expressionism. In 1909, Hartley appeared in a solo exhibition at Alfred Stieglitz's Gallery 291 in New York, which established him as a leading figure in Stieglitz's modernist circle. The Maine native traveled restlessly for much of his life, his style often evolving from place to place. MRA

PAUL STRAND

United States, 1890–1976

59 Rock, Georgetown, Maine 1927

Gelatin silver print

10 x 8 inches

Museum purchase with support from the
Photography Fund, 2006.15

Rock, Georgetown, Maine is part of Paul Strand's decades-long study of the natural world explored in small snatches of focused detail. Strand, who had a wide-ranging career, is among the best-known photographers of the twentieth century. He first learned photography from social documentarian Lewis Hine in New York around 1907. Strand's early work, such as his portrait of a blind woman, reflects his first mentor's humanitarianism and use of photography to expose social inequality.

In the 1920s, Strand met influential photographer, publisher, and promoter Alfred Stieglitz, and altered his photographic style to embrace so-called "straight photography." By this time, Stieglitz had distanced himself from the painterly Pictorialist style favored by his Photo-Secession co-founder Gertrude Käsebier (see CAT. 50). Instead, Stieglitz advocated for seemingly "pure" photographs, apparently not retouched or manipulated during the development and printing processes. Straight photography elevated artistry with the camera itself in exposure, developing, and printing, rather than using the brush and the hand to alter images as many Pictorialists did.

Stieglitz anointed Strand straight photography's consummate practitioner, dedicating the entire final issue of his publication *Camera Work* to Strand's photographs in 1917. Stieglitz also introduced Strand to modern painting by inviting him into his New York circle, which included the painters Arthur Dove, Marsden Hartley and John Marin (see CATS. 58, 60, and 62). Strand readily absorbed these artists' pared-down mode of rendering everyday objects and landscapes. His series of the late 1920s reflect these artistic influences with closely observed and nearly abstract glimpses of natural forms, rendered in sharp focus with an expansive tonal range.

Strand followed members of Stieglitz's circle to Maine and spent summers in Georgetown in 1925, 1927, and 1928 with his friend, artist Gaston Lachaise. Unlike many artists who naturally gravitated towards the area's dramatic rocky coastlines, Strand turned away from the sea to frame flowers, cobwebs, and slabs of layered rock. *Rock, Georgetown, Maine*, is a tightly cropped image, devoid of any markers of scale, that depicts the varied surface of a sheer rock. Strand's nearly abstract photograph captures quartz veins and water stains across layers of stone. The image condenses the massive scale of New England's geological features and the incremental pace of their creation into a single composition. As curator John Szarkowski observed, "Strand rediscovered the rhythms of the wilderness in microcosm."[5]

Strand's Maine nature studies inspired many photographers, including Paul Caponigro, whose 1959 *Quartz Veins in Granite, Nahant, Massachusetts* takes up a similar subject (FIG. 20). Caponigro's vertically oriented, tightly cropped composition harkens back to Strand's exploration of similar terrain. Like Strand, Caponigro captured the very small and the impossibly large, immersing his viewer in richly toned, precisely focused visions of the natural world. DJG

FIG. 20
Paul Caponigro (United States, born 1932), *Quartz Veins in Granite, Nahant, Massachusetts*, 1959, gelatin silver print, 14 x 11 inches. Portland Museum of Art, Maine. Museum purchase with support from the Friends of the Collection, 2002.43.1

JOHN MARIN

United States, 1870–1953

60 **Boat Fantasy, Deer Isle, Maine, No. 30** 1928

Watercolor and crayon over graphite on paper

18 x 23 1/8 inches

Bequest of Elizabeth B. Noyce, 1996.38.34

John Marin was one of many artists deeply inspired by the coast of Maine. A pioneer of American modernism, Marin began his love affair with Maine in 1914, following a summer visit to West Point on the Phippsburg Peninsula. The next year, the artist purchased an uninhabited island, dubbed "Marin's Island," near Small Point as a spot for sketching. The prolific watercolorist also frequented other seaside towns during his yearly visits, including Cape Split, Stonington, and Deer Isle, the site of numerous works, including *Boat Fantasy, Deer Isle, Maine, No. 30.*

Featuring a two-masted schooner, *Boat Fantasy* depicts a common sight for the residents of Deer Isle, once a thriving trading post. The schooner and the sea, composed of blocky forms, jagged lines, and hasty brushstrokes, reflect the strong influence of French Cubism and express the artist's distinctive, energetic approach to painting. Despite appearing to be a scene in motion, *Boat Fantasy* has a surprisingly stable composition. Bulky crosses, shell-like fans, and diamonds form a decorative border around the boat. The internal frame locks the schooner in place and imposes a sense of spatial order. A common motif in Marin's work, the border in *Boat Fantasy* encroaches unusually far into the composition, giving this image of a commonplace shipping vessel a dreamlike quality. The watercolor's otherworldliness is enhanced by a muted palette of gray and light brown and by the soft,

hazy quality of the artist's brushstrokes, an effect created by lightly blotting the transparent washes of pigment and diluting them with water. A true master of the medium, Marin used a variety of techniques in *Boat Fantasy*, including exploiting the blank page, drawing in black crayon, and allowing his preliminary pencil marks to remain visible. The artist integrated drawing and painting by incorporating graphic marks as central elements of his compositions—a dramatic shift from traditional watercolor practice, which champions the translucency of the medium. He once declared, "Drawing and paint side by side makes for the Splendid."[67]

Like many of his contemporaries, the New Jersey native traveled abroad, spending six years in Europe from 1905 to 1911. Marin's encounters with European avant-garde movements, specifically Cubism, had a profound impact on his work and brought him to the attention of Alfred Stieglitz and his circle of artists, including Arthur Dove, Paul Strand, Georgia O'Keeffe, and Edward Steichen. Though Marin also worked in oil, he is best known and acclaimed for his progressive and imaginative watercolors. Along with his contemporary Charles Burchfield (see CAT. 52), who shared his deep reverence for nature, Marin helped to situate the medium as an important and vibrant part of American modernism. MRA

EDWARD HOPPER

United States, 1882–1967

61 **Pemaquid Light** 1929

Watercolor and graphite on paper

14 x 20 inches

Anonymous gift, 1980.166

The 1920s marked an important transitional moment in the career of realist painter Edward Hopper. After early struggles, he started to earn critical acclaim for his paintings, allowing him to give up the commercial illustration and etching work that had previously sustained him. Hopper also began a more serious engagement with watercolor, establishing his lifelong practice of working in watercolor outdoors during summer sojourns in New England and in oil in his New York studio during the winter months. Between 1926 and 1929, the artist spent several summers in Maine visiting Rockland, Portland, Cape Elizabeth, and Pemaquid, where this watercolor was made. (After 1929, he summered in Cape Cod, Massachusetts.) In Maine, his favorite subjects included some of the state's most iconic structures: the lighthouses that dot its rugged shorelines. Jo (Josephine) Nivison Hopper described her husband's lighthouse pictures as "self-portraits," suggesting an analogy between such structures and Hopper, who was also tall, solitary, and taciturn.[68] *Pemaquid Light* depicts the nineteenth-century lighthouse and its ancillary buildings, located at Pemaquid Point on the Muscongus Bay in the Midcoast region. The Hoppers stopped at this site between June 27 and July 3, 1929, while wending their way up the coast from their base at Cape Elizabeth, south of Portland.

Pemaquid Light showcases the austere stillness, clarity of forms, strong lighting effects, and unusual perspective that are hallmarks of Hopper's mature œuvre. The top of the lighthouse is cropped off and the structure is seen from the back, rather than from a more picturesque vantage point showing it perched high on a surf-battered headland. Always a deliberative artist, Hopper first laid down a light pencil sketch to establish the outlines of the buildings. Broad washes of transparent colors—mostly blues and purples—depict the expansive sky, band of sea, and long shadows on the structures, with green and brown hues for the grassy foreground. He used more controlled strokes for architectural details and the area along the curved face of the lighthouse where sunlight turns into shade. This passage provides a sense of movement in an otherwise static composition, as these expressive strokes suggest the flickering effects of light reflecting off waves. Hopper masterfully exploited the transparency of the medium to allow the bright white of the paper to show through the watercolor, imbuing the scene with the crystalline brilliance of a sunny New England day. Interestingly, *Pemaquid Light* is the only one of his lighthouse pictures to include figures—a notable exception, given Hopper's renown for capturing the sense of alienation and loneliness associated with modern life in America. KAS

MARSDEN HARTLEY

United States, 1877–1943

62 **Kinsman Falls** 1930

Oil on canvas

27 1/8 x 19 inches

Museum purchase with lead gift from an anonymous donor and support from the Friends of the Collection, the Bernstein Acquisition Fund, the Peggy and Harold Osher Acquisition Fund, Museum Board Acquisition Funds, Curatorial Acquisition Fund, Deaccession Funds, and gifts in memory of Dorothy Jensen and in memory of Henry McCorkle, 2000.32

In 1930, Marsden Hartley painted *Kinsman Falls*, a dramatic image of the ruggedness of the American landscape and the sheer force of nature, shortly after returning to the United States from an extended trip to Europe. After his arrival, Hartley suffered from a deep sense of alienation, having spent much of his adult life in Europe. The United States was in the midst of Regionalism, a broad cultural phenomenon that developed in the 1920s and 30s. Spurred by widespread nativism and economic and social upheaval in the wake of World War I, poets, writers, and artists, including Grant Wood and Thomas Hart Benton, turned to rural themes and regional subject matter in search of a distinctly American tradition. Labeled an expatriate and rejected by critics, Hartley sought to rediscover his identity as an American artist and establish himself as "*the* painter from Maine."[69] This quest would occupy the Maine native for his final years.

In June of 1930, Hartley, encouraged by supporters, traveled to Sugar Hill in the Franconia Valley of New Hampshire, hoping to reconnect with his roots and "to get into some really wild places" after the comparative tameness of the European landscape that he experienced.[70] A relentless traveler, Hartley often found visual inspiration and creative renewal in local landscapes from the deserts of New Mexico to the Italian Alps. Although Hartley was apparently disappointed with Sugar Hill, he found solace in difficult hikes through the Lost River region, where he encountered Kinsman Falls.

This waterfall gave Hartley a perfect opportunity to apply his modernist style to the familiar subject of the New England landscape. Bursting with visual energy, *Kinsman Falls* shows how the artist blended many influences to create his unique brand of modernism. While the work's muted tonality and subdued palette of deep greens, purples, and browns may allude to the artist's bleak mental state, the dark outlining of forms reflects the influence of French painter Georges Rouault, best known for his heavy contouring and painting style inspired by German Expressionism. The impact of famed Post-Impressionist Paul Cézanne appears in Hartley's tightly controlled, deliberate layers of paint. The abstract, fragmented forms of rushing water and monumental boulders reveal his interest in the Cubism of Pablo Picasso and Georges Braque. Furthermore, Hartley's heavy paint handling, which adds dimensionality to the canvas, highlights his fascination with the texture of the medium itself. The somber palette and expressive nature of *Kinsman Falls* would become the hallmarks of the artist's later work. MRA

Oil on canvas

30 1/4 x 40 1/4 inches

Hamilton Easter Field Art Foundation
Collection, Gift of Barn Gallery Associates, Inc.,
Ogunquit, Maine, 1979.13.10

STUART DAVIS

United States, 1892–1964

In 1928 at age thirty-five, Stuart Davis, a well-established and highly regarded figure in New York's modernist circles, traveled to Paris for a yearlong stay. He was captivated by the cafés, handsome architecture, and lively art scene in the French capital. He wandered around the city, making sketches and spending time with members of the cultural avant-garde. *New York—Paris No. 2* is one of a series of three paintings, along with drawings and prints, created in the years following his Parisian sojourn. The work shows the culminating effects of Davis' long engagement with European modernism and anticipates the future direction of his art.

New York—Paris No. 2 depicts a hybridized, imaginary cityscape with architectural and other motifs from both cities. These include a poster-covered kiosk with an advertisement for Suze liquor, the El (New York's elevated train line), two different types of street lamps, flags and other signage, and buildings of diverse architectural styles. Signs reading "Hotel de France" and "United States" indicate the dual identity of this painted locale. Davis reduced all of these forms into crisp-edged geometric shapes and lines, rendered in flat planes of bold colors and large passages of white. He also painted a green border around the entire composition. The faceted planes, spatial distortions, and multiple perspectives of *New York—Paris* show Davis' debt to Cubism, a style he had been experimenting with since the 1910s, and particularly to the work of Fernand Léger (see CAT. 66). In developing his unique artistic vocabulary, Davis used Cubist pictorial structure to explore his own ideas about composition. This canvas expresses his principle about the relationship between color and space. According to what he would later call his "color-space theory," a color

appears to advance or recede from the picture plane depending on its juxtaposition to other hues. In this painting, the white façade of the central building, for example, seems to face a different angle than the neighboring structures in red and black. Davis made a preparatory drawing to help him work out the composition (FIG. 21).

After his *New York—Paris* series, Davis turned exclusively to American subjects for inspiration. His time in Paris ultimately convinced him of the cultural dynamism of the United States, with its jazz music, consumer culture, and thriving cities. His late works, which would approach even greater degrees of abstraction while still incorporating recognizable motifs from modern American life, had a profound influence on Abstract Expressionist and Pop artists. KAS

FIG. 21

Stuart Davis (United States, 1892–1964), *Study for New York—Paris No. 2*, circa 1928–31, graphite on paper, 15 x 19 15/16 inches. Portland Museum of Art, Maine. Museum purchase with a gift from Mary-Leigh Call Smart, 1982.183

JOHN STORRS

United States, 1885–1956

64 **Study for Abstract Sculpture**

January 13, 1931

Crayon on paper

14 $\frac{11}{16}$ x 11 $\frac{1}{2}$ inches

Museum purchase with a gift from
William D. Hamill, 1985.191

Modernist sculptor John Storrs' crayon study for an abstract sculpture marks a transitionary moment in his career. During the first decades of the twentieth century, the artist concentrated on public projects, bringing together architectural principles, industrial aesthetics, and sculptural materials. After the American economy crashed in 1929, however, the sculptor found himself without his usual commissions. Instead, he began experimenting with abstract and Surrealist ideas in two-dimensional media. This drawing shows Storrs' efforts to negotiate these varied styles.

In the work, Storrs layered a set of vertical planes with rounded, ornamental components in a composition that recalls architectural structures and ornamentation. The emphasis on the overlapping planarity of the motifs reflects his interest in Cubist ideas and in the two-dimensionality of modernist art. On the sides of the central components, Storrs repeated three groups of pointed decorative designs, which he recycled from the surface treatment of Art Deco sculptures he had created years earlier. At the same time, the inclusion of these motifs anticipates the Surrealist paintings that Storrs executed later in 1931.

The son of an architect, Storrs began his artistic training in his native Chicago before moving to Germany, where he studied with Arthur Bock, a sculptor. Bock introduced Storrs to the concept of *Gesamtkunstwerk*, an aesthetic dictum that championed harmony among the arts. Storrs surely found this vision of a "total work of art" appropriate to his interest in combining geometric forms, architectural motifs, and industrial philosophies. After leaving Bock's studio, Storrs eventually settled in France, where he worked briefly for Auguste Rodin, who also investigated the unity between architecture and sculpture.

During his early years in France, Storrs developed a passion for the nation and its artistic culture. He immersed himself in the Parisian avant-garde and drew influence from European modernism. Storrs eventually married a Frenchwoman, established his home in his adopted country, and even participated in the French Resistance during World War II. Because of a clause in his father's will, however, he continued to spend time in America every year in order to profit from his inheritance. His sculpture shows his engagement with the artistic communities on both sides of the Atlantic. The columnar compositions of his metal and stone sculptures, as well as this drawing, demonstrate his interest in the vertical thrust of America's machine-age skyscrapers, while the linear surface ornamentation confirms his attention to the European taste for Art Deco style. AJE

13-1-31

ROBERT LAURENT

United States, born France, 1890–1970

65 **Reclining Figure** circa 1935–40

Mahogany

28 1/16 x 53 inches

Hamilton Easter Field Art Foundation Collection, Gift of Barn Gallery Associates, Inc., Ogunquit, Maine, 1979.13.46

When Robert Laurent began experimenting with direct carving about 1910, he was one of the first American-based sculptors working in this avant-garde mode.[71] Direct carving, which had grown in prominence in Europe in the decades surrounding 1900, signaled a modernist departure from the conventions of the sculptural process. The established method depended on an artist modeling an initial figure in clay or plaster before a skilled laborer translated the design into marble, stone, or bronze. Direct carvers, however, cut directly into a hard material, claiming full responsibility for the creative origin of the composition and its artisanal craftsmanship. Because of their unmediated connection to the unique pieces of wood or stone, direct carvers prioritized a credo of "truth to materials," which led them to emphasize the physical nature of the object, often highlighting the patterning of wood grains or veins of marble.

In *Reclining Figure*, Laurent demonstrated the intimate relationship between the figure depicted and the wooden surface. Rendered in low relief, the voluptuous woman lies across the width of the mahogany panel. Laurent accentuated the elegant and somewhat abstracted curves of her body through the smoothness and high polish of the wood. He emphasized the wavy pattern of the mahogany grain as it undulates across her body, complementing her rounded forms. Behind her, however, Laurent distinguished the background space with rough, vertical carving marks. The juxtaposition of the surface treatments creates an illusion of depth and reveals Laurent's process. The distinction between the raw and polished surfaces illustrates the artist's core belief that direct carving was a process of liberating the sculptural form from its covering.[72]

In developing his direct carving approach, Laurent drew inspiration from a variety of artistic sources (for more on Laurent's training and influences, see CAT. 56). This work also shows the influence of Laurent's friend Gaston Lachaise, who had inspired the artist to turn his attention to the representation of voluptuous nude women. Artists such as Lachaise, Laurent, and Aristide Maillol often focused on this classical subject in their modernist practices. Though their aesthetics broke significantly from such traditions in sculpture, their return to the iconic genre demonstrates a self-conscious effort to position their creations within the broader trajectory of Western art. AJE

FERNAND LÉGER

France, 1881–1955

66 **Untitled** 1937
Oil on canvas
25 5/8 x 36 7/8 inches
Bequest of Ellen Hunt Harrison, 1996.8.14

In the first decades of the twentieth century, French artist Fernand Léger developed a distinct Cubism that made him one of the most influential painters of the era. Throughout those years, he considered the relationship of technological advances to modern circumstances and environments. Léger frequently investigated the dynamism of the new century and its mechanical potential in energetic compositions, in which figures and urban forms are tightly interlaced across the flat surface of the picture plane. Yet around 1930, the artist critiqued his reliance on industrial sources and announced that he would look to nature to reinvigorate his art.[73]

This untitled painting demonstrates the "new realism" that Léger developed. By realism, he did not intend an image that would illustrate the objects or conditions of nature. Instead, he claimed that by using pure color and expressive form, artists could create compositions that corresponded to the energizing forces of the modern world. In this work, a series of soft-edged, twisting shapes rendered in unmodulated, vibrant colors sometimes evokes real-world objects, including a bunch of grapes or perhaps a flower. Despite these reference points, the painting derives its pictorial force from the relationship between the intermingling shapes of pure color. Stretched across the silver-gray ground, the shapes overlap, but they resist the interlocked patterns and formal tension of the artist's earlier machine-based paintings.

Léger was born in northwestern France in 1881 and came to Paris around the turn of the century to work as an architectural draftsman. Once in the French capital, he took classes with the academic painter Jean-Léon Gérôme and at the Académie Julian, a private art school. His early work shows the influence of the Impressionist movement and of modernist painters such as Paul Cézanne, Pablo Picasso, and Georges Braque. As his style developed and his reputation grew into the 1930s, he made several trips to the United States, where he enjoyed major exhibitions at galleries and the Museum of Modern Art. During these visits, he became friendly with the architects who designed New York's Rockefeller Center, including Wallace Harrison. This relationship, and his belief that large public murals could positively impact the condition of the working classes, led Léger to prepare (but not execute) a mosaic for Radio City Music Hall at Rockefeller Center. Though the PMA's picture is scaled for a domestic interior, it has much in common with the spirit of Léger's designs for that aborted project. AJE

MARGUERITE THOMPSON ZORACH

United States, 1887–1968

In this large canvas, modernist artist Marguerite Thompson Zorach presented an enigmatic juxtaposition of a nude woman seated in a workaday fishing dory. The painting's title alludes to the ancient Roman goddess Diana, associated with the moon, childbirth, and the hunt. Her traditional moon and star symbols appear on the lining of the blue blanket wrapped about the figure. Zorach has recast Diana as a kind of modern bathing beauty, posed with one arm crooked behind her head and legs bent. Here, her realm is the sea, indicated by the stylized, swirling forms of waves in the background, and her "catch" consists of the lobsters, crab, and starfish strewn around the belly of the boat. Combined with this natural bounty, Diana's monumentality and sexualized body turn her into a universal symbol of female fecundity.

Diana of the Sea synthesizes many of Zorach's artistic and personal concerns, including her interests in Greco-Roman mythology and the female figure. Bathers and other nudes had long appeared in her work. For Zorach, the female body functioned as a link to the figurative traditions of Western art and a sign of the freedom and close-to-nature existence of her rustic life in Maine. Like many New York City artists, she and her husband, sculptor William Zorach, and their two children (including daughter Dahlov Ipcar, also an artist; see CAT. 86), spent their summers in the country. In 1923, they purchased a home in Robinhood on Georgetown Island, off the coast of Maine. The sea creatures in *Diana of the Sea*, particularly the iconic lobster, suggest a Maine setting for this contemporary goddess.

67 Diana of the Sea 1940

Oil on canvas

44 x 34 inches

Museum purchase in memory of Tessim Zorach, with support from the Friends of the Collection, the Peggy and Harold Osher Acquisition Fund, Mr. and Mrs. Charlton H. Ames, Mr. and Mrs. Donald Beddie, Mr. and Mrs. Fletcher Brown, Joan B. Burns, Lewis Cabot, Mr. and Mrs. Peter Cardone, Dr. and Mrs. Jerome Collins, Henry and Lucy Donovan, Margaret Early, Mrs. Leslie M. Emerson, Sr., Sally Fowler, Ed and Alberta Gamble, Caroline Glassman, Susan K. Hamill, William D. Hamill, Alison D. Hildreth, Mr. and Mrs. Lawrence Hughes, Mr. and Mrs. Harry Konkel, Mr. and Mrs. Donald Lowry, Mr. and Mrs. Harold Nelson, Nancy Masterton, Dr. and Mrs. Alfred Osher, Harold and Peggy Osher, Frannie Peabody, John B. Pierce, Jr. (LaChaise Foundation), Nelson Rarities, Arlene and Bill Schwind, Charles and Samuella Shain, John and Gale Shonle, Mr. and Mrs. Samuel Z. Smith, Mr. and Mrs. Henry Trimble, Diana J. Washburn, Mrs. Betty Winterhalder, and Katherine and Roger Woodman, 1995.13

When she painted this work, Marguerite Zorach was well established as a pioneering figure in American modernist circles. She first achieved acclaim in the 1910s for her inventive synthesis of the fractured geometries of Cubism with the bold, saturated colors of Fauvism—two avant-garde European styles she had absorbed while studying in Paris from 1908 to 1911. During the 1920s and 1930s, she devoted increasing amounts of time to textile work as a vital part of her creative practice. Throughout her career, Zorach exhibited widely, participated actively in artists' groups, and was highly regarded, although her contributions have long been overshadowed by those of her husband, due in part to gender biases. *Diana of the Sea* characterizes Marguerite Zorach's mature painting style, in which the planar disjunctions of her earlier Cubist mode were softened by a decorative approach to modeling, lyrical outlines, and expressive brushwork. KAS

N. C. (NEWELL CONVERS) WYETH

United States, 1882–1945

Three generations of the Wyeth family—N. C. (Newell Convers), his son Andrew, and his grandson Jamie (James)—constitute one of America's most influential artistic dynasties. With careers spanning the twentieth and twenty-first centuries, the Wyeths have received tremendous popular acclaim, as well as strident criticism, for their works in watercolor, oil on canvas, and tempera.

Widely regarded as the greatest illustrator of his day, N. C. depicted far-flung worlds of medieval Europe and the high seas in his fanciful pictures, but also memorialized New England fishermen in the coastal Maine towns he visited throughout his later life. N. C.'s son Andrew returned continually to the coast's brittle winter landscapes, its understated architecture, and the men and women who inhabited these places. Andrew's paintings were tremendously successful, but attracted vitriol from critics who dismissed his seemingly anachronistic illusionism in the age of Abstract Expressionism. Pegged as the consummate realist, Andrew in fact painted works that picture an unstable, shifting world in styles ranging from tightly controlled tempera to boldly abstract dry-brush technique. Andrew's son Jamie has continued in the tradition of his father and grandfather with watercolors and oils that record the weathered yet sturdy architecture and people of Monhegan Island off Maine's coast.

N. C. Wyeth was born in 1882 in rural Needham, Massachusetts, where he developed an early interest in scenes of outdoor labor. In 1902, he left Massachusetts for Delaware to study with renowned illustrator Howard Pyle. The younger artist quickly earned commissions to illustrate classic titles such as *Treasure Island*, *Kidnapped*, and *Robin Hood*. His forays into fine art often reflected this training as an illustrator, with their vignette-like staging of groups caught in action and observed unawares.

By the 1930s, N. C. was a frequent visitor to Port Clyde and Cushing, Maine, where he encountered the dockworkers and fishermen pictured in his 1943 *Dark Harbor Fishermen* (CAT. 68). N. C. visualized the scene of four small dories, one laden with fish, at a slight remove, as if the viewer were standing on the thin sliver of dock, looking out as one fisherman doles out his catch and gulls look on hungrily. He used a muted palette, punctuated with the bold yellow waders of the central figure to focus the viewer's attention. For all the energy in the man's bent posture, the image, executed in tempera, exudes stillness. Indeed, the waiting dories and seagulls seem to sit above the surface of the unmoving dark water. N. C. painted this scene in two iterations, first in oil and then again in tempera, a mixture of dry pigment, water, and egg yolk applied in thin layers. For an artist who gravitated towards energy and motion, tempera required time and patience and produced subdued compositions such as this one.

ANDREW WYETH

United States, 1917–2009

Andrew Wyeth took up tempera painting and became its most famous modern practitioner. Born in 1917 in Chadds Ford, Pennsylvania, Andrew was the youngest of N.C.'s five children and trained under his father beginning at age sixteen. While N.C. traveled widely, Andrew's lifelong project centered on the topography around his family's homes in Chadds Ford and Cushing, Maine. The New England coast captivated Andrew. As he explained, "A white mussel shell on a gravel bank in Maine is thrilling to me because it's all the sea— the gull that brought it there, the rain, the sun that bleached it there by a stand of spruce woods. . . . There's something very basic about the country there. It has an austere quality—very exciting—the quietness, the freedom."[74] In Maine, Andrew discovered windswept landscapes and native residents, such as farmer Alvaro Olson and his sister Christina, who served as the model for Wyeth's best-known painting, *Christina's World* of 1948 (Museum of Modern Art, New York).

69 **Maine Room** 1991
Watercolor and graphite on paper
28 1/4 x 36 1/4 inches
Bequest of Elizabeth B. Noyce, 1996.38.61

Andrew's *Maine Room* (CAT. 69) pictures an unmade cot in front of a dark hearth. Raking sunlight catches the burnished metal of andirons and throws the shadows of two stuffed birds onto the wall. Devoid of human presence, the scene is nonetheless charged with the specter of an absent inhabitant. The bedsheet cast to the end of the cot; the door left ajar; the box of kindling ready to ignite the fire; even the helmet on the mantel suggest a person recently departed. Andrew's mastery of watercolor combines the measured application of pigment with bold, broad dry-brush gestures to create the shadows that extend across the surface of the image.

ANDREW WYETH

Raven's Grove 1985
Tempera on panel
30 x 26 inches
Gift of Elizabeth B. Noyce, 1991.26

70

Andrew Wyeth's *Raven's Grove* (CAT. 70) similarly conjures phantom figures by depicting the residue of action. The site is a stretch of ground under spindly pine boughs that look like raven's wings. The foreground of the image, littered with the empty shells of the birds' seaside meal, is tilted precipitously towards the viewer. Even given the detail Andrew lavished on the cracked shells of crabs, mussels, and urchins, his unusually low vantage point creates a disorienting composition. He devoted the large central portion of the canvas to the brown expanse of grass between land and sea, a space at the center of the frame composed purely of repeated minuscule brushstrokes. The artist's hallmark precision is on view in the detail of every rock on the stony sliver of beach beyond the grasslands, where bone-like driftwood trunks echo the horizontal pine branches.

At the top of the painting, his hard, defined lines abruptly disappear as the slender bands of hazy ocean and sky dissolve into one another.

The seeming clarity and objective vision of paintings such as *Raven's Grove* were not lost on Andrew's champions or his critics, who exalted his fastidious technique or lambasted it and his choice of subject as "retrogressive, short-sighted, and strangely empty and banal."[75] On closer inspection, the commonly accepted link between the artist's technical rigor and his realism dissolves entirely. In *Raven's Grove*, Andrew stitched multiple vantage points together into a single composition and populated the central expanse of the image with layered abstract markings. The painting supports Andrew's proclamation, "I honestly consider myself an abstractionist."[76]

JAMIE (JAMES) WYETH

United States, born 1946

Jamie Wyeth also finds inspiration in the regions that captivated his father and grandfather. Jamie began his training under his aunt Carolyn Wyeth, also an accomplished painter and teacher. In many ways, his approach owes more to the legacy of his grandfather N.C.'s dynamic oil compositions and expansive palette than to his father's circumscribed tonal range. Like Andrew, however, Jamie is drawn to vacant, windswept scenes and weathered architecture that reflects years of wear, particularly in the homes and landscapes on Monhegan Island. As he has observed, "There's isolation in island life, isolation from each other, a kind of alienation which comes from the environment."[77]

In his 1990 watercolor *Milk of Magnesia* (CAT. 71), Jamie painted a four-paned window, cut into weathered clapboard siding, that frames a teapot, sugar bowl, and two bright blue bottles. As in his father's images, these objects are proxies for the home's absent owners, with the window serving as an apparent entry to the world within. The window, however, shows only an indistinct interior and a glimpse at the parallel aperture on the opposite side of the house. Like so much of his father's work, Jamie's spare composition provides a detailed view of a home and its owners that manages to shelter and obscure the inner life of its inhabitants. DJG

71 **Milk of Magnesia** 1990
Gouache and watercolor on paper
22 3/4 x 28 3/4 inches
Bequest of Elizabeth B. Noyce, 1996.38.62

ALEXANDER CALDER

United States, 1898–1976

72 **Snow Flurry III** 1948

Painted metal and wire

53 x 90 inches

Anonymous gift, 1990.31

Snow Flurry III, composed of thirty-two sheet metal discs painted in winter white, is one of Alexander Calder's famed sculptural mobiles. The constellation of "flurries" gracefully hovers and moves with the subtle air currents as viewers walk around the mobile. Depending on the direction of the light, the mobile also projects shadows onto the nearby walls. Calder used light and theatricality as integral components of his three-dimensional constructions. As he was also fascinated with movement, he created mobiles to incorporate into modern dance performances.

During the 1920s, Calder began creating *Cirque Calder*, built from wire, wood, rubber, and other tactile materials. Artistic aptitude was part of his family tradition, since his father and grandfather were prominent sculptors. As a recent engineering graduate, the artist had the technical knowledge to create objects that were mechanically complex and compositionally balanced. Calder intended some of his sculptures to move, either on their own, prompted by airflow, or with the assistance of built-in motors. The introduction of motion into sculpture marked a groundbreaking shift in the history of art, opening up many possibilities for the definition of sculpture and the forms that it could take. In 1931, Dada artist Marcel Duchamp coined the term "mobiles" for his

friend's structures. The word soon became a generic name for all free-floating contraptions that hang from the ceiling with pendants that dance in air currents. By contrast, Calder's ground-based sculptures were called "stabiles." During his career, the artist created more than two thousand mobiles, including ten *Snow Flurry* mobiles, which are now in museum collections throughout the world.

Although his works are abstract, they often possess titles reflecting real-world objects, creatures, or natural phenomena. Calder and his contemporaries, such as Piet Mondrian and Joan Miró, experimented with geometric forms and the dynamic intersections between the abstract and the figurative.

Refusing to limit himself to a single medium, Calder made sculpture, paintings, jewelry, theater sets, and drawings. Throughout his prolific career, he designed monumental sculptures that appear in major cities across the world, many coated in a saturated hue of "Calder red." Though the artist traveled extensively worldwide, he maintained a studio in Roxbury, Connecticut, for much of his life. AHE

ROCKWELL KENT

United States, 1882–1971

73 Wreck of the D. T. Sheridan

circa 1949–53

Oil on canvas

27 3/8 x 43 7/8 inches

Bequest of Elizabeth B. Noyce, 1996.38.25

A man of versatile talents, Rockwell Kent—painter, printmaker, writer, illustrator, architect, and political activist—was one of the most famous American artists of the first half of the twentieth century. Throughout his long career, his restless and adventurous spirit took him to far-flung locales including Newfoundland, Greenland, Alaska, Tierra del Fuego, and elsewhere. Monhegan Island, off the coast of Maine, was one of the first of these dramatic, remote landscapes to inspire Kent's painting. He initially became enthralled with Monhegan's rugged beauty and close-knit fishing community during extended stays from 1905 to 1910 and in 1917. Wanderlust took him further afield in subsequent decades, but he returned to the island again between 1949 and 1953. *Wreck of the D. T. Sheridan* was painted during this later encounter.

In this stunning example of his mature work, Kent depicted the hulking wreck of a tugboat beached along the rocky shore of Lobster Cove on the southern tip of Monhegan. The *D. T. Sheridan* had run aground in a storm in November 1948 (its scattered ruins are still visible to this day). Although there were no human casualties, the subject allowed Kent to meditate on one of his favorite themes: the relationship between humankind and the powerful forces of nature. Here, he distilled the vista into its essential elements: a jumble of rocks in the foreground, the elliptical form of the boat's hull, a band of white-capped ocean, and a wide expanse of sky, all rendered in the crisp-edged, simplified realism that characterized his style. A few waves and a small flock of seagulls animate the picture, while also endowing the scene with a melancholic sense of timelessness as the human tragedy is subsumed into the rhythms of nature.

From Maine to the Arctic, Kent was always drawn to the effects of northern light. In *Wreck of the D. T. Sheridan*, he devoted half of the composition to the sky, capturing its crystalline clarity with horizontal striations of lurid colors ranging from yellow to cobalt blue. He found the dramatic light on Monhegan particularly striking, noting: "The fairest, clearest, sharpest days I loved the most . . . when the windblown ocean plain stretched dark as indigo to a horizon knife-sharp against the golden lower sky; when the sky from gold became by imperceptible gradations emerald, and the emerald became cobalt; and the cobalt, a deep purple at the zenith."[78] KAS

LOIS DODD

United States, born 1927

74 **Brook** 1961

Oil on canvas

72 x 76 inches

Museum purchase with support from the Peggy and Harold Osher Acquisition Fund and the Bernstein Acquisition Fund, 2013.7

When Lois Dodd began her college education at the Cooper Union School of Art in New York, she intended to become a textile designer, a profession with the appealing promise of steady work. Yet she quickly fell in with a group of painters and, through them, began painting. Dodd became a painter during a period when New York School abstraction was in its heyday, holding great allure for young artists. In the summer of 1951, she joined her friends, fellow artists Alex Katz (see CATS. 78–80), Jean Cohen, and Bill King, in Lincolnville, Maine. Her encounter with the Maine landscape—particularly its everyday sights, such as livestock grazing on open pasturelands—gave her painting practice its future subject matter. She is known for her elegantly rendered domestic interiors, views from her window, and images of the Maine woods, often painted *en plein air*, or outdoors. During the late 1950s and early 1960s, however, when she painted *Brook*, she sketched in the fields in and around Lincolnville in the summer, then brought her sketches back to New York City as references for the oil paintings she created throughout the fall and winter.

Brook, one of Dodd's very few early large-scale paintings, captures the freshness of her direct encounter with nature, while showing the influence of midcentury New York abstraction. The painting balances areas of flat color—muted green, white, and brown hues—with descriptive, energetic lines that seem to outline a tree or register a rock-like shape, without adding any suggestion of weight. The elements of the natural landscape hover, as though all of its elements are assembled in one place, yet somehow, magically, are not subject to the laws of gravity. In its balance between pure form and reference to the outside world, *Brook* recalls the paintings of Willem de Kooning, whose time spent on eastern Long Island also had a profound effect on his art.

Although de Kooning was a generation older than Dodd and her peers, his work and presence in the downtown art scene were crucial to their development, bringing fame and authority to a small community of much younger artists. In 1952, Dodd cofounded Tanager Gallery, the first of a wave of artist-run galleries, with fellow artists King, Charles Cajori, Angelo Ippolito, and Fred Mitchell. She spent much of the following decade making studio visits with other artists and doing the everyday work of running the gallery. By 1962, when the gallery closed, her own paintings had shifted towards representing the natural world with clarity and crispness. The moment of ambiguity between representation and abstraction was gone. JM

ROBERT INDIANA

United States, born 1928

75 **4-Star Love** 1961

Oil on canvas

12 x 11 1/8 inches

Gift of Todd R. Brassner in memory
of Doug Rosen, 1999.7

Monochromatic and highly graphic, *4-Star Love* was Robert Indiana's first painting to incorporate the word *LOVE*, anticipating his most recognizable and beloved motif. Divided into two registers, this work depicts the word *LOVE* below four stacked stars, an arrangement that became the inspiration for the letters' later configuration into Indiana's iconic sculpture. According to the artist, his fascination with the word began when he was a child growing up in the Christian Scientist church. The word was often emblazoned on the otherwise sparsely decorated walls of the sect's churches as a reminder of God's divine love.[79]

Here, the juxtaposition of the four stars with the word *LOVE* may suggest a qualitative ranking system for love, similar to tourist ratings of hotels or restaurants.[80] The stars could also be interpreted as autobiographical references, emblems of America, and allusions to fame. Regardless of the specific meaning, symbolism plays a significant role in *4-Star Love* and in Indiana's œuvre. In addition to acting as symbols, the stars and the letters serve as formal elements in the painting. Indiana often incorporates shapes, numbers, and short words like *EAT*, *HUG*, and *DIE* into his compositions. In his simple, iconic images, words and numbers are not just components of language or signifiers of meaning, but visual forms that can be appreciated for their pictorial qualities (see CAT. 88).

The bold, minimal presentation of the forms in *4-Star Love* recalls the influence of the hard-edge, geometric abstractions of Ellsworth Kelly. Indiana's delicate, smooth paint handling and the stenciled look of the letters give the work a mass-produced quality that highlights the artist's place within the second wave of Pop art. By masking his own hand, Indiana rejected traditional notions of the artist's involvement, a central feature of New York School abstraction. As an artist whose work is highly personal, however, his touch is seen in the word *LOVE*. The irregular appearance of the letters suggests that he did not stencil the word, but instead meticulously drew it onto the canvas.

Born Robert Clark, the self-proclaimed "American painter of signs" rose to prominence as a Pop artist after moving to New York City in 1954.[81] He began experimenting with the word *LOVE* several years later, stacking letters into the now-famous configuration in the mid-1960s. Indiana's *LOVE* motif became a powerful symbol of that tumultuous decade, visually representing the counterculture slogan, "make love, not war." Since 1978, Indiana has lived and worked in Vinalhaven, Maine. MRA

FAIRFIELD PORTER

United States, 1907–1975

76 Harbor at Great Spruce Head Island 1961

Oil on canvas

30 1/16 x 24 inches

Bequest of Anne I. Carroll, 1999.25

In contrast to many of his contemporaries who experimented with more abstract and painterly forms of expression, Fairfield Porter, the brother of photographer Eliot Porter (see CAT. 87), emphasized realism and recognizable subject matter. His paintings often depict his most immediate surroundings and intimate scenes from daily life, including his family and house on Great Spruce Head Island. The artist grew up summering on the island, located in Penobscot Bay off the Maine coast. His father, an architect and amateur naturalist, purchased the island in 1912 and built several homes, including the "Big House" featured in many of Porter's paintings. Childhood experiences in Maine contributed to Porter's lifelong and deep appreciation for nature.[82] As an adult, the artist returned annually to Great Spruce Head Island during the summer to paint.

Harbor at Great Spruce Head Island portrays a tranquil scene of the island's harbor. In an image of a peaceful summer day, four different pristine white boats float in the crystalline water just off the shore-line, framed by a sandy beach and the tree-lined coast. The minimal use of shadow, lack of shading, and the vista's warm, pink tonality give the impression of a scene lit by the bright midday sun, enhancing the painting's naturalism and demonstrating Porter's interest in the effects of light. A great colorist, Porter composed *Harbor at Great Spruce Head Island* using broad, directly applied swaths of pure color, which emphasize the expansive planes of land, sea, and water and the canvas' flatness. A pop of orange on the fishing boat and touches of yellow among the island's foliage, in an otherwise muted palette, reveal an attention to color harmonies.

Though Porter mainly worked in a descriptive mode, he was highly knowledgeable about contemporary modes of abstraction. A prolific and talented art critic, he wrote on the New York School of abstraction and a wide range of other art for *ARTnews*, *Art in America*, and *The Nation*. His leftist politics placed him in direct contact with New York's most progressive literary figures and artists, such as his close friend and mentor Willem de Kooning. Despite this entrenchment in the New York School circle, Porter developed a unique style of figurative work. His descriptive canvases and direct, naturalistic aesthetic inspired and paved the way for the next generation of twentieth-century painters who were returning to representation in the postwar period, including Lois Dodd and Alex Katz (see CATS. 74 and 78–80). MRA

WILL BARNET

United States, 1911–2012

77 **Enclosure** 1963

Woodcut on paper

28 x 23 inches

Bruce Brown Print Collection, Portland, Maine, gift in honor of Susan Danly, Retired PMA Senior Curator, 2014.29

Throughout his long and acclaimed career, painter, printmaker, and teacher Will Barnet adopted varying degrees of figuration and abstraction in his art. During a period of deep engagement with abstraction from the late 1940s to the early 1960s, he was an active member of American Abstract Artists and was also affiliated with the Indian Space Painters, a group that used symbolic forms reminiscent of Native American pictographs to express elemental forces. "All nature is space," he wrote, "both what we see as solids and what we see as air."[83] Linked to a series of works inspired by the landscape and cloud-filled sky over eastern Washington, where Barnet taught in 1963, *Enclosure* distills such natural forms and energies, while also strongly evoking the animal pictographs on Northwest Coast Native totem poles, masks, and other objects. The woodcut contains a blue spiral within a womb-like shape, bulging and thinning as it winds toward the center of the composition. A slender gray wedge and a fat crescent kiss opposite edges of this swirling form, while a rectangular field of ochre frames the arrangement. The artist signed the museum's unique first state impression on two sides, indicating that it could be displayed either horizontally or vertically.[84]

Trained at the School of the Museum of Fine Arts, Boston, and the Art Students League of New York, Barnet had early exposure to modernist innovations. While working as a graphic artist for the Federal Art Project of the Works Progress Administration (WPA) during the Great Depression, he made prints influenced by the realism of nineteenth-century French artist Honoré Daumier. Barnet abandoned naturalistic representation in subsequent decades. Even during his exploration of pure abstraction, however, he believed that following classical principles of order, harmony, and stability was the antidote to the teeming emotionalism of Abstract Expressionism and the alienating effect of most abstract art. In the 1960s, Barnet began to refer to human subjects again in his art, this time represented with abstracted forms and geometric simplification. The likely source for *Enclosure* is a sketch of Barnet's wife, Elena, and their daughter, Ona, which informed the figurative painting *Mother and Child* of 1961 (private collection). In the drawing, encircled in the shape created by her mother's arm and lap, Ona is reduced to the same centripetal form that defines *Enclosure*.[85] Forty years later, in 2003, Barnet revisited this essential, eloquent form in an oil painting of the same name.[86] HWB

Enclosure 1963

Will Barnet

ALEX KATZ

United States, born 1927

78 **Ada and Neil, Maine (Study for *Lawn Party*)** 1965

Oil on board

24 1/2 x 32 inches

Museum purchase with support from the Freddie and Regina Homburger Endowment for Acquisitions, the Friends of the Collection, and the Harold P. and Mildred A. Nelson Art Purchase Endowment Fund, 2013.19

The Portland Museum of Art's collection of Alex Katz's work spans the painter's seven-decade career, offering glimpses of his multistage drawing, printmaking, and painting process. Collectively, the PMA's collections suggest the contours of Katz's career, from his earliest small-scale easel paintings to major figure-in-landscape paintings of the early twenty-first century. They also reveal the primary motifs and methods of an artist who is generally regarded as the finest figurative painter in postwar America.

Katz's experiences in the state of Maine have been definitive for the artist. He first came to Maine in the summer of 1949. While he was a student at the Cooper Union School of Art in New York, he enrolled in the summer program at the recently founded Skowhegan School of Painting and Sculpture in central Maine in both 1949 and 1950. There, he took classes with one of the school's founders, the traditionalist painter Henry Varnum Poor, who pushed the urbane, modernist Katz to paint from nature. The experience of what Katz has since called "the Maine light," as well as the physical, sensual experience of taking his painting materials out into the rural landscape of Skowhegan, had a profound influence on the young artist. He has written, "At Skowhegan I tried *plein air* painting and found my subject matter and a reason to devote my life to painting."[87]

Katz and a small group of friends eventually purchased a farmhouse in Lincolnville, Maine, where the artist and his wife, Ada Katz, still spend their summers. The yellow house and surrounding property appear frequently in paintings made throughout his career.

Katz's paintings often show the community of friends—artists, dealers, collectors, and critics—who live and work in Maine and New York City. In *Ada and Neil, Maine (Study for "Lawn Party")*, painted in the summer of 1965, Katz depicted fellow painter Neil Welliver talking to Ada (CAT. 78). In this summertime plein air study for one of Katz's first major large-scale paintings, *Lawn Party* of 1965 (FIG. 22), every inch of the board seems to vibrate, a result of the artist's bright palette and loose paint handling. Yet the vivid painting reinforces the sense of a specific occasion, as the pair experiences a moment of intimacy on the farmhouse lawn. In the final version, Katz preserved the two figures at the center of the canvas, but they are surrounded by others, like still points in a revolving social environment.

FIG. 22
Alex Katz (United States, born 1927), *Lawn Party*, 1965, oil on canvas, 108 x 144 inches. The Museum of Modern Art, New York, Fractional and promised gift of the Ovitz Family Collection, 320.2004

ALEX KATZ

79 **Vincent with Jacket** 1976

Graphite on paper

21 $^{15}/_{16}$ x 14 $^{13}/_{16}$ inches

Museum purchase with matching grants
from the National Endowment for the Arts
and Casco Bank and Trust Company, 1981.99

Katz spent the summer preparing for *Lawn Party*, and *Ada and Neil* is among the most important of the preparatory oil sketches he made. Yet his planning for the multi-figure composition extended back to the previous winter, when he traveled to Europe for the first time. There, he looked intently at historic European paintings, especially the works of eighteenth-century French artist Jean-Antoine Watteau, to learn how to produce a multi-figure composition in which all the figures were connected loosely, like planets orbiting the sun. Art historian and critic Simon Schama has reflected on the relationship between improvisation and planning in Katz's landscape paintings, writing:

> Much of this amazing formal organization happens in the original conception of the work, between the observation and its translation into paint. Katz remains famous for both the intensely painstaking quality of his preparation, and the dazzling, almost impulsive quality of the painting itself, which he himself compares to musical performance: concentrated virtuosity after lengthy and unsparing rehearsal.[88]

The Katzes' son Vincent was a small child in the summer of 1965. During that decade, Katz occasionally included him in paintings of Ada or in multi-figure works. In the 1970s, Katz depicted his son more often, especially in prints and drawings. The PMA's 1976 graphite drawing, *Vincent with Jacket* (CAT. 79), shows him at sixteen, with long, loose hair that falls to his shoulders and an open, slightly oversized shirt and jacket. In preparation for finished paintings, Katz often makes sketches in oil or graphite. He then translates them into larger charcoal drawings, called cartoons, which he punctures with a tool called a pouncing wheel in order to transfer the outlines onto canvas. This drawing, however, does not appear to be a preamble to a painting. Instead, it is one of many images that Katz made of his son, apparently from life, during Vincent's late childhood and teenage years. These pictures suggest recurrent yet fleeting moments of interaction between a father and son. In this featherlight drawing, Katz outlined Vincent's eyes and eyebrows more darkly than his tufts of hair, which are so delicately rendered that they appear ethereal, ready to lift off the page.

ALEX KATZ

October 2002

Oil on canvas

146 x 109 inches

Promised gift of Alex Katz, 2.2010

Landscapes have become increasingly important subjects over the course of Katz's long and productive career. In his landscapes and floral images, the artist has long favored contingency, rendering the specific experience of one's perception at a single moment in time, rather than faithfully describing the contours of the land or the enduring image of the natural environment. Many of his landscapes are unrecognizable as specific places, yet the moonlight on the lake near his studio, the trees framed against a darkening sky, or the irregularity of flowers in bloom feel uncannily true to our experiences of nature. Katz's astonishing crashing waves in *October* (CAT. 80) give form to the look of a wave breaking at the shoreline on a gray day. Although crashing waves are staples of Maine painting, immediately bringing Winslow Homer's *Weatherbeaten* to mind (see CAT. 23), *October* is not a "Maine painting." Katz made the painting in Ostend, Belgium, as a commission for the Provinciaal Museum voor Moderne Kunst (PMMK), a modern art museum, and their 2002 Triennial for Contemporary Art by the Sea. Katz has not painted shorelines often and has remarked privately that water is an exceptionally difficult subject.[89] Yet the perceptual accuracy of *October*, which conveys the power of the breaking wave as well as its sound and cool temperature, contrasts with the improvisational quality of the paint, hinting at the decades Katz has spent watching waves crash against the Maine coastline. To return to Simon Schama's analogy between Katz's technique and musical performance, the painting suggests complete immediacy and spontaneity, yet paradoxically the artist achieved the "all-at-once" look of a moment through decades of focused observation and preparation. JM

NEIL WELLIVER

United States, 1929–2005

81 **Two Boys in a Canoe** 1966–69

Oil on canvas

80 x 83 3/8 inches

Gift of John and Annmarie Walsh, 1995.58

Neil Welliver was one of Maine's most acclaimed contemporary landscape painters. Along with his friends and fellow artists Lois Dodd and Alex Katz (see CATS. 74 and 78–80), Welliver helped to revive postwar figurative painting in the United States. Welliver first came to Maine at Katz's urging and eventually bought land in Lincolnville in the 1950s. Unlike Katz, Welliver distanced himself from the New York art world, electing to focus on local subjects. He produced oil sketches of the landscape around his home *en plein air*, or outdoors, year-round. Welliver tromped across his acreage, observing the swampy, thicketed woods and marshlands. Once back in his studio, he translated his small studies into large cartoon outlines that he then enlarged and applied to massive canvases.

Much of Welliver's later work visualizes dense woods in saturated tones, but many of the artist's early images, such as this painting of two young boys in a canoe on a still lake, feature figures within a landscape. Welliver often painted his family, in this case two of his four sons. The older, bare-chested figure in the front of the boat holds his oar across his lap while the younger boatman in the bow, dressed in a collared shirt, holds no oar at all, leaving the two adrift and motionless on the glassy water. The artist enveloped the boys in dark, encroaching foliage rendered in large, loose brushstrokes.

Welliver's painting blurs boundaries between solid and liquid and object and reflection. The rocks behind the canoe, for instance, emerge from the water, yet also appear to plumb the lake's depths like glaciers. The two boys and their boat sit atop the water, but also blend into their own reflections in a massive plume of green at the center of the work. The indistinct divisions between the corporeal and the illusory destabilize the image's presumed depth.

Critics have long celebrated Welliver's landscapes as the successors to the American Hudson River School and painters such as Frederic Edwin Church (see CAT. 43), who portrayed northeastern landscapes as majestic and monumental. Yet throughout his career, the artist consistently stated his allegiance to the Abstract Expressionists and their embrace of gesture and pure surface. Welliver's canvases are marvelously suspended somewhere in between, constantly requiring the viewer to navigate back and forth between perspectival space and the visible brushstrokes on the canvas' surface. As he described in 1985, "The whole painting process is a war between the two elements of image and surface. And that war is absolutely central to the painting."[90]

Welliver's images are carefully observed meditations on natural places well known to the artist from a lifetime of observation. Like fellow painter Andrew Wyeth (see CATS. 69–70), however, Welliver has never been entirely bound by the rules of perspectival space. Rather, his enormous paintings envision a world at once carefully recorded and fancifully imagined, a space expertly suspended between surface and depth. DJG

SIR ANTHONY CARO

England, 1924–2013

82 **Moment** 1971

Varnished steel

53 x 104 x 78 inches

Gift of Guido Goldman in honor of
Leonard and Merle Nelson, 2012.12.1

British sculptor Sir Anthony Caro created *Moment* following a summer in Bennington, Vermont. There, Caro had worked in the company of America's leading modernist artists at a time when he and his peers were thinking critically about the role of materiality and illusion in art. With *Moment*, Caro embraced the spirit of that high modernism, asserting the importance of compositional balance, material purity, and the experience of viewing.

Composed of industrial steel, specifically I-beams and H-beams, *Moment* sits low to the ground. Its harmoniously abstract metal composition seems to expand both vertically and horizontally, denying a single viewpoint. Instead, the viewer is encouraged to walk around the entire piece, considering it from all angles. The work offers an alternative to the long-standing conventions of public sculpture, in which the display of famous people on high plinths was meant to edify the public. *Moment*'s abstract form negates any didactic possibilities, and its industrial components insist on its material presence. As a result, the viewer contends with the sculpture as a work of art and as a physical object that shares his or her space.

Caro applied a flat varnish to the steel beams and organized an elegant composition that unifies the individual components, but he did not hide their material nature. The only illusionistic quality of the sculpture is its deceptive lightness, as the steel parts appear to balance in a way that denies their weight. According to the influential modernist critic Michael Fried, Caro's work maintains a sense of purity. The juxtaposition of the beams and the "syntax" of the arrangement marginalize the sculpture's "objecthood," instead prioritizing its artistic dimension.[91]

Moment signals Caro's increasing interest in new approaches to art-making during the second half of the twentieth century. He had trained at the Royal Academy Schools in London in his youth before apprenticing with his countryman, sculptor Henry Moore. In the late 1950s, Caro was increasingly interested in the New York School of American painting and in the criticism of Clement Greenberg. His conversations with Greenberg proved influential as Caro developed his mature style. Greenberg's counsel led the artist to work in a "constructed" process. He made his sculptures by combining industrial components, instead of modeling, molding, or carving as in traditional practice. Throughout his nearly seventy-year career, Caro experimented with form and color and explored the importance of scale in sculpture. In working through these innovations, he was a consistent force in the development of modernist art. AJE

LOUISE NEVELSON

United States, born Russia, 1900–1988

83 **Untitled** circa 1975–76

Painted wood

62 x 38 x 8 inches

Museum purchase with support from the Friends of the Collection, the Bernstein Acquisition Fund, the Peggy and Harold Osher Acquisition Fund, the David Rockefeller Fund, and individual gifts from Mr. and Mrs. Charlton H. Ames, Joan B. Burns, Mr. and Mrs. Peter W. Cox, Judith and Albert Glickman, Susan K. Hamill, William D. Hamill, Mr. and Mrs. Harry W. Konkel, Claude P. Maher, Henry and Joanna McCorkle, Leonard and Merle Nelson, Mr. and Mrs. Peter L. Sheldon, John and Gale Shonle, and an anonymous donor, 1996.29

Untitled is a three-dimensional collage of wood scraps arranged and glued together in a box-like composition. Louise Nevelson did not create drawings or plans for her sculptures, but rather assembled them intuitively after collecting discarded items from dumpsters and scrapyards.[92] Characteristic of Nevelson's signature work, *Untitled* is composed of raw lumber, wooden disks, and furniture pieces, all covered in mysterious jet-black paint. Her sculptures often incorporate pieces of diverse wooden household objects, such as baseball bats, instruments, kitchen tools, rifles, and decorative molding. This eclecticism piques the curiosity of viewers and encourages them to identify the components. Assemblage, or using found objects to build a work of art, was a new concept in the twentieth century. Nevelson and her fellow assemblage artists, including Joseph Cornell and Robert Rauschenberg, developed innovative ways to include ordinary items in their work.

Nevelson's family emigrated from Russia to Rockland, Maine, in 1905. Her father worked in the lumber industry, which inspired her interest in wood as a material for her artistic practice. At a young age, she decided that she would become a sculptor. In 1918, she moved to New York City, where she took classes and attended exhibitions. She studied with Hans Hofmann at his school of modern art in Munich in the 1930s, where she was introduced to modern abstraction and Cubism. During this formative decade, she also worked in the circle of Diego Rivera,

Frida Kahlo, and Max Weber in New York City. Early in her career, she created figure studies in bronze, terracotta, and wood before moving on to abstraction. In contrast to the austere feel of her work, Nevelson cultivated a persona of opulence, femininity, and extravagance throughout her life.

In 1941, Nevelson earned her first solo exhibition of wood assemblages. She developed her signature black sculptures during the 1950s. One of the defining moments in Nevelson's career was her inclusion in the Museum of Modern Art's watershed *Sixteen Americans* exhibition in 1959. By the time she made *Untitled* in the 1970s, she had honed her recognizable, distinct aesthetic. Though black was her trademark color, she also created works covered in washes of white and gold. The artist transformed her sculptures built of discarded scraps into cohesive artworks as she unified them with coats of paint, a process that she equated to alchemy.[93] AHE

JASPER JOHNS

United States, born 1930

84 **Corpse and Mirror** 1976

Lithograph on paper

30 ⅞ x 39 ⅝ inches

Bequest of Dr. Bruce Eugene Evans, 1989.40.1

Jasper Johns is a pivotal figure in twentieth-century American art whose work bridges Abstract Expressionism and Pop art. His paintings of targets, numbers, and the American flag are emblematic of a lifelong project to capture high and low, surface and depth, abstraction and figuration. Johns' work as a printmaker is less well known, but the medium is fundamental to his Pop-inflected experimentation with the original, the copy, and the multiple.

Johns' 1976 *Corpse and Mirror* belongs to a group of prints and canvases of the same name that the artist produced between 1972 and 1983. The artist claimed that he discovered the motif of parallel lines in a fleeting glimpse of passing car. The attraction was instantaneous: "It had all the qualities that interest me," he remarked, "literalness, repetition, an obsessive quality, order with dumbness and the possibility of complete lack of meaning."[94]

In his *Corpse and Mirror* works, Johns used white on black, black on white, and multicolored markings in both paint and ink to build up patterns divided into units that replicate and reflect across a field. The title *Corpse* alludes to the bonelike appearance of parallel lines, while *Mirror* explains Johns' repetition of patterns throughout the compositions. The title also suggests the Surrealist game *cadavre exquis* (exquisite corpse), in which players draw a portion of a figure without viewing each other's contributions, thus creating a single image of conjoined but disparate parts.

Johns produced his 1976 *Corpse and Mirror* lithograph print at Universal Limited Art Editions with Tatyana Grosman, one of his frequent collaborators. Using white ink on black paper, Johns divided the composition into six quadrants that appear as mirror images reflected across a central vertical axis. Johns' reworking of the *Corpse and Mirror* subject in lithography references the cross-hatching marks that printmakers have relied on for centuries to render shadow and create the illusion of depth. In Johns' hands, however, the lines appear grossly enlarged, making their function as indicators of depth or shadow obsolete.

While the two halves of the lithograph initially appear as faithful reflections, Johns created discrepancies that exaggerate subtle variations across the six rectangular portions of the composition. Additionally, the quality of the impression varies among each of the six quadrants, leaving some portions starkly white and others as more transparent ghostly impressions. Johns further disrupted the replicated image by inserting a hand-drawn *X* and a circle outlined in black into two sections at the right of the print. He also retained areas of imperfect print registration, in which sections appear slightly misaligned with gaps or overlaps. For the viewer, these disjunctions upend assumptions about printing as an exact replication process. The variations also suggest the uncanny experience of looking at a mirror and finding a reflection that is familiar, yet eerily detached from the self-image one expected to see. DJG

BERNARD LANGLAIS

United States, 1921–1977

85 **Untitled** 1977

Paint, wood, and metal

Dimensions variable

Gift of Builders Investment Group, 1985.91

In 1974, Bernard Langlais was commissioned to create an outdoor sculpture and fountain for the entrance to the new Treadway Samoset Resort in Rockport, Maine. Like the original hotel buildings, the work incorporated repurposed wood from a Portland grain mill. As an acclaimed local artist and an enthusiast of working with old lumber, Langlais was an obvious choice for the project. In the late 1950s, after nearly a decade of painting in Europe and New York City, he abandoned the medium to work exclusively in wood. His first experiments were abstract reliefs that earned him success in contemporary art circles. Eager for more working space, easy access to materials, and a deeper connection to his roots, Langlais left New York permanently for his native state of Maine in 1966. With this move, he embraced figurative subjects, particularly animals, and a back-to-the-land work ethic that drove him to build outdoors on a large scale. By the time of the Samoset commission, he had created an art environment on his land in nearby Cushing (reopened as the Langlais Sculpture Preserve in 2015).

Consistent with other works from his last years, the Samoset fountain is an homage to the local, to the wildlife denizens of the Maine coast, and to the natural and architectural forms familiar to a seaside community. In its original configuration, which followed his model (FIG. 23), the sculpture consisted of a support structure of wooden beams inhabited by carved and painted maritime creatures, including several kinds of birds (a puffin, seagulls, and sandpipers) and fish. Measuring different heights and clustered together like pier pilings, the beams provided a strong upward momentum with a profile resembling a ship's mast or a stylized wave crashing against the shore. At the apex was a large figure resembling local celebrity Andre the Seal, spotted, bewhiskered, and rendered with childlike simplicity.[95]

Langlais' sculpture became a storied subject of controversy in Maine in subsequent decades. In 1979, new management at the Samoset deemed the work out of place with a re-landscaping scheme. They disassembled the sculpture and attempted to sell it, first quietly and then under a firestorm of press that could be characterized by one headline: "The Chain Saw Massacre."[96] The hotel management temporarily installed several of the figurative components around the grounds, though one intrepid photographer discovered parts of the sculpture on the hotel's cordwood pile. Artist Louise Nevelson (see CAT. 83) cancelled a planned stay at the hotel in protest, garnering added media attention. Langlais' whimsical creation seemed fated to be cut down and dispersed.

If Langlais had lived a few more years, he might have made light of the Samoset's gaffe, as he often accepted man-made or natural changes to his works with amusement. The artist's widow, Helen Friend Langlais, however, was devastated by the incident. She felt that the work could no longer be attributed to Langlais, although she later acknowledged that restoration was possible.[97] In a 1979 assessment, the Portland Museum of Art found all the pieces intact except for several interior beams. The museum began discussions with Helen and the Samoset's parent company about the sculpture's ultimate fate, and all parties agreed that the best solution was to have the resort donate the work to the museum. The sculpture

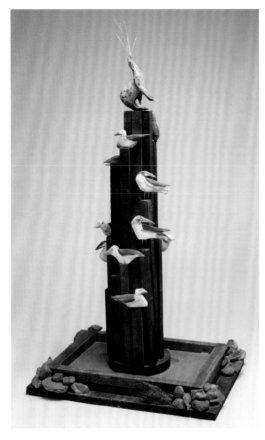

FIG. 23

Bernard Langlais (United States, 1921–1977), *Untitled (Model for Samoset Commission)*, circa 1970s, stained and painted wood, nails, stones, dried grass, 36 x 19 x 15 inches. Colby College Museum of Art, The Bernard Langlais Collection, Gift of Helen Friend Langlais, 2010.282

remained in storage for several decades, a boon for its preservation, but not for its compromised reputation. Recently, the Samoset sculpture has been revitalized in a new configuration (without the interior beams) that focuses on the array of charming marine creatures. This installation dispels the myth of a monumental loss, revealing Langlais' intuitive and earnest testament to place: not to a hotel, but to the magnificent Midcoast region, a place that beckons tourists every summer and lures birds, seals, and artists to its shore. HWB

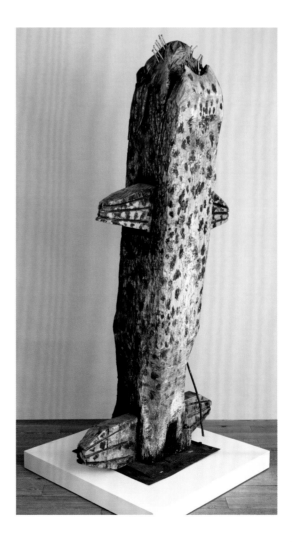

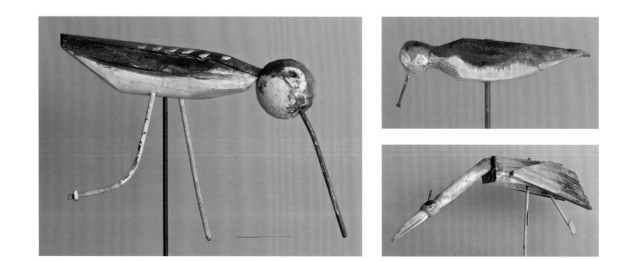

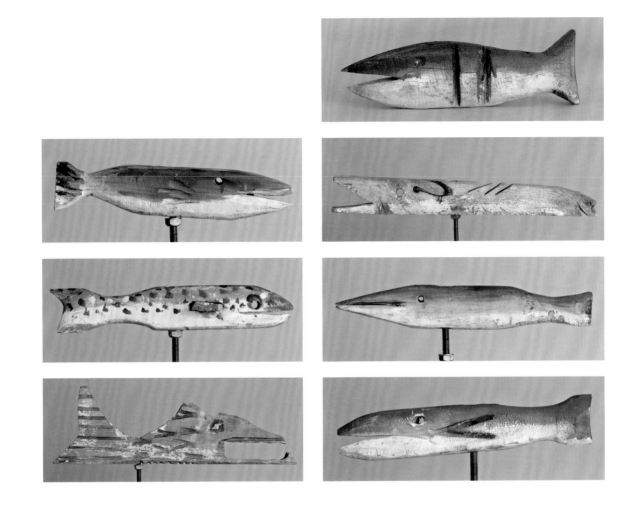

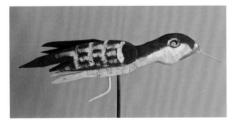

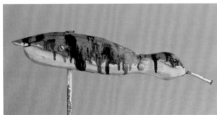

86 **Blue Savanna** 1978
Oil on canvas
36 1/16 x 50 1/4 inches
Gift of the artist, 1987.58

DAHLOV IPCAR

United States, born 1917

The animals in Dahlov Ipcar's painting *Blue Savanna* are not drawn from life, but from her memories of wildlife photographs and visits to zoos. "I never liked to work from anything in front of me," she wrote.[98] Ipcar's parents were artists William and Marguerite Zorach (see CAT. 67), who raised her in New York City's Greenwich Village and at a summer farm in Robinhood on Georgetown Island, Maine. With her father carving sculptures in one room and her mother painting or sewing embroideries in another, Ipcar's art emerged not from formal training (she spent just two semesters in art school before dropping out), but through creative osmosis and parental doting that encouraged artistic experimentation. By the time of her first solo exhibition in 1939 at the Museum of Modern Art in New York, she had already settled permanently on her parents' Maine farm, attracted by the self-reliant rural lifestyle. Over nearly eight decades, she has produced paintings, prints, collages, and soft sculptures, and written and illustrated more than thirty children's books.

Ipcar penned a key to identifying the African animals in *Blue Savanna* that reads like free verse:

TOP: Comet-tailed moth, giraffe, 2 impala, 2 cheetahs, bush baby (high in tree), crowned crane, pangolin, 3 wild dogs, python

UPPER CENTER: 3 topi, moth, kingfisher, 4 wildebeests (on blue), 2 moths (on red triangle), chameleon (on black triangle), lion

LOWER CENTER: 2 carmine bee-eaters, leopard, bush buck, red forest hog, secretary bird, 5 zebras & foal, 6 vult[u]rine guinea fowl

BOTTOM: Agama lizard, checker-back shrew, 2 ground squirrels, gaboon viper, 2 bat eared foxes, serval, moth, civet, scorpion (my zodiac sign)[99]

Radiating with cerulean blues, viridian greens, ochres, and umbers, *Blue Savanna* resembles a jewel-toned crazy quilt or a kaleidoscope's scintillating, prismatic wonders. Flora and fauna alike burst through the hard edges of the painting's underlying geometric structure. Ipcar's calculated arrangement of spots, stripes, and overlapping geometric shapes allows a multitude of images to coexist without being crowded. The painting also creates an open-ended narrative, as relationships among the creatures inhabiting this savanna of the imagination are not explicit, only suggested. Might the lively wildebeests be leaping into the lion's jaw? Are those bat-eared foxes narrowly escaping the viper lurking in the grass? HWB

ELIOT PORTER

United States, 1901–1990

87 **Redbud Tree in Bottom Land, Red River Gorge, Kentucky, April 17, 1968** 1968

From the portfolio *Intimate Landscapes* 1979

Published by Daniel Wolf, ed. 250

Dye imbibition print by Berkey K&L

13 1/8 x 10 3/4 inches

Gift of Owen W. and Anna H. Wells, 2013.17.47

Eliot Porter, the brother of painter Fairfield Porter (see CAT. 76), was raised in a Chicago family that summered at Great Spruce Head Island off the coast of Maine. Although he was trained as a physician and spent his young adulthood working as a biomedical researcher at Harvard University, Porter increasingly devoted himself to photography, which became his life's work by the 1940s. He approached photography with the curiosity and purposefulness of a scientist, as others had since the earliest days of the medium. Porter is best known for his lyrical and highly specific images of the natural world. His interest in nature photography blossomed between the 1960s and 1980s into a long-lasting affiliation with the Sierra Club, which published his first five books, including *In Wildness Is the Preservation of the World* (1962), a landmark of environmental awareness and preservationism. With its delicate evocation of a budding tree in an untouched forest, *Redbud Tree in Bottom Land, Red River Gorge, Kentucky* is one of Porter's most famous photographs, first published in his book *Appalachian Wilderness* (1970). The work became much better known after it was included in *Intimate Landscapes*, a 1979 exhibition at the Metropolitan Museum of Art, New York, and published in a finely produced portfolio by legendary photography dealer Daniel Wolf shortly thereafter.

Porter's fame as one of the preeminent nature photographers of the twentieth century, alongside Ansel Adams, sometimes eclipses his remarkable technical achievements as a pioneering color photographer in an era when black-and-white silver gelatin prints dominated fine-art photography. In order to make perfectly calibrated color images prior to chromogenic or inkjet printing, Porter mastered the dye imbibition, or dye transfer, process.[100] The prints required him to produce separate color matrices from his negatives and to balance the entire range of hues in his mind's eye prior to registering each matrix separately on the final print. Porter's skill at this process—and that of the master printers who worked under his supervision—is unparalleled, allowing him to portray the subtle pink redbuds in a sea of fresh spring yellow-greens, the fleeting heralds of a new season. JM

ROBERT INDIANA

United States, born 1928

88 SEVEN 1980/2003

Weathering steel

96 x 96 x 48 inches

Museum purchase with support from Judith Ellis Glickman, Peter and Paula Lunder—The Lunder Foundation, Sheri and Joe Boulos, Roger and Jane Goodell, The 2014 PMA Contemporaries, Paul and Giselaine Coulombe, Eileen Gillespie and Timothy Fahey, Nina and Michael Zilkha, Alison and Horace Hildreth, Alice and Richard Spencer, The Robert and Dorothy Goldberg Charitable Foundation, Lila Hunt, The Roy A. Hunt Foundation, The VIA Agency, and the Emily Eaton Moore and Family Fund for the Collection, 2014.12

A monumental steel sculpture, Robert Indiana's *SEVEN* is a single element in a much larger project, not unlike a sheet from a portfolio. In 1980, an Indianapolis real estate company commissioned the Indiana-born artist to produce a series of large-scale outdoor sculptures. The result was something of a "comeback" project for an artist long associated with images and sculptures on the *LOVE* theme (see CAT. 75). Indiana, born Robert Clark, created a sequence of ten painted aluminum sculptures of single numerals, called *Numbers*. The font, which he developed in his two-dimensional work (FIG. 24), has a vintage feel, recalling historic American printing with carved wood letters, yet is difficult to identify precisely. The sculptures' quasi-historic shapes support Indiana's statement that his own interest in numbers dates to his childhood, when he became absorbed with the numbers of the houses where his family lived (and left behind, since they moved regularly). The series is an exuberant landmark in late Pop art, bringing together the pleasures of color, sculptural form, and straightforward meaning.

Indiana first portrayed his iconic *LOVE* image as a single form in a 1966 painting (*LOVE*, now at the Indianapolis Museum of Art) and has since produced it in multiple sizes and different materials. Likewise, the artist began working with numeral forms in paint in the 1960s. By 1980, he planned to execute the numerals in various sizes in weathering steel as well as in polychrome aluminum. Despite his ambitions for the series, however, Indiana lacked the funding to complete the editions until the late 1990s, when the Brooklyn foundry Milgo/Bufkin cast the full sequence of sculptures.

One of the most remarkable aspects of Indiana's *SEVEN* at the Portland Museum of Art is its soft, almost velvety surface appearance, a result of his choice of weathering steel (also called Corten). The industrial steel continuously rusts, so that the sculpture literally evolves over time as its patina changes. *SEVEN*'s surface delicacy and softly curving lines contradict the hard, industrial character of the steel. Corten emerged as an industrial material in the 1960s and was quickly embraced by American sculptors such as Robert Irwin and, later, Richard Serra. American artists' use of the material for large-scale sculpture reached its heyday in the 1970s and 1980s, when Indiana conceived of replicating the polychrome aluminum numerals beyond his home state. JM

FIG. 24
Robert Indiana (United States, born 1928), *The Ten Stages Number Sculpture Reflected*, 1980, screenprint, 25 3/8 x 33 inches. Indianapolis Museum of Art, Gift of Mr. and Mrs. Fred Pacheo, 1988.276

DAVID C. DRISKELL

United States, born 1931

89 **Procession II** 1988

Paint, encaustic, and collage on paper

22 x 30 inches

Gift of the American Academy of Arts and Letters, New York; Hassam, Speicher, Betts and Symons Funds, 1994.1.1

In *Procession II*, American modernist David C. Driskell layered twelve almost evenly spaced but irregular strips of painted paper onto the canvas. He covered the surface of the mixed-media collage with a varied, energetic application of paint and a dynamic combination of vibrant and cool colors. His technique created a lively instability between the image's surface and depth, as the sense of what is flat and what is textured vacillates. Yet for the many ways that Driskell marks his image, there is no effect of chaos; the different colors and forms complement each other, and the vertical bands provide a rhythmic harmony.

Driskell began his career as an artist at Howard University. His professors there encouraged him to spend the summer of 1953 at Maine's Skowhegan School of Painting and Sculpture. This training provided his first exposure to the Maine landscape, which has continued to inform his work. This environment has specific resonance for *Procession II*, which Driskell created at his Falmouth home where large pines dominate the environment.

In the *Procession* series, Driskell also referred to West African, Brazilian, and American artistic styles.[101] He has noted that the layering of materials and the treatment of the decorative surface emerged from his goal of trying to "pattern [his] art with certain aspects of African and African-American iconography."[102] Such motifs are not restricted to this series of works. Throughout his collages, the artist draws influence from varied African textile traditions, such as the Egungun costume of Yoruba dancers.

In addition to his painting and printmaking, Driskell has become a leading art historian, educator, and curator. He curated and wrote the catalog for the landmark 1976 exhibition *Two Centuries of Black American Art, 1750–1950* (Los Angeles County Museum of Art), which proved foundational for the development of African American art history, and he later served as a presidential advisor on art acquisitions for the White House.[103] AJE

ANNETTE LEMIEUX

United States, born 1957

90 **Stampede** 1989

Latex on canvas and press type on wood door

83 x 166 x 3 ¼ inches

Gift of The Carol and Arthur Goldberg Collection, 2013.21.3a,b

The work of conceptual artist Annette Lemieux blurs boundaries between media, prompting viewers to contemplate serious topics such as war, mass media, and freedom of speech. *Stampede* belongs to a group of works that tackle subjects related to World War II. A larger-than-life reproduction of goose-stepping Nazi soldiers covers the canvas, recalling print and film coverage of the war. In front of the canvas, a wooden door is propped. Printed in cursive on the door are thirty-three terms for groups of animals—such as "a flight of swallows," "a swarm of bees," and "a crash of rhinoceroses"—taken from James Lipton's popular book *An Exaltation of Larks* (1968). The final two lines read "a band of men" and "a sea of faces," alluding to the facelessness of war and the millions of people who were displaced or killed, or who committed acts of brutality during the conflict. The phrases also refer to the concept of "herd mentality," suggesting that humans behave differently when grouped together.

Soon after it was made, *Stampede* was included in a 1989 exhibition, *The Appearance of Sound*, at the New Museum in New York. The works depicted appropriated images of recognizable events or actions that viewers viscerally associate with specific sounds, such as the deafening explosion of a bomb, piano music, or soldiers marching. This body of work related directly to the conceptual art movement of the middle to late twentieth century, when many artists were creating works that challenged the definition of art and the formalism of previous generations. Robert Rauschenberg's artwork, which often combined painting, collage, and found objects, paved the way for younger conceptual artists such as Lemieux, Sophie Calle, and Hans Haacke.

Much of Lemieux's work incorporates found objects with a vintage aesthetic, partly inspired by her childhood trips antiquing with her mother. In her military-themed work, she may have found inspiration from her father, who was a Marine. After the terrorist attacks of September 11, 2001, Lemieux began including images of comfort, Americana, and nostalgia in her pieces. She often uses type, found objects, and symbols, removing signs of the artist's hand. Lemieux has experimented with photography, painting, sculpture, and a mixture of media throughout her career. Though she emphasizes ideas rather than craft, her works often possess a beautiful simplicity. AHE

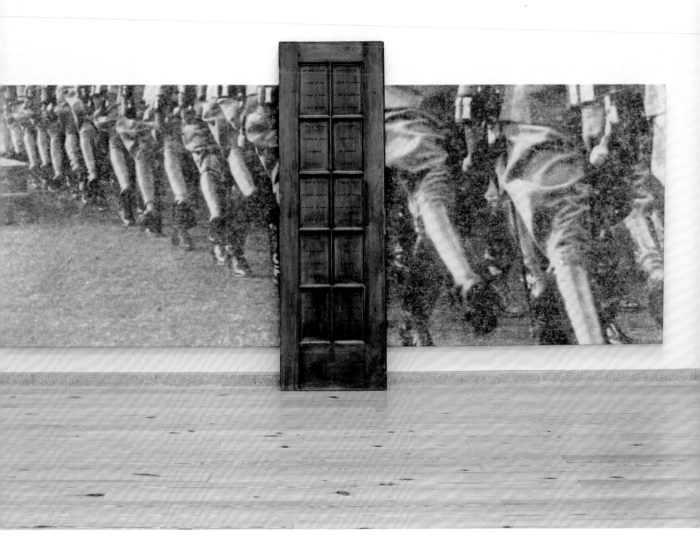

BETTY WOODMAN

United States, born 1930

91 **Gythion (Diptych)** 1990

Glazed earthenware

A: 23 1/2 x 18 1/2 inches; B: 25 3/4 x 23 inches

Museum purchase with support from
Roger and Katherine Woodman, 1991.3a,b

Like much of Betty Woodman's œuvre, the pair of vessels that make up *Gythion* defy easy categorization. As cylindrical earthenware vessels, they resemble vases. With their flying appendages and monumental presence, one might easily call them sculptures. Their freely painted and brightly toned surfaces suggest their place in the realm of painting. Woodman, one of the most innovative contemporary ceramicists in the United States, embraces this very ambiguity in her practice. As she explains, "my work uses painting with ceramics, I make sculpture and combine that with painting."[104]

Throughout her career, Woodman has drawn from a vast and eclectic range of international influences. Trained at Alfred University in upstate New York, the artist divides her time between Boulder, Colorado, New York City, and Tuscany, along with her husband, painter George Woodman. She has traveled extensively and studied antique and contemporary precedents, including Etruscan and Minoan pottery, Chinese Tang dynasty porcelain, Japanese Oribe ware, East Asian textiles, and the paintings of Henri Matisse and Pierre Bonnard. The title of this work, *Gythion,* refers to the seaport of the ancient kingdom of Sparta. Woodman's palette of white, blue, and ochre tones on both vessels recalls the red-tiled roofs, whitewashed façades, and saturated blue ocean vistas of that seaside village today.

Woodman created both vessels in the pair by throwing separate hollow forms and connecting them to one another with an invisible seam. She then affixed large, wing-like extensions to these oversized empty forms. On the appendages, Woodman added swirling surface texture that both amplifies and disrupts the pink, blue, red, green, and gray glazes that the artist brushed across each vessel with loose and expressive strokes.

Either of these two figures could stand independently. Yet Woodman has paired the two in what she calls a diptych, inviting the viewer to consider them together as two bodies in dialogue. When placed side by side, the fingerlike extensions of one vase appear to reach out towards the diagonally oriented flat plane of the other, which seems to lean away from the overture. *Gythion*'s anthropomorphic shapes react and respond to one another. Like all of Woodman's work, the pair is awash in playfully rendered contradictions. The vases are simultaneously solid and fragile, angular and sinuous, abstract and concrete, modern and indebted to global histories of pottery and painting. DJG

YVONNE JACQUETTE

United States, born 1934

92 **Dragon Cement Co., Thomaston, Maine II** 1995

Oil on linen

80 x 63 1/2 inches

Museum purchase with support from the Friends of the Collection, 2002.15

Yvonne Jacquette has been described as an Emersonian, a transcendentalist, and an American visionary for her paintings that investigate human-kind's place in the world. Since she began making aerial landscape imagery in the early 1970s, her work has inspired philosophical meditations by critics, curators, and fellow artists. They have linked her work to the wide-ranging artistic traditions of Japanese printmaking, nineteenth-century Impressionism, Tibetan thangka painting, and the Hudson River School of American landscape painters.

The 1995 painting *Dragon Cement Co., Thomaston, Maine II* is one of the vertigo-inducing views Jacquette achieves by sketching from chartered airplanes or from the upper floors of high-rise buildings. She makes quick pastel drawings of the vista below, whether the bustling streets of Manhattan, the neon jungles of Tokyo, or the industrial landscape of Maine, where she has summered every year since the early 1960s. Back in the studio, she projects the drawings onto canvases, enlarging and elaborating the details to create her finished compositions. Her motivations for working this way are mainly practical, though tinged with Buddhist spirituality. Suffering from farsighted-ness, Jacquette finds looking at a distance more comfortable for her eyes. Her tendency toward night scenes may derive from a similar impulse to observe the world through an obscuring veil.[105]

Rendered in blues, dusky pinks, oranges, and greens, *Dragon Cement Co.* is undoubtedly inspired by a twilight flight in summer. The hypnotic, vivid blue of the evening sky is reflected on pavement and water alike. While distance is central to the painting's creation, the experience of looking at the work also depends on how closely it is seen. At a certain range, the viewer recognizes the objects on the canvas: concrete façades, parking lots, flickering streetlights, the round tops of cement storage silos. As the viewer pieces together the architecture of this industrial giant, there is a sensation, both exhilarating and disorienting, of seeing the material world in miniature, like a fragile balsa-wood model that could be crushed underfoot. Examined up close, the painting is a series of dots, curls, and dashes, rudimentary marks that emphasize the flatness of the picture plane. The massive and substantial—here, the literal weight of the manufacturing complex—become fleeting and insignificant, mere wisps of colored light. At a distance, these painterly units disappear into an abstract, maplike composition of stripes, squares, amoebas, and circles. Jacquette leaves the viewer adrift in the boundless blue, contemplating paint and life. HWB

LOS CARPINTEROS

Cuba, established 1991

93 **Escalera** 1997

Colored woodcut on paper, edition of three

68 1/2 x 35 1/2 inches

Museum purchase with support from the
Contemporary Art Fund in memory of
Bernice McIlhenny Wintersteen, 2010.21.1

Escalera, an oversized woodcut printed on thin paper, depicts a spiral staircase of galvanized steel that leads nowhere, immersed at its base in an antique zinc tub, along with details of its measurements and materials. The text traveling up the staircase translates as, "What if we climb this spiral staircase and evaporate?" Typical of Los Carpinteros' work, the print depicts a nonsensical yet elegant structure. The Cuban group, whose name means "The Carpenters," is known for devising elaborate, meticulous plans for utopian structures or spaces that have no function. They also do the opposite, taking a useful, everyday object (such as a bed) and distorting it to make it useless. Sometimes these works take the form of drawings; in other instances, they are actual built environments, constructed with care and craftsmanship from wood, cardboard, or concrete.

Los Carpinteros had three members when they created *Escalera*: Marco Antonio Castillo Valdes (born 1971), Dagoberto Rodríguez Sánchez (born 1969), and Alexandre Jesús Arrechea Zambrano (born 1970), who has since left the group. They formed their collaboration in 1992 after meeting at the Instituto Superior de Arte in Havana, Cuba. The trio rose to international prominence during the 1990s, participating in their first show outside Cuba at the Whitechapel Gallery in London in 1995, followed by their noteworthy installation at the seventh Havana Biennial in 2000, *Ciudad Transportable* (Transportable City). They soon became known for using salvaged, found materials and wood to construct their work with traditional artisanal tools, challenging the cultural boundaries between craftsman and artist, collaboration and individual, and high and low art. When Los Carpinteros began making art together, Cuban cities were deteriorating under the Communist regime and art supplies were scarce, so they often cut down trees or removed materials from abandoned buildings to obtain the wood for their projects. Their collaborative identity and working process echo the tradition of artisan guilds and the socialist society of their home country. AHE

JOCELYN LEE

United States, born Italy, 1962

94 A **Untitled (Kara on Easter)** 1997

B **Untitled (Kara on bed)** 1998

C **Untitled (Kara in snow)** 2002

D **Untitled (Kara's first pregnancy)** 2005

E **Untitled (Kara in August)** 2013

Inkjet prints, printed 2013

Each 40 x 50 inches

Museum purchase with support from
the Irving Bennett Ellis Fund, and the
Contemporary Art Fund in memory of
Bernice McIlhenny Wintersteen, 2013.27.1a–e

Jocelyn Lee's open-ended series consists of five photographs taken between 1997 and 2013 of a single sitter, Lee's onetime neighbor Kara. Throughout her career, Lee has created portraits—often rendered on a large scale with lush color—that record the lives of close friends, family, and strangers. The *Kara* series is one of several sequential portraits in which Lee returns repeatedly to sitters over the course of years to make photographs that register time as both instantaneous and incremental. As the shutter clicks, Lee freezes a single moment. Seen together, her portraits also capture physical and emotional alterations gradually imprinted on the body over years and decades.

Lee recalls being instantly captivated by Kara's outsized presence, even at a young age, in their shared Munjoy Hill neighborhood in Portland.[106] Her 1997 portrait (CAT. 94A) pictures Kara in a white Easter dress, with stockinged toes peeking out of ill-fitting shoes. Kara stands stiffly with legs together and fingers knit as if in prayer. Lee photographed Kara near their homes, beside a chain-link fence and against a brown and muted landscape with a view of the ocean beyond.

Lee's image of Kara the following year (CAT. 94B) envisions a budding teenager in a yellow two-piece bathing suit, sitting on an unmade bed. Kara slouches forward. Her compressed posture exposes rolls of baby fat that echo the valleys and peaks of the pink blanket. The closely cropped bedroom scene presents an uneasy vision of a girl, not yet a woman, whose presence in the small bedroom implies knowledge of the adult world beyond her years.

In 2002, Lee photographed Kara again (CAT. 94C), now as a full-fledged teenager, standing on virtually the same spot as she had on Easter in 1997. Kara crosses

A

B

her arms as if to deflect the camera. The picture's diagonal horizon line and white winter environment capture an off-kilter frame and a bleak landscape.

Lee pictured Kara in 2005 (CAT. 94D) wearing a pale pink bikini reminiscent of the bathing suit she wore in the 1998 photograph. Posed on a mound of grass with a vast sky beyond, Kara appears to stand at the edge of the world, with the bulge of her pregnant belly echoing the rounded curve of the grassy hill. Unlike previous portraits, in this image Kara does not meet Lee's gaze. Her side-long glance reflects trepidation about the monumental and imminent change that motherhood will bring.

Lee's last image to date (CAT. 94E) pictures Kara in 2013 as a fully grown adult. As in Lee's 2005 photograph, Kara cocks her head to one side and glances beyond the picture frame. Lee captured her sitter's body caught between light and shade, much as she did in her 1998 bedroom portrait, in which Kara appears half bathed in raking light and half cloaked in shadow. Here, Lee did not record her subject straight on. Rather, the photographer observed her subject at an angle so that shadows fall across her features to accentuate Kara's careworn expression.

Like the images in the *Kara* series, Lee's photographs often capture sitters before or after cataclysmic change: a youth on the brink of puberty; an expectant mother weeks before birth; a person in the throes of grave illness; a corpse minutes after death. Her crisp compositions, often printed on a massive scale in a saturated palette, pull viewers into intimate encounters with her subjects. The photographs are journalistic in their unflinching exposure of people at their most vulnerable. Yet Lee's deep empathy towards her subjects endows her sitters with a profound sense of grace. DJG

c

D

E

KATHERINE BRADFORD

United States, born 1942

95 **Woman Flying** 1999

Oil on canvas

84 x 72 inches

Museum purchase with support from the
Friends of the Collection, 2012.14

In *Woman Flying*, an ambiguous nude female figure soars through the rich blue sky. Though the painting, which appeared in the 2001 Portland Museum of Art Biennial before entering the collection, has a simple composition, its meaning is more enigmatic. Donning a vibrant red cape, the woman can be read as a superhero, or more appropriately as a symbol of a superhero. According to the artist, the subject's attire suggests her achievements and her desire for power.[107] The figure, floating upwards, seems to rise far above the sliver of horizon at the bottom edge of the canvas. Depicting a common motif in Katherine Bradford's œuvre, *Woman Flying* is the first of her superhero works. It belongs to a larger series that addresses the subject of a solitary figure aspiring to connect to a higher dimension. A white halo of paint surrounding the woman enhances the painting's mystical quality, while the limited palette of blue, red, white, and pink contributes to the work's striking appearance.

Despite the lofty themes in *Woman Flying*, Bradford's images of superheroes, cruise liners, and swimmers exude wit and levity. Here, the heroic woman is clunky and awkward, with splayed arms and legs kicking through the air. Thick, uneven contour lines and blocky limbs give her a weightiness that is incompatible with flying. Bradford has elaborated, "I have presented her as barely able to fly, more in a state of longing than accomplishment. Because she is seen as trying to do something for which she is unequipped, we catch her in a state of vulnerability and exposure."[108] The multiplicity of meanings in *Woman Flying* is enhanced by the image's ambiguous perspective. Is the woman ascending or landing? Are we viewing her from above or below? How the viewer answers these questions affects the interpretation of the figure's supposed triumph or helplessness.

The artwork illustrates the fluidity between abstraction and figuration in late twentieth-century American painting. Although the subject matter is easily identifiable, the scene lacks a clear narrative and the schematic figure is reduced to essential forms with little shading. The surface of *Woman Flying*, which is painted on a canvas dropcloth, is highly irregular, with the dropcloth's seams and residual paint splatters drawing attention to the texture of the painting and to the work's physicality. By using such a support, Bradford plays with ideas of verticality and horizontality, mimicking the painting's subject matter. With both the canvas and the figure, the artist takes what is normally on the ground and suspends it in the air.

Born in New York City, Bradford began her career as a purely abstract painter. Influenced by the expressiveness of iconic symbols in the cartoon-like work of Philip Guston and Donald Baechler, she shifted to recognizable imagery in order "to tell stories."[109] MRA

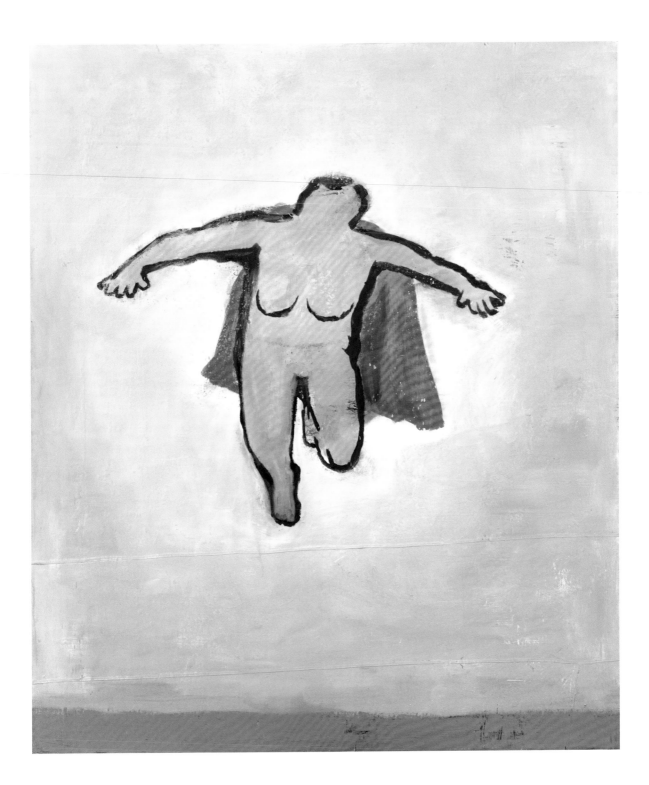

RICHARD ESTES

United States, born 1932

96 **Beaver Dam Pond, Acadia National Park** 2009

Oil on board

12 ³/₈ x 29 ⁷/₈ inches

Anonymous gift, 2014.2

This tranquil, panoramic scene by Richard Estes depicts Beaver Dam Pond, a small body of water at the base of Champlain Mountain in Acadia National Park on Mount Desert Island, Maine, a popular seasonal tourist destination. Since the 1970s, Estes has divided his time between New York City and this area of Maine. The artist chose to paint the landscape at the end of its autumn splendor. Bright swaths of orange and yellow are sprinkled throughout the pines and the craggy ledges of the mountain. Estes frequently depicts multiple perspectives through reflections. Here, a reflection of the terrain above appears in the water below.

At first glance, the viewer may wonder whether *Beaver Dam Pond, Acadia National Park* is a painting or a photograph, but when seen up close, nuances and brushstrokes show that it is a painting. Estes is known for this photo-based realism. The artist, who has spent his lifetime taking photographs, brings these images back to his studio, cuts them apart (sometimes subtly distorting the perspective), and glues them together to create compositions for his paintings.

Richard Estes is one of the most recognized contemporary realist painters. Born in Kewanee, Illinois, he spent most of his childhood in Chicago, where he attended the School of the Art Institute of Chicago. After moving to New York City in 1958, he worked as a freelance illustrator and photographer for advertising agencies. Along with his contemporaries such as Chuck Close, he has spent his career focusing on

realism, also finding inspiration in the photographic cityscapes of Eugène Atget, Walker Evans, and Lee Friedlander. Estes is best known for his glossy depictions of metropolitan intersections and storefronts in New York, Hiroshima, London, Chicago, and elsewhere.

In stark contrast to his city imagery, Estes also paints wild areas, such as glaciers in Antarctica, the mountains of New Zealand, and the Maine forest, which he interprets as raw and untouched. Most of his landscape paintings lack built structures or other evidence of human presence. Like his images of urban environments, however (FIG. 25), his landscapes, including *Beaver Dam Pond*, display his characteristic meticulous detail and prominent, sometimes illusory reflections. AHE

FIG. 25

Richard Estes (United States, born 1932), *Bus with Reflection of the Flatiron Building*, 1967–68, oil on canvas, 36 x 48 inches. Private collection

97 **Maybe** 2009–10

MDF board, sardine cans, plastic bag,
cardboard box, nails, electrical extension
cord, paint, and graphite

96 x 96 x 18 inches

Gift of Emily Fisher and Alex Fisher, 2010.13

WILLIAM POPE.L

United States, born 1955

Conceptual and performance artist William Pope.L
is renowned for using his own body to make art that
expands traditional boundaries of medium and
subject matter, and brings racial and class stereotypes
uncomfortably close to the artist and his audiences.
Pope.L, whose name integrates his father's surname
with the first letter of his mother's maiden name,
Lancaster, creates artwork that has a strong element
of time, through his performances or—in many
cases—their residue. When, in 2002, he wrote, "I do
not picture the hole. I **am** the hole," he suggested
that his art is rooted in his own body, thoughts, and
experience.[110] The Zen-like statement also points to
his aesthetic interests in the interior, the murky, and
the base (all qualities identified by Surrealist leader
Georges Bataille as "the formless," or *informe*, in his
"Critical Dictionary" of 1929–30). Although much of
Pope.L's work involves food, he is less interested in
photogenic cuisine than in the alimentary process as
a metaphor for human consumption. In one famous
performance, *Eating the Wall Street Journal* (2000),
Pope.L actually consumed the daily edition of the
financial paper, dipping strips of newsprint in condiments.

Maybe recalls the act of eating, yet leaves open the
basic question whether the process is a pleasurable
part of everyday life or a deliberately uncomfortable
ritual. Although the work is based on Pope.L's physical
experience, *Maybe* is not the residual document
of a public performance. Instead, it is not unlike a
modern abstract painting, with a large-scale backing
board that meets the floor and secures to a wall.
Glued to the backdrop of the work is a near-perfect
grid of empty sardine cans, the contents eaten by
Pope.L. Yet the grid is incomplete, and assorted
materials in front of the work—including loose, empty
cans and an ordinary orange electrical cord—suggest
the kinds of equipment from an artist's studio that
one rarely sees in an art museum. *Maybe* thus creates
bridges between everyday life and making art, between
the formal space of the museum, the wild, messy,
imaginative space of the studio, and the artist's own
body. We are invited to move back in time, from the
artist's consumption of sardines, one can at a time,
through the conception and planning of a work of art,
to the museum staff, carefully installing objects meant
to recall the exciting haze of discovery. JM

TIM ROLLINS

United States, born 1955

K.O.S.

United States, established 1984

98 Adventures of Huckleberry Finn—
Asleep on the Raft (after Mark Twain)
2011

Matte acrylic, book pages, and gesso on canvas

48 x 60 x 1$^{1}/_{2}$ inches

Museum purchase with support from the
Leonard and Merle Nelson Fund for Social Justice,
the Harold P. and Mildred A. Nelson Art Purchase
Fund, and the Friends of the Collection, 2012.22

Tim Rollins has worked collaboratively with the Kids of Survival (K.O.S.) since 1984. He grew up in Pittsfield, Maine, and attended the University of Maine at Augusta before moving to New York City and earning a B.F.A. at the School of Visual Arts in 1980. Not long after, Rollins founded K.O.S., which currently has eight members. As a middle-school art teacher in the South Bronx, Rollins formed an after-school club for special education students called the Art and Knowledge Workshop. The group then named itself the Kids of Survival, referring to their struggles with poverty, violence, and drug use. K.O.S. provided a refuge and a sense of optimism for its young members. Decades later, they continue to assemble to discuss literature and create artwork inspired by their conversations.

Pairing book pages with painted imagery forms the core of the group's practice. They have recently used text from Shakespeare's *A Midsummer Night's Dream*, *Dracula* by Bram Stoker, *The Scarlet Letter* by Nathaniel Hawthorne, writings by Martin Luther King, Jr., and *On the Origin of Species* by Charles Darwin. *Adventures of Huckleberry Finn—Asleep on the Raft (after Mark Twain)* depicts the character Jim from the classic 1884 American novel. Huck Finn's companion in adventure sits on a raft, his weary arms resting on his knees. The background is formed by a collage of pages ripped from a copy of the book, beginning with the text that corresponds to the scene that the painting portrays, and pasted onto the canvas in an orderly, sequential grid. The painted composition layered above is the artists' re-creation of E. W. Kemble's illustration from the first edition of Twain's book. When speaking about the group's works inspired by the novel, Rollins connected this image to racial equality and historic oppression of African Americans: "It doesn't matter what you look like. . . . We're on the raft together. We need each other to survive."[111] The subtly distorted treatment of Jim's figure alludes to the racism of the late nineteenth century, while also prompting questions about American history, appropriation, literature, and the nature of illustration. AHE

SCOTT KELLEY

United States, born 1963

99 **Self-Portrait as Ishmael's Arm** 2012

Watercolor on paper

18 x 20 inches

Museum purchase with support from the
Friends of the Collection, 2012.23.1

In this image, Scott Kelley depicted himself as Ishmael, narrator of Herman Melville's famed 1851 novel *Moby-Dick*, who tattooed a sperm whale's dimensions on his right arm in order to visualize and remember the giant whale he was seeking. The novel follows the ill-fated quest of the crew of the ship *Pequod* to locate and harpoon the formidable white whale, ending with Ishmael as the sole survivor of the shipwreck. Kelley's identification with Ishmael can be interpreted as the artist's recognition of his own passionate desire to understand and depict the natural world.

Inspired by several readings of *Moby-Dick* and extensive historical research (including a trip to the New Bedford Whaling Museum in Massachusetts), Kelley created a body of work about the whaling industry in New England. In a series entitled *Children of Lost Whalers*, he drew images of children from Peaks Island, off the coast of Maine, where he has lived since 2004. His subjects were dressed in period costume in order to portray the orphaned children of fictional drowned whalers. Pictures of marine life are also included in his whaling series. This rendering of the artist's arm is positioned on a striking backdrop of aquamarine, a color that appears throughout Kelley's whaling-themed works.

Though his ideas and use of color are fresh, vibrant, and contemporary, Kelley's work has an old-fashioned sensibility. He has even added imitation foxing, the rust-colored spotting that frequently appears over time on old documents, to his works on paper. Kelley's watercolors display a remarkable attention to detail, portraying visual data that only become apparent through close observation. He works in the tradition of naturalist artists like Albrecht Dürer and John James Audubon, but with a conceptual twist.

Best known for his watercolors of wildlife, Kelley has an unusual background that places him in an artistic category of his own. He studied at the Cooper Union in New York and the Slade School of Fine Art in London and completed a fellowship at the Glassell School of Art at the Museum of Fine Arts, Houston. Kelley apprenticed briefly with the art forger David Stein to refine his talent for realism and worked for seven years with conceptual art superstar Julian Schnabel. He served as an artist-in-residence at Palmer Station in Antarctica in 2003, then transitioned to making paintings of specimens from nature in a trompe l'œil style. AHE

AHMED ALSOUDANI

United States, born Iraq, 1975

100 **Untitled** 2013

Acrylic and charcoal on canvas

80 x 50 inches

Museum purchase with support from the Emily Eaton Moore and Family Fund, the Friends of the Collection, and anonymous donors, 2013.20

In Ahmed Alsoudani's *Untitled* from 2013, a seething mass of interlocking flesh-like forms stretches across a large vertical canvas. Weaving in and out of one another, these phallic shapes suggest bone, muscle, and tendon that have been broken, bruised, slashed, punctured, and sutured. As in many of his compositions, Alsoudani created the work by melding dry scratches of charcoal line with layered accretions of bright acrylic paint, evoking the char of fire on the glistening inner organs of a once-living creature.

Within the tangle of pink, orange, yellow, gray, and purple, the artist has embedded two frightened eyeballs, a familiar feature of Alsoudani's canvases that here suggests a human head set atop narrow shoulders. Read as a portrait, the painting depicts a battered face bearing wounds of war, yet rendered deaf and dumb by the absence of mouth and ears, making the subject unable to describe what he has seen and felt.

In the tradition of Pablo Picasso or Francisco de Goya's images of wartime violence, Alsoudani's painting foregrounds the destruction inflicted on civilians during armed conflict. The Iraqi-born artist does not represent one particular act of carnage or an individual victim. Rather, his images spring from his accumulated experience: his childhood in Baghdad during the first Gulf War and a lifetime of exile, during which Alsoudani has watched his homeland in crisis. The artist fled Iraq as a young man and lived as a refugee in Syria until 1998, when the U.S. government granted him asylum. Alsoudani moved to the United States, first to Washington, D.C., and then to Portland, Maine. Trained at the Maine College of Art, Yale University, and the Skowhegan School of Painting and Sculpture, Alsoudani has risen rapidly in the world of contemporary art because of his novel approach to age-old themes.

Since childhood, Alsoudani has used painting to respond from afar to the second Iraq War, the political upheavals of the Arab Spring, and escalating extremist violence across the globe. His canvases are efforts to confront his powerlessness to help friends and family still caught in the region. As he has remarked, "I'm in a painful gray area, and there is no way for me not to think about it [Iraq]."[112] Alsoudani's unmoored mass in *Untitled* is a portrait of war and its catastrophic effects. It is also a record of the artist's painful dislocation—that very gray area rendered here in graphite and paint on canvas. DJG

NOTES

A Short History of the Portland Museum of Art

This introductory essay is based primarily upon research in the archives of the Portland Museum of Art and an unpublished manuscript, "Portland Museum of Art, 1882–2011," by Amber Degn, which is on file at the museum.

1 John Neal, "Painting," *The Yankee* (Portland, Maine), February 6, 1828, 48.

2 S. R. Koehler, *The United States Art Directory and Year Book* (New York: Caswell and Company, 1884), 142.

3 Margaret Mussey Sweat to John Calvin Stevens, October 16, 1905, Portland Museum of Art Archives, 1908.291a,b.

4 "L. D. M. Sweat Memorial," *American Architect*, September 17, 1913, 112.

5 Henry N. Cobb articulated his vision in *Where I Stand* (Cambridge, Mass.: Harvard Graduate School of Design, 1980).

6 Many of the works from this gift are featured in this catalogue; see Cats. 2, 10, 26, 29, 30, and 39.

7 Among the Noyce gifts featured in this catalogue are Cats. 15, 51, 60, 68–71, and 73.

Catalogue Entries

1 Pepperrell and Warren remained comrades after the war. In addition to the set of silver, the two men also exchanged portraits.

2 *Reeding* refers to the carved dimensional linear decoration along the surfaces of the table legs.

3 Against the advice of fellow builders who feared the tower would collapse in heavy winds, Moody used wood to construct his tower rather than brick. However, he painted the planks bright red to appease onlookers who might assume that Moody had heeded their instructions.

4 A. G. Tenney, "Miss Narcissa Stone," *Brunswick Telegraph*, November 23, 1877.

5 Anita Schorsch, "Mourning Art: A Neoclassical Reflection in America," *American Art Journal* 8, no. 1 (May 1976): 5.

6 "Stuart. The Vandyke of the Present Day," *The World, and Fashionable Advertiser* (London), March 10, 1787, 3.

7 Stuart frequently lost interest in a portrait after rendering the face, leaving the remainder of the painting unfinished or giving it to assistants for completion. It is unknown if this was the case for the PMA's portrait. The suggestion that Stuart's daughter Jane (1812–1888), one of his assistants, finished Dearborn's costume and background is erroneous given her life dates.

8 For additional information on Dearborn and his portrait, see Carrie Rebora Barratt and Ellen G. Miles, *Gilbert Stuart* (New York: Metropolitan Museum of Art, 2004), 304–6.

9 Philip Conisbee, "Rome, 1806–1820," in *Portraits by Ingres: Image of an Epoch*, ed. Gary Tinterow and Philip Conisbee (New York: Metropolitan Museum of Art, 1991), 111.

10 Charles Blanc, *Ingres: Sa vie et ses ouvrages* (Paris: Vve. Jules Renouard, 1870), 45.

11 Frederick Sylvester North Douglas, *An Essay on Certain Points of Resemblance between the Ancient and Modern Greeks*, 3rd ed., corr. (London, 1813).

12 Neal's encouragement helped the careers of several local artists, including Benjamin Paul Akers and Charles Codman (Cats. 18 and 12).

13 The information in this entry is drawn primarily from Jessica Nicoll and Jessica Skwire Routhier, *Charles Codman: The Landscape of Art and Culture in 19th-Century Maine* (Portland, Maine: Portland Museum of Art, 2002).

14 John Neal, "Codman's Pictures," *Portland Advertiser* (Maine), September 19, 1829.

15 Susan Babson, quoted in James A. Craig, *Fitz H. Lane: An Artist's Voyage through Nineteenth-Century America* (Charleston, S.C.: History Press, 2006), 149.

16 Horace Greeley, *Art and Industry as Represented in the Exhibition at the Crystal Palace, New York, 1853–4* (New York: Redfield, 1853), 123.

17 Gustave Le Gray, *Photographie: Nouveau traité théorique et pratique des procédés et manipulations sur papier sec, humide, sur verre au collodion, à l'albumine, nouvelle édition renfermant tous les perfectionnements apportés à cet art jusqu'à ce jour* (Paris: Plon, May 1854), 70–71 (author's translation).

18 Nathaniel Hawthorne, *The Marble Faun: or, The Romance of Monte Beni* (1860; repr., Cambridge, Mass.: The University Press, 1889), 1:142–43.

19 Julian Hawthorne, quoted in Richard Cary, "The Misted Prism: Paul Akers and Elizabeth Akers Allen," *Colby Library Quarterly*, ser. 8, no. 5 (March 1966): 246.

20 Elizabeth Akers Allen to J. W. Penney, September 29, 1907, PMA Curatorial Files.

21 For additional discussion of the Payson gifts and the Homer Studio, see Earle G. Shettleworth's introductory essay in this volume, pp. 17–18, 21–22.

22 Decades after the war, Homer recalled to a friend his experience of looking through the sight of a sharpshooter's rifle "as being as near murder as anything I could think of in connection with the army & I always had a horror of that branch of the service." Winslow Homer to George Briggs, February 19, 1896, quoted in Marc Simpson, *Winslow Homer: Paintings of the Civil War* (San Francisco: Fine Arts Museums of San Francisco, 1988), 38.

23 "National Academy of Design," *New York Daily Tribune*, July 3, 1865.

24 The PMA owns a nearly comprehensive collection of Homer's work in commercial illustration, thanks in large part to a generous gift of hundreds of prints from Peggy and Harold Osher.

25 "The Empty Sleeve at Newport; or, Why Edna Ackland Learned to Drive," *Harper's Weekly*, August 26, 1865, 534.

26 The PMA's collection includes a painting with a similar subject, *Taking an Observation* of 1884, which Homer made as a decorative panel for the cabin of his brother's sailboat.

27 For a thorough discussion of Homer's life and work at Prouts Neck, see Thomas A. Denenberg, ed., *Weatherbeaten: Winslow Homer and Maine* (New Haven and London: Yale University Press for the Portland Museum of Art, Maine, 2012).

28 *Weatherbeaten* was awarded a gold medal when it was exhibited in 1896 at the Pennsylvania Academy of the Fine Arts in Philadelphia.

29 Bruce J. Talbert, *Gothic Forms Applied to Furniture, Metal Work and Decoration for Domestic Purposes* (Boston: James R. Osgood, 1873), 1.

30 Ibid.

31 J. S. Palmer, *Design for a Goblet*, U.S. Patent 3,152, issued August 4, 1863, quoted in Clifton R. Sargent, "The Rarest Portland Glass Company Pattern," *Glass Club Bulletin* 151 (Winter 1986–87): 12.

32 Gustave Courbet to Francis Wey, published in *La Lumière* 1, no. 8 (March 30, 1851): 31, quoted in Dominique de Font-Réaulx, "Realism and Ambiguity in the Paintings of Gustave Courbet," in *Gustave Courbet* (New York: Metropolitan Museum of Art, 2008), 31–32.

33 Patricia Mainardi, "The Political Origins of Modernism," *Art Journal* 45, no. 1 (Spring 1985): 11–17.

34 Today, Wildcat Falls is known as the Diamond Cascade; however, it is commonly referred to as the Silver Apron.

35 Kate Nearpass Ogden, "Sublime Vistas and Scenic Backdrops: Nineteenth-Century Painters and Photographers at Yosemite," *California History* 69, no. 2 (Summer 1990): 139.

36 Mary V. Jessup Hood and Robert Barlett Hass, "Eadweard Muybridge's Yosemite Valley Photographs, 1867–1872," *California Historical Society Quarterly* 42, no. 1 (March 1963): 17.

37 Oscar Wilde, "The Grosvenor Gallery," *Dublin University Magazine*, July 1877, 124, quoted in Linda Merrill, *A Pot of Paint: Aesthetics on Trial in Whistler v. Ruskin* (Washington, D.C., and London: Smithsonian Institution Press, 1992), 40.

38 For a discussion of this painting's complex history, see Merrill, *A Pot of Paint*, 37–42, and Andrew McLaren Young, et al., *The Paintings of James McNeill Whistler* (New Haven and London:

Yale University Press, 1980), text vol., cat. no. 107, 66–67. The author also wishes to thank Margaret F. MacDonald of the online catalogue raisonné, *The Paintings of James McNeill Whistler: A Catalogue Raisonné* (University of Glasgow, http://whistlerpaintings.gla.ac.uk) for her insights on this painting (personal communication, May 14, 2015).

39 Ambroise Vollard, *Degas: An Intimate Portrait*, trans. Randolph T. Weaver (New York: Crown Publishers, 1937), 87.

40 Johnson frequently used family members and local friends as models for these works, although the figures in *The Quiet Hour* are unidentified.

41 Lucy W. Hayes to Theodore R. Davis, August 2, 1880, quoted in *The White House Porcelain Service: Designs by an American Artist, Illustrating Exclusively American Fauna and Flora* (New York: Haviland & Co., 1880), 88.

42 For a discussion of the accusations of fraud surrounding Haberle's *Reproduction* and *U.S.A.* (*The Chicago Bill Picture*, circa 1889, Indianapolis Museum of Art)—a painting that, in order to dispel suspicion, was subjected to tests to ensure that the pictured bills were made entirely of paint—see Gertrude Grace Sill, *John Haberle: American Master of Illusion* (New Britain, Conn.: New Britain Museum of Art, 2009), 21–29.

43 Teresa A. Carbone, *American Paintings in the Brooklyn Museum: Artists Born by 1876* (Brooklyn, N.Y.: Brooklyn Museum of Art, 2006), 2:1060.

44 Michael Quick, *American Expatriate Painters of the Late Nineteenth Century* (Dayton, Ohio: Dayton Art Institute, 1976), 142.

45 Martha R. Severens, "Franklin Simmons and His Civil War Monuments," *Maine History* 36, nos. 1–2 (Summer–Fall 1996): 12.

46 For a discussion of landscape paintings as metaphors of the Civil War, see Eleanor Jones Harvey, *The Civil War and American Art* (Washington, D.C.: Smithsonian American Art Museum, 2012), 17–71. Church's *Our Banner in the Sky* is reproduced on p. 36.

47 Frederic Edwin Church to Isabel Church, November 10, 1895, quoted in John Wilmerding, *Maine Sublime: Frederic Edwin Church's Landscapes of Mount Desert and Mount Katahdin* (Hudson, N.Y.: Olana Partnership, 2012), 68.

48 Sally Cary Curtis Iselin, typescript family history, PMA Curatorial Files. Iselin was the granddaughter of the sitter.

49 Siegfried Bing, "Louis C. Tiffany's Coloured Glass Work," first published in German as "Die Kunstgläser von Louis C. Tiffany," *Kunst und Kunsthandwerk* (Vienna: Österreichischen Museum für Kunst und Industrie, 1898), 1:105–111, translated in Siegfried Bing, *Artistic America, Tiffany Glass, and Art Nouveau* (Cambridge, Mass.: MIT Press, 1970), 211.

50 Peto remained in obscurity until the late 1940s, when scholars looking for works by his colleague William Harnett "discovered" Peto.

51 This portrait reproduces John Chester Buttre's engraving after a well-known Mathew Brady photograph. Peto owned a copy of the Buttre print.

52 For a thorough discussion of this interpretation, see John Wilmerding, *Important Information Inside: The Art of John F. Peto and the Idea of Still-Life Painting in Nineteenth-Century America* (Washington, D.C.: National Gallery of Art, 1983), chap. 6.

53 Ibid., 183.

54 Elie Nadelman, "My Drawings," in "Photo-Secession Notes," *Camera Work* 12 (October 1910): 41.

55 Financial struggles during the Great Depression forced the Nadelmans to sell their folk art collection, most of which went to the New-York Historical Society.

56 Vance Thompson, "A Preachment in Paint," *Hearst's Magazine* 25 (January–June 1914): 709–10.

57 W. E. B. Du Bois was one of several writers who commented on the painting's themes of race and discrimination; see "The Drop Sinister," *The Crisis* 10 (October 1915): 286–87.

58 George Bellows to Robert Henri, September 8, 1916, quoted in Jessica F. Nicoll, *The Allure of the Maine Coast: Robert Henri and His Circle, 1903–1918* (Portland, Maine: Portland Museum of Art, 1995), 29.

59 Alfred Barr, introduction to *Charles Burchfield: Early Watercolors 1916 to 1918* (New York: Museum of Modern Art, 1930), 6.

60 Charles Burchfield, journal for November 23, 1917, quoted in John H. I. Baur, introduction to Charles Burchfield and Kennedy Galleries, *Charles E. Burchfield Watercolors from 1915 to 1920: May 10 to June 10, 1983* (New York: Kennedy Galleries, 1983); Charles Burchfield, inscription on verso of watercolor.

61 Yasuo Kuniyoshi, "East to West," *Magazine of Art*, February 1940, 73.

62 Eila Kokkinen, *George Ault: Paintings and Drawings* (New York: Zabriskie Gallery, 2004), n.p.

63 After Field's death in 1922, Laurent continued the work by establishing the Hamilton Easter Field Foundation. In 1979, the Foundation's collection of modern American art was donated to the Portland Museum of Art.

64 Marsden Hartley, *Adventures in the Arts: Informal Chapters on Painters, Vaudeville, and Poets* (New York: Boni and Liveright, 1921), 36.

65 Marsden Hartley, quoted in Bruce Robertson, *Marsden Hartley* (New York: Harry N. Abrams, 1995), 87.

66 John Szarkowski, *Looking at Photographs: 100 Pictures from the Collection of the Museum of Modern Art* (New York: Museum of Modern Art; Greenwich, Conn.: New York Graphic Society, 1973), 96.

67 John Marin, quoted in Martha Tedeschi with Kristi Dahm, *John Marin's Watercolors: A Medium for Modernism* (Chicago: Art Institute of Chicago, 2010), 52.

68 Jo (Josephine) Nivison Hopper, quoted in Kevin Salatino, ed., *Edward Hopper's Maine* (Brunswick, Maine: Bowdoin College Museum of Art, 2011), 32.

69 Marsden Hartley, quoted in Elizabeth Mankin Kornhauser, *Marsden Hartley* (New Haven and London: Wadsworth Atheneum Museum of Art in association with Yale University Press, 2002), 175 (emphasis added).

70 Marsden Hartley to Paul Strand, November 19, 1929, and March 6, 1929, quoted in Gail R. Scott, *Marsden Hartley* (New York: Abbeville Press, 1988), 87.

71 Joan Marter, Roberta K. Tarbell, and Jeffrey Wechsler, *Vanguard American Sculpture, 1913–1939* (New Brunswick, N.J.: Rutgers University, 1979): 48.

72 Judith Zilczer, "The Theory of Direct Carving in Modern Sculpture," *Oxford Art Journal* 4, no. 2 (November 1981): 45.

73 Fernand Léger, "Deus ex machina," *L'Intransigeant* (Paris), January 27, 1930.

74 Andrew Wyeth and Richard Meryman, "Andrew Wyeth: An Interview," *Life*, May 14, 1965, 108.

75 Jonathan Jones, "Andrew Wyeth's Work Represents the Worst of America," *The Guardian* (London), January 20, 2009.

76 Wyeth and Meryman, "Andrew Wyeth: An Interview," 93.

77 Jamie Wyeth, quoted in Richard McLanathan and Jamie Wyeth, *Jamie Wyeth on Monhegan* (Rockland, Maine: The Island Institute, 1991), 4.

78 Rockwell Kent, *It's Me O Lord: The Autobiography of Rockwell Kent* (1955; repr., New York: Da Capo Press, 1977), 191.

79 Daniel E. O'Leary, Aprile Gallant, and Susan Elizabeth Ryan, *Love and the American Dream: The Art of Robert Indiana* (Portland, Maine: Portland Museum of Art, 1999), 79.

80 Ibid.

81 Robert Indiana, quoted in Susan Elizabeth Ryan and Robert Indiana, *Robert Indiana: Figures of Speech* (New Haven: Yale University Press, 2000), 93.

82 James M. Carpenter, *Fairfield Porter, Paintings; Eliot Porter, Photographs* (Waterville, Maine: Colby College Museum of Art, 1969), n.p.

83 Will Barnet, quoted in *Will Barnet: The Abstract Work* (New York: Tibor de Nagy Gallery, 1998), n.p.

84 Barnet made another state of the woodcut in an edition of ten, entitled *Enveloping Forms*, which used different colored inks.

85 Sketches for both the painting and the woodcut, including the specific study where the connection is explicit, are illustrated in Patrick J. McGrady, *Will Barnet: Painting without Illusion* (University Park, Pa.: Palmer Museum of Art, 2003), 17.

86 Barnet apparently began the oil painting *Enclosure* (private collection) in 1962 and completed it in 2003. See ibid., p. 16, ill. p. 18.

87 Alex Katz, "Starting Out," *The New Criterion*, December 2002, 4, quoted in Suzette McAvoy, foreword to *Alex Katz in Maine* (Milan: Charta, 2005), 9.

88 Simon Schama, "Alex Katz's Landscapes," in *Alex Katz Under the Stars: American Landscapes, 1951–1995* (New York: Institute for Contemporary Art/P.S. 1, 1996), 12.

89 Alex Katz, in discussion with the author at the Portland Museum of Art, Summer 2013.

90 Neil Welliver, quoted in Tony Glavin, "Modern Master in the Rough," *Down East Magazine*, July 1985, 97.

91 Michael Fried, "Art and Objecthood," in *Art and Objecthood* (Chicago and London: University of Chicago Press, 1998), 161–62.

92 Germano Celant, *Louise Nevelson* (Milan: Skira, 2012), 16.

93 Louise Nevelson and Diana MacKown, *Dawns + Dusks: Taped Conversations with Diana MacKown* (New York: Charles Scribner's Sons, 1976), 126, quoted in Germano Celant, *Louise Nevelson* (Milan: Skira, 2012), 139.

94 Jasper Johns, quoted in Kirk Varnedoe, introduction to *Jasper Johns: A Retrospective* (New York: Museum of Modern Art, 1996), 25.

95 Andre (1961–1986) was a part-wild, part-domesticated harbor seal who lived in Rockport's harbor. For more than two decades, he delighted visitors to the region with his antics and, from 1974, with his annual swim home from winter quarters in Massachusetts. The internationally famous seal became the subject of films and children's books.

96 Sandra Garson, "The Chain Saw Massacre," *Maine Times*, August 17, 1979, 14.

97 "Shivered Timbers," *ARTnews* 10, no. 10 (December 1979): 14.

98 Dahlov Ipcar, *Creative Growth* (Portland, Maine: Portland Museum of Art, 1970), n.p.

99 Dahlov Ipcar, memo to the Portland Museum of Art, July 10, 2000, PMA Curatorial Files.

100 Although various media for printing in color, including chromogenic prints, were available in the United States throughout much of the twentieth century, most American artist photographers did not embrace chromogenic printing until the 1980s.

101 David C. Driskell, quoted in *David Driskell: Recent Work* (Waterville, Maine: Colby College Museum of Art), 1989, n.p.

102 David C. Driskell, quoted in *David Driskell: Painting Across the Decade, 1996–2006* (New York: DC Moore Gallery), 2006, n.p.

103 David C. Driskell, *Two Centuries of Black American Art* (New York: Alfred A. Knopf, 1976).

104 Betty Woodman, quoted in Vibhuti Patel, "An Art Traveler Lets Go of the Vessel," *Wall Street Journal*, May 8, 2013.

105 For evidence for this idea, see, for example, Vincent Katz, *Yvonne Jacquette: Evening: Chicago and New York* (New York: DC Moore Gallery, 2000), 12.

106 Jocelyn Lee, in conversation with the author, April 17, 2015.

107 Katherine Bradford, artist's statement, 2000/2001, PMA Curatorial Files.

108 Katherine Bradford, quoted in *2001 Portland Museum of Art Biennial* (Portland, Maine: Portland Museum of Art, 2001), 19.

109 Katherine Bradford, quoted in Carl Little, "Katherine Bradford's Bountiful Boats," *Maine Boats, Homes & Harbors*, April/May 2012, 37.

110 William Pope.L, "Hole Theory: Parts Four & Five," unpublished notes, January 2002, reproduced in Mark H. C. Bessire, ed., *William Pope.L: The Friendliest Black Artist in America* (Cambridge, Mass., and London: MIT Press, 2002), 78.

111 "Tim Rollins at deFINE ART 2014," YouTube video, 2:13, from gallery talk for *RIVERS* exhibition, Savannah College of Art and Design, Savannah, Georgia, 2014, posted by Savannah College of Art and Design, February 20, 2014, https://www.youtube.com/watch?v=g7jxxKOBE9Y.

112 Ahmed Alsoudani, quoted in Stephen Wallis, "Eyes Open," *Architectural Digest*, June 2011, 50.

PRESIDENTS AND DIRECTORS OF THE PORTLAND MUSEUM OF ART

Presidents of the Portland Society of Art / Portland Museum of Art

James Phinney Baxter	1882–1883	James B. Goodbody	1975–1977
William E. Gould	1883–1886	D. Brock Hornby	1977–1979
Charles F. Libby	1887–1890	Rosalyne S. Bernstein	1979–1981
John E. DeWitt	1890–1891	David Plimpton	1981–1982
Harrison Bird Brown	1892–1893	Leonard M. Nelson	1982–1984
George F. Morse	1893–1894	Owen W. Wells	1984–1986
John Calvin Stevens	1895–1898	Roger F. Woodman	1986–1989
Charles Frederick Kimball	1899–1903	Rachel F. Armstrong	1989–1991
George F. Morse	1903–1922	Leslie B. Otten	1991–1994
John Calvin Stevens	1922–1940	Anne O. Jackson	1994–1996
John Howard Stevens	1940–1952	William D. Hamill	1996–1998
Neal W. Allen, Sr.	1952–1955	Charlton H. Ames	1998–2001
Sidney St. F. Thaxter	1955–1956	Lawrence R. Pugh	2001–2003
Sally C. Fowler	1956–1959	Kevin P. O'Connell	2003–2006
Henry R. Hilliard, Jr.	1959–1961	Hans Underdahl	2006–2009
Sally C. Fowler	1961–1965	James L. Moody, Jr.	2009–2010
Mary R. Thompson	1965–1967	John F. Isacke	2010–2013
Roger C. Lambert	1967–1970	Anna H. Wells	2013–2015
George M. Lord	1970–1973	Jeffrey D. Kane	2015–
William H. Webster	1973–1975		

Directors of the Portland Museum of Art

Alexander Bower	1931–1951	John Holverson	1975–1987
Bradford Brown	1951–1959	Barbara S. Nosanow	1988–1993
Donelson F. Hoopes	1960–1962	John J. Evans (*interim*)	1993
John E. Pancoast	1963–1969	Daniel E. O'Leary	1993–2008
John Holverson Curator (*no director*)	1970–1974	Thomas A. Denenberg (*interim*)	2008–2009
Goldthwaite Higginson Dorr, III	1974–1975	Mark H. C. Bessire	2009–

INDEX OF CATALOGUE ARTISTS

CREDITS

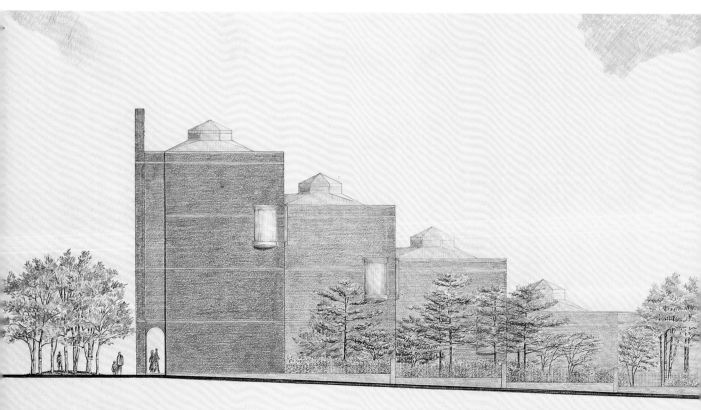

Laurie Olin (United States, born 1938) for I. M. Pei and Partners (United States, established 1966), *Portland Museum of Art, High Street Elevation*, 1980, colored pencil over black line print on paper, 14 7/8 x 51 inches. Portland Museum of Art, Maine. Museum commission, 2005.13

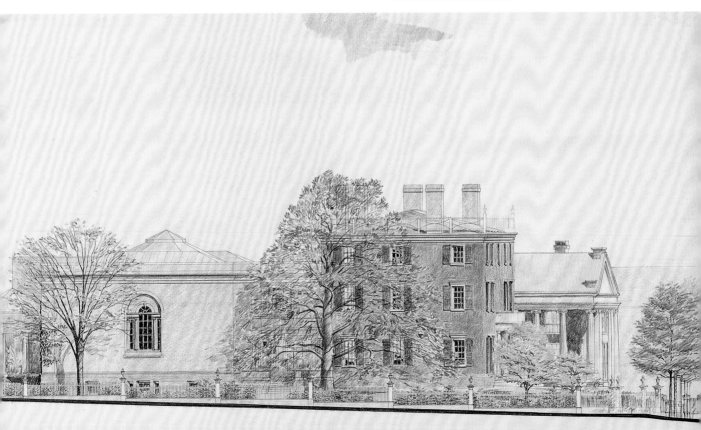

Published by the Portland Museum of Art

Seven Congress Square

Portland, Maine 04101

PortlandMuseum.org

Library of Congress Control Number: 2015947826

ISBN: 978-0-916857-61-5

Production by Sandra M. Klimt, Klimt Studio, Inc.

Designed by Malcolm Grear Designers

Edited by Jane E. Boyd

Proofread by Juliet Clark

Separations by Martin Senn

Printed by Verona Libri, Italy

This project is supported in part by awards
from the National Endowment for the Arts
and the Wyeth Foundation for American Art.

ART WORKS.

**National
Endowment
for the Arts**
arts.gov

FRONT COVER: **Frederic Edwin Church** (United States,
1826–1900), *Mount Katahdin from Millinocket Camp*
(detail), 1895, oil on canvas, 26½ x 42¼ inches.
Gift of Owen W. and Anna H. Wells in memory of
Elizabeth B. Noyce, 1998.96 (CAT. 43)

FRONT FLAP: **Winslow Homer** (United States,
1836–1910), *Eight Bells* (detail), 1887, etching on
parchment, 23½ x 29½ inches. Museum purchase
with support from the Peggy and Harold Osher
Acquisition Fund with partial gift of Mr. and Mrs.
Vaughan W. Pratt, 2014.3 (CAT. 22)

BACK COVER: **N. C. (Newell Convers) Wyeth** (United
States, 1882–1945), *Dark Harbor Fisherman* (detail),
1943, tempera on panel, 35 x 38 inches. Bequest of
Elizabeth B. Noyce, 1996.38.63 (CAT. 68)

BACK FLAP: **Katherine Bradford** (United States, born
1942), *Woman Flying* (detail), 1999, oil on canvas,
84 x 72 inches. Museum purchase with support from
the Friends of the Collection, 2012.14. © Katherine
Bradford (CAT. 95)